THE
SECRET LIFE

VOLUME ONE (1904-1924)

SALVADOR DALÍ

THE SECRET LIFE (VOLUME ONE)

Salvador Dalí

ISBN-13: 978-1-84068-685-2

Published 2023 by Deicide Press

Copyright © Deicide Press 2023

Translated by Haakon M. Chevalier

Cover: *Masochistic Instrument* by Salvador Dalí, 1933-34

All rights in the visual works of Salvador Dalí reserved by Fundación Gala-Salvador Dalí, Figueras

The right of Salvador Dali to be identified as author of this work has been asserted in accordance with Section 77 of the Copyright, Designs and Patents Act 1988

PROLOGUE

À Gala-Gradiva, celle qui avance

At the age of six I wanted to be a cook. At seven I wanted to be Napoleon. And my ambition has been growing steadily ever since.

Stendhal somewhere quotes the remark of an Italian princess who was eating ice cream with enormous relish one hot evening. "Isn't it too bad this it not a sin!" she exclaimed. When I was six, it was a sin for me to eat food of any kind in the kitchen. Going into this part of the house was one of the few things categorically forbidden me by my parents. I would stand around for hours, my mouth watering, till I saw my chance to sneak into that place of enchantment; and while the maids stood by and screamed with delight I would snatch a piece of raw meat or a broiled mushroom on which I would nearly choke but which, to me, had the marvelous flavor, the intoxicating quality, that only fear and guilt can impart.

Aside from being forbidden the kitchen I was allowed to do anything I pleased. I wet my bed till I was eight for the sheer fun of it. I was the absolute monarch of the house. Nothing was good enough for me. My father and mother worshipped me. On the day of the Feast of Kings I received among innumerable gifts a dazzling king's costume – a gold crown studded with great topazes and an ermine cape; from that time on I lived almost continually disguised in this costume. When I was chased out of the kitchen by the bustling maids, how often would I stand in the dark hallway glued to one spot – dressed in my kingly robes, my sceptre in one hand, and in the other a leather-thonged mattress beater – trembling with rage and possessed by an overwhelming desire to give the maids a good beating. This was during the anguishing hour before the sweltering, hallucinatory summer noon. Behind the partly open kitchen door I would hear the scurrying of those bestial women with red hands; I would catch glimpses of their heavy rumps and their hair straggling like manes; and out of the heat and confusion that rose from the conglomeration of sweaty women, scattered grapes, boiling oil, fur plucked from rabbits' armpits, scissors spattered with mayonnaise,

kidneys, and the warble of canaries – out of that whole conglomeration the imponderable and inaugural fragrance of the forthcoming meal was wafted to me, mingled with a kind of acrid horse smell. The beaten white of egg, caught by a ray of sunlight cutting through a whirl of smoke and flies, glistened exactly like froth forming at the mouths of panting horses rolling in the dust and being bloodily whipped to bring them to their feet. As I said, I was a spoiled child.

My brother died at the age of seven from an attack of meningitis, three years before I was born. His death plunged my father and mother into the depths of despair; they found consolation only upon my arrival into the world. My brother and I resembled each other like two drops of water, but we had different reflections. Like myself he had the unmistakable facial morphology of a genius.[1] He gave signs of alarming precocity, but his glance was veiled by the melancholy characterizing insurmountable intelligence. I, on the other hand, was much less intelligent, but I reflected everything. I was to become the prototype *par excellence* of the phenomenally retarded "polymorphous perverse", having kept almost intact all the reminiscences of the nursling's erogenous paradises: I clutched at pleasure with boundless, selfish eagerness, and on the slightest provocation I would become dangerous. One evening I brutally scratched my nurse in the cheek with a safety pin, though I adored her, merely because the shop to which she took me to buy some sugar onions I had begged for was already closed. In other words, I was viable. My brother was probably a first version of myself, but conceived too much in the absolute.

We know today that form is always the product of an inquisitorial process of matter – the specific reaction of matter when subjected to the terrible coercion of space choking it on all sides, pressing and squeezing it out, producing the swellings that burst from its life to the exact limits of the rigorous contours of its own originality of reaction. How many times matter endowed with a too-absolute impulse is annihilated; whereas another bit of matter, which tries to do only what it can and is better adapted to the pleasure of molding itself by contracting in its own way before the tyrannical impact of space, is able to invent its own original form of life.

What is lighter, more fanciful and free to all appearances than the arborescent blossoming of agates! Yet they result from the most ferocious constraint of a colloidal environment, imprisoned in the most relentless of inquisitorial structures and subjected to all the tortures of compression and moral asphyxiation, so that their most delicate, airy, and ornamental ramifications are, it seems, but the traces of its hopeless search for escape from its death agony, the last gasps of a bit of matter that will not give up before it has reached the ultimate vegetations of the mineral dream. Hence what we have in the case of the agate is not a plant transformed into a mineral, or even a plant caught and swallowed

1. Since 1929 I have had a very clear consciousness of my genius, and I confess that this conviction, ever more deeply rooted in my mind, has never excited in me emotions of the kind called sublime; nevertheless, I must admit that it occasionally affords me an extremely pleasurable feeling.

up in a mineral. On the contrary, we actually have the spectral apparition of the plant, its arborescent and mortal hallucination: the end and form of the inquisitorial and pitiless constraint of the mineral world.

So too the rose! Each flower grows in a prison! In the aesthetic point of view freedom is formlessness. It is now known, through recent findings in morphology (glory be to Goethe for having invented this word of incalculable moment, a word that would have appealed to Leonardo!) that most often it is *precisely* the heterogeneous and anarchistic tendencies offering the greatest complexity of antagonisms that lead to the triumphant reign of the most rigorous hierarchies of form.

Even as men with unilateral, one-way minds were burned by the fire of the Holy Inquisition, so multiform, anarchistic minds – precisely because they were such – found in the light of these flames the flowering of their most individual spiritual morphology. My brother, as I have already said, had one of those insurmountable intelligences with a single direction and fixed reflections that are consumed or deprived of form. Whereas I was the backward, anarchistic polymorphous perverse. With extreme mobility I reflected all objects of consciousness as though they were sweets, and all sweets as though they were materialized objects of consciousness. Everything modified me, nothing changed me; I was soft, cowardly, and resilient; the colloidal environment of my mind was to find in the unique and inquisitorial rigour of Spanish thought the definitive form of the bloody, jesuitical, and arborescent agates of my curious genius. My parents baptized me with the same name as my brother – Salvador – and I was destined, as my name indicates, for nothing less than to rescue painting from the void of modern art, and to do so in this abominable epoch of mechanical and mediocre catastrophes in which we have the distress and the honour to live. If I look toward the past, beings like Raphael appear to me as true gods; I am perhaps the only one today to know why it will henceforth be impossible even remotely to approximate the splendours of Raphaelesque forms. And my own work appears to me a great disaster, for I should like to have lived in an epoch during which nothing needed to be saved! But if I turn my eyes toward the present, although I do not underestimate specialized intelligences much superior to my own – yes, I shall repeat it a hundred times – I would for nothing in the world change places with anyone, with anyone whomsoever among my contemporaries. But the ever-perspicacious reader will already have discovered without difficulty that modesty is not my specialty.

One single being has reached a plane of life whose image is comparable to the serene perfections of the Renaissance, and this being happens to be precisely Gala, my wife, whom I had the miracle to choose. She is composed of those fleeting attitudes, of those Ninth-Symphony-like facial expressions, which, reflecting the architectonic contours of a perfect soul, become crystallized on the very shore line of the flesh, at the skin's surface, in the sea foam of the hierarchies of her own life, and which, having been classified, clarified by the most delicate breezes of the sentiments, harden, are organized, and become architecture in flesh

and bone. And for this reason I can say of Gala seated that she resembles perfectly, that she is posed with the same grace as, Il Tempietto di Bramante near the church of San Pietro in Montorio at Rome; for, like Stendhal in the Vatican, I too can measure exactly the slim columns of her pride, the tender and stubborn banisters of her childhood, and the divine stairways of her smile. And so, as I watch her from the corner of my eye during the long hours I spend huddled before my easel, I say to myself that she is as well painted as a Raphael or a Vermeer. The beings around us look as though they were not even finished, and so badly painted! Or rather, they look like those sordid caricatural sketches hastily drawn on café terraces by men with stomachs convulsed by hunger.

I have said that at the age of seven I already wanted to be Napoleon, and I must explain this. On the third floor of our house lived an Argentine family named Matas, one of whose daughters, Ursulita, was a renowned beauty. It was whispered in the Catalonian oral mythology of 1900 that she had been selected by Eugenio d'Ors as the archetype of Catalonian womanhood, in his book *La Ben Plantada* ("The Well-Planted One").

Shortly after I reached the age of seven, the all-powerful social-libidinal attraction of the third floor began to exercise its sway over me. In the sultry twilights of early summer I would sometimes abruptly interrupt the supreme pleasure of drinking from the terrace faucet (delightfully thirsty, my heart beating fast) when the almost imperceptible creaking of the third-floor balcony door made me hope it would perhaps open. On the third floor I was worshipped as I was at home. There, every day at about six, around a monumental table in a drawing room with a stuffed stork, a group of fascinating creatures with the hair and the Argentine accent of angels would sit and take *maté*,[2] served in a silver sipper which was passed from mouth to mouth. This oral promiscuity troubled me peculiarly and engendered in me whirls of moral uneasiness in which the blue flashes of the diamonds of jealousy already shone. I would in turn sip the tepid liquid, which to me was sweeter than honey, that honey which, as is known, is sweeter than blood itself – for my mother, my blood, was always present. My social fixation was scaled by the triumphal and sure road of the erogenous zone of my own mouth. I wished to sip Napoleon's liquid! For Napoleon too was there, in the third-floor drawing room; there was a picture of him in the centre of the circle of glorious polychromes that adorned one end of a tin keg; this little keg was painted to look like wood and contained the voluptuous substance of the *maté*. This object was preciously placed on a centrepiece in the exact middle of the table. Napoleon's image, reproduced on the *maté* keg, meant everything to me; for years his attitude of Olympian pride, the white and edible strip of his smooth belly, the feverish pink flesh of those imperial cheeks, the indecent, melodic, and categorical black of the spectral outline of his hat, corresponded exactly to the ideal model I had chosen for myself, the king.

2. An Argentinian tea.

At that time people were singing the stirring song:
Napoléon en el final
De un ramillette colossal.

This little picture of Napoleon had forcefully taken hold of the very core of the still non-existent contours of my spirit, like the yolk of an egg fried in a pan (without the pan, and yet already in the centre of the pan).

Thus I frantically established hierarchies in the course of a year; from wanting to be a cook I had awakened the very person of Napoleon from my impersonal costume of an obscure king. The furtive nutritive delights had assumed the architectural form of a small tabernacle – the keg containing the *maté*. The swarming erotic emotions aroused by the confused visions of the creatures, half women, half horses, who inhabited the kitchen below had given way to those of the third-floor drawing room, provoked by the serene image of a true lady, Ursulita Matas, the 1900 archetype of beauty.

Later on I shall explain and minutely describe several thinking machines of my invention. One of these is based on the idea of the wonderful "edible Napoleon", in which I have materially realized those two essential phantoms of my early childhood – nutritive oral delirium and blinding spiritual imperialism. It will then become clear as daylight why fifty small goblets filled with lukewarm milk hung on a rocking chair are to my mind exactly the same thing as the plump thighs of Napoleon. Since this may become true for everyone, and since there are all sorts of advantages in being able to look upon things in this way, I shall explain these and many other enigmas, even stranger and no less exact, in the course of this sensational book. One thing, at least, is certain: everything, absolutely everything, that I shall say here is entirely and exclusively my own fault.

CHAPTER ONE
ANECDOTIC SELF-PORTRAIT

I know what I eat
I do not know what I do

Fortunately I am not one of those beings who when they smile are apt to expose remnants, however small, of horrible and degrading spinach clinging to their teeth. This is not because I brush my teeth better than others; it is due to the much more categorical fact that I do not eat spinach. It so happens that I attach to spinach, as to everything more or less directly pertaining to food, essential values of a moral and aesthetic order. And of course the sentinel of disgust is ever on hand, vigilant and full of severe solicitude, ceremoniously attentive to the exacting choice of my foods.

I like to eat only things with well-defined shapes that the intelligence can grasp. I detest spinach because of its utterly amorphous character, so much so that I am firmly convinced, and do not hesitate for a moment to maintain, that the only good, noble and edible thing to be found in that sordid nourishment is the sand.

The very opposite of spinach is armour. That is why I like to eat armour so much, and especially the small varieties, namely, all shell-fish. By virtue of their armour, which is what their exoskeleton actually is, these are a material realization of the highly original and intelligent idea of wearing one's bones outside rather than inside, as is the usual practice.

The crustacean is thus able, with the weapons of its anatomy, to protect the soft and nutritive delirium of its insides, sheltered against all profanation, enclosed as in a tight and solemn vessel which leaves it vulnerable only to the highest form of imperial conquest in the noble war of decortication: that of the palate. How wonderful to crunch a bird's tiny skull![1] How can one eat brains any other way! Small birds are very much like small shell-fish. They wear their armour, so to speak, flush with their skin. In any case Paolo Uccello painted armour that looked like little ortolans and he did this with a grace and mystery worthy of the true bird that he was and for which he was named.

I have often said that the most philosophic organs man possesses are his jaws. What, indeed, is more philosophic than the moment when you slowly suck

1. The bird always awakens in man the flight of the cannibal angels of his cruelty. Della Porta in his *Natural Magic* gives the recipe for cooking turkey without killing it, so as to achieve that supreme refinement: to make it possible to eat it cooked and living.

in the marrow of a bone that is being powerfully crushed in the final destructive embrace of your molars, entitling you to believe that you have undisputed control over the situation? –For it is at the supreme moment of reaching the marrow of anything that you discover the very taste of truth, that naked and tender truth emerging from the well of the bone which you hold fast between your teeth.

Having once overcome the obstacle by virtue of which all self-respecting food "preserves its form", nothing can be regarded as too slimy, gelatinous, quivering, indeterminate or ignominious to be desired, whether it be the sublime viscosities of a fish-eye, the slithery cerebellum of a bird, the spermatozoal marrow of a bone or the soft and swampy opulence of an oyster.[2] I shall undoubtedly be asked: *In that case, do you like Camembert? Does it preserve its form?* I will answer that I adore Camembert precisely because when it is ripe and beginning to run it resembles and assumes exactly the shape of my famous soft watches, and because being an artificial elaboration its original form, though honorable, is not one for which it is entirely responsible. Furthermore I would add that if one were to succeed in making Camembert in the shape of spinach I should very probably not like it either.

But do not forget this: a woodcock, properly high and over which a fine grade of brandy has been burned, served, in its own excrement with all the ritual of the best restaurants of Paris, will always represent for me, in this grave domain of food, the most delicate symbol of an authentic civilization. And how beautiful a woodcock is to look upon as it lies naked in the dish! Its slender anatomy achieves, one might say, the proportions of Raphaelesque perfection.

Thus I know exactly, ferociously, what I want to eat! And I am all the more astonished to observe habitually around me creatures who will eat anything, with that sacrilegious lack of conviction that goes with the accomplishment of a strict necessity.

But while I have always known exactly and with premeditation what I wished to obtain of my senses, the same is not true of my sentiments, which are light and fragile as soap-bubbles: For, generally speaking, I have never been able to foresee the hysterical and preposterous course of my conduct, and even less the final outcome of my acts, of which I am often the first astonished spectator and which always acquire at their climax the heavy, categorical and catastrophic weight of leaden balls. It is as if each time one of these thousand iridescent bubbles of my sentiments strays from the course of its ephemeral life and miraculously reaches the earth – reaches reality – it is at that moment transformed into an important act, suddenly changed from something transparent and ethereal into something opaque, metallic and menacing as a bomb. Nothing can better illuminate this than the kinds of stories which are to follow, selected for this chapter without chronological order from the anecdotic

2. I have always refused to eat a shapeless mess of oysters detached from their shells and served in a soup-dish, even though they were the freshest and best in the world.

stream of my life. When they are strictly authentic and bluntly told, as these are, such anecdotes offer their colours and contours with the guarantee of an unmistakable resemblance that is essential to any honest attempt at self-portraiture. They would have been, I know, secrets forever sealed for many. My fixed idea in this book is to kill as many of these secrets as possible, and to kill them with my own hands!

I : I was five years old, and it was springtime in the village of Cambrils, near Barcelona. I was walking in the country with a boy smaller than I, who had very blond curly hair, and whom I had known only a short time. I was on foot, and he was riding a tricycle. With my hand on his back I helped to push him along.

We got to a bridge under construction which had as yet no railings of any kind. Suddenly, as most of my ideas occur, I looked behind to make sure no one was watching us and gave the child a quick push off the bridge. He landed on some rocks fifteen feet below. I ran home to announce the news.

During the whole afternoon bloodstained basins were brought down from the room where the child, with a badly injured head, was going to have to remain in bed for a week. The continual coming and going and the general turmoil into which the house was thrown put me in a delightful hallucinatory mood. In the small parlor, on a rocking chair trimmed with crocheted lace that covered the back, the arms and the cushion of the seat, I sat eating cherries. The lace was adorned with plump plush cherries. The parlor looked out on the hall, so that I could observe everything that went on, and it was almost completely dark, for the shutters had been drawn to ward off the stifling heat. The sun beating down on them lit up knots in the wood, turning them to a fiery red like ears lighted from behind. I don't recall having experienced the slightest feeling of guilt over this incident. That evening while taking my usual solitary walk I remember having savoured the beauty of each blade of grass.

II : I was six years old. Our drawing-room was full of people. They were talking about a famous comet that would be visible that same evening if there were no clouds. Someone had said it was possible that its tail might touch the earth, in which case the world would come to an end. In spite of the irony registered on most of the faces I was seized with a growing agitation and fright. Suddenly one of my father's office clerks appeared in the drawing-room doorway and announced that the comet could be seen from the terrace. Everyone ran up the stairs except myself; I remained sitting on the floor as if paralyzed with fear. Gathering a little courage I in turn got up and dashed madly toward the terrace. While crossing the hall I caught sight of my little three-year-old sister crawling unobtrusively through a doorway. I stopped, hesitated a second, then gave her a terrible kick in the head as though it had been a ball, and continued running, carried away with a "delirious joy" induced by this savage act. But my father, who was behind me, caught me and led me down into his office, where I remained for punishment till dinner time.

The fact of not having been allowed to see the comet has remained seared in my memory as one of the most intolerable frustrations of my life. I screamed with such rage that I completely lost my voice. Noticing how this frightened my parents, I learned to make use of the stratagem on the slightest provocation. On another occasion when I happened to choke on a fish-bone my father, who couldn't stand such things, got up and left the dining room holding his head between his hands. Thereafter on several occasions I simulated the hacking and hysterical convulsions that accompany such choking just to observe my father's reaction and to attract an anguished and exclusive attention to my person.

At about the same period, one afternoon, the doctor came to the house to pierce my sister's earlobes. My feeling for her was one of delirious tenderness, which had only grown since the incident of my kicking her. This ear-piercing appeared to me an act of outrageous cruelty which I decided to prevent at all costs.

I waited for the moment when the doctor was already seated, had adjusted his glasses, and was ready to perform the operation. Then I broke into the room brandishing my leather-thonged mattress beater and whipped the doctor right across the face, breaking his glasses. He was quite an old man and he cried out with pain. When my father came running in he fell on his shoulder.

"I would never have thought he could do a thing like that, fond of him as I was!" he exclaimed in a voice finely modulated as a nightingale's song, broken by sobs. Since then I loved to be sick, if only for the pleasure of seeing the little face of that old man whom I had reduced to tears.

III : Back to Cambrils again, and to my fifth year. I was taking a walk with three very beautiful grown women. One of them especially appeared to me miraculously beautiful. She held me by the hand and she was wearing a large hat with a white veil twisted round it and falling over her face, which made her extremely moving. We reached a deserted spot, whereupon they began to titter and to whisper among themselves in an ambiguous way. I became troubled and jealous when they began to insist on my running off somewhere to play by myself. I finally left them, but only in order to find a point of vantage from which to spy on them. Suddenly I saw them get into odd postures.

The most beautiful one was in the center, curiously observed from a distance of a few feet by the other two who had stopped talking. With a strange look of pride, her head slightly lowered, her legs very rigid and outspread, her hands by her hips delicately and imperceptibly raised her skirt, and her immobility seemed to convey the expectation of something that was about to happen. A stifling silence reigned for half a minute, when suddenly I heard the sound of a strong liquid jet striking the ground and immediately a foaming puddle formed between her feet. The liquid was partially absorbed by the parched earth, the rest spreading in the form of tiny snakes that multiplied so fast that her white-coloured shoes did not escape them in spite of her attempts

to extend her feet beyond their reach. A greyish stain of moisture rose and spread on the two shoes, on which the whiting acted as blotting paper.

Intent on what she was doing, the "woman with the veil" did not notice my paralyzed attention. But when she raised her head and found herself looking right into my face she tossed me a mocking smile and a look of unforgettable sweetness, which appeared infinitely troubling, seen through the purity of her veil. Almost at the same moment she cast a glance at her two friends with an expression that seemed to say: "I can't stop now, it's too late." Behind me the two friends burst out laughing, and again there was silence. This time I immediately understood, and my heart beat violently. At almost the same moment two new streams struck hard against the ground; I did not turn my head away; my eyes were wide open, fixed on those behind the veil. A mortal shame welled into my face with the ebb and flow of my crazed blood, while in the sky the last purples of the setting sun melted into the twilight, and on the calcinated earth these three long-confined, hard and precious jets resounded like three drums beneath cascades of wild topazes in ebullition.

Night was falling as we started back, and I refused to give my hand to any of the three young women. I followed them at a short distance, my heart torn between pleasure and resentment. In my shut fist I was carrying a glow-worm which I had picked up by the roadside, and from time to time I gently half-opened my hand to watch it glow. I kept my hand so carefully contracted that it dripped with perspiration, and I would shift the glow-worm from one hand to the other to keep it from getting drenched. Several times in the course of these operations it fell out of my grasp, and I had to look for it in the white dust over which the faint moonlight cast a bluish tinge. And once as I stooped a drop of sweat fell from my hand, making a hole in the dust. The sight of this hole made me shiver. I felt myself tingling with goose flesh. I picked up my glow-worm and, seized with a sudden fright, ran toward the three young women who had left me far behind. They were waiting for me, and the one with the veil vainly held out her hand to me. I wouldn't take it. I walked very close to her, but without giving her my hand.

When we had almost reached the house my twenty-year-old cousin came out to meet us. He was carrying a small rifle slung across his shoulder and his other hand held up some object for us to see. Upon coming nearer we saw that it was a small bat that he held dangling by the ears and that he had just shot in the wing. When we got home he put it in a little tin pail and made me a present of it, when he saw that I was dying to have it. I ran back to the wash-house, which was my favourite spot. There I had a glass under which I kept some ladybugs, with green metallic gleams, on a bed of mint leaves. I put my glow-worm inside the glass, which I placed inside the pail, where the bat remained almost motionless. I spent an hour there before dinner deep in reverie. I remember that I spoke aloud to my bat, which I suddenly adored more than anything in the world, and which I kissed again and again on the hairy top of its head.

The next morning a frightful spectacle awaited me. When I reached the back of the wash-house I found the glass overturned, the ladybugs gone and the bat, though still half-alive, bristling with frenzied ants, its tortured little face exposing tiny teeth like an old woman's. Just then I caught sight of the young woman with the veil passing within ten feet of me. She paused to open the garden gate. Without a moment's reflection I found myself picking up a rock and throwing it at her with all my might, possessed by a mortal hate, as though she were the cause of my bat's condition. The stone missed its mark, but the sound of it made the young woman turn around, and she gave me a look full of maternal curiosity. I stood trembling, overcome by an indescribable emotion in which shame quickly got the upper hand.

Suddenly I committed an incomprehensible act that drew a shrill cry of horror from the young woman. With a lightning movement I picked up the bat, crawling with ants, and lifted it to my mouth, moved by an insurmountable feeling of pity; but instead of kissing it, as I thought I was going to, I gave it such a vigorous bite with my jaws that it seemed to me I almost split it in two. Shuddering with repugnance I flung the bat into the wash-house and fled. The opalescent water in the wash-house was bestrewn with black over-ripe figs that had fallen from a large fig tree shading it. When I went back to within a few feet of there, my eyes filled with tears. I could no longer distinguish the bat's dark little body, which was lost among the other black specks of the floating figs. Never again did I have a desire even to go near the wash-house, and still today, each time some black spots recall the spatial and special arrangement (which remains quite clear in my memory) of the figs in the tub where my bat was drowned, I feel a cold shudder run down my back.

IV : I was sixteen. It was at the Marist Brothers' School in Figueras. From our classrooms we went out into the recreation yard by a nearly vertical stone stairway. One evening, for no reason at all, I got the idea of flinging myself down from the top of the stairs. I was all set to do this, when at the last moment fear held me back. I was haunted by the idea, however, secretly nursing the plan to do it the following day. And the next day I could in fact no longer hold back, and at the moment of going down with all my classmates I made a fantastic leap into the void, landed on the stairs, and bounced all the way to the bottom. I was violently bumped and bruised all over, but an intense and inexplicable joy made the pain entirely secondary. The effect produced upon the other boys and the superiors who came running to my aid was enormous. Wet handkerchiefs were applied to my head.

I was at this time extremely timid, and the slightest attention made me blush to the ears; I spent my time hiding, and remained solitary. This flocking of people around me caused in me a strange emotion. Four days later I re-enacted the same scene, but this time I threw myself from the top of the stairway during the second recreation period, at the moment when the animation in the yard was at its height. I even waited until the brother superior was also outdoors. The

effect of my fall was even greater than the first time: before flinging myself down I uttered a shrill scream so that everyone would look at me. My joy was indescribable and the pain from the fall insignificant. This was a definite encouragement to continue, and from time to time I repeated my fall. Each time I was about to go down the stairs there was great expectation. Will he throw himself off, or will he not? What was the pleasure of going down quietly and normally when I realized a hundred pairs of eyes were eagerly devouring me?

I shall always remember a certain rainy October evening. I was about to start down the stairs. The yard exhaled a strong odor of damp earth mingled with the odor of roses; the sky, on fire from the setting sun, was massed with sublime clouds in the form of rampant leopards, Napoleons and caravels, all dishevelled; my upturned face was illuminated by the thousand lights of apotheosis. I descended the stairway step by step, with a slow deliberation of blind ecstasy so moving that suddenly a great silence fell upon the shouting whirlwind in the play-yard. I would not at that moment have changed places with a god.

V : I was twenty-two. I was studying at the School of Fine Arts in Madrid. The desire constantly, systematically and at any cost to do just the opposite of what everybody else did pushed me to extravagances that soon became notorious in artistic circles. In the painting class we had the assignment to paint a Gothic statue of the Virgin directly from a model. Before going out the professor had repeatedly emphasized that we were to paint exactly what we "saw".

Immediately, in a dizzy frenzy of mystification, I went to work furtively painting, in the minutest detail, a pair of scales which I copied out of a catalogue. This time they really believed I was mad. At the end of the week the professor came to correct and comment on the progress of our work. He stopped in frozen silence before the picture of my scales, while all the students gathered around us.

"Perhaps you see a Virgin like everyone else," I ventured, in a timid voice that was not without firmness. "But I see a pair of scales."[3]

VI : Still at the School of Fine Arts.

We were assigned to do an original picture in oil for a prize contest in the painting class. I made a wager that I would win the prize by painting a picture without touching my brush to the canvas. I did in fact execute it by tossing splashes of paint from a distance of a metre, and I succeeded in making a *pointilliste* picture so accurate in design and colour that I was awarded the prize.

3. It is only in writing down this anecdote that I am struck by the obvious connection, if only as a pure association of ideas, between the Virgin and the scales in the signs of the Zodiac. As she now appears in my memory, moreover, the Virgin was standing on a "celestial sphere". This would-be mystification was therefore nothing more nor less than an anticipation, the first realization of the future Dalínian philosophy of painting; that is to say the sudden materialization of the suggested image; the all-powerful fetishistic corporeality of virtual phantoms which are thereby endowed with all the attributes of realism belonging to tangible objects.

VII : The following year I came up for my examination in the history of art.

I was anxious to be as brilliant as possible. I was wonderfully well prepared. I got up on the platform where the examining committee of three sat, and the subject of my oral thesis was drawn by lot. My luck was unbelievable: it was exactly the subject I should have preferred to treat. But suddenly an insurmountable feeling of indolence came over me, and almost without hesitation, to the stupefaction of my examiners and the people who filled the hall, I got up and declared in so many words, "I am very sorry, but I am infinitely more intelligent than these three professors, and I therefore refuse to be examined by them. I know this subject much too well."

As a result of this I was brought before the disciplinary council and expelled from the school.

This was the end of my scholastic career.

VIII : I was twenty-nine, and it was summer, in Cadaqués. I was courting Gala, and we were having lunch with some friends at the seashore, in a vine-covered arbour over which hung the deafening hum of bees. I was at the peak of my happiness although I bore the ripening weight of a new-born love clutching my throat like a veritable octopus of solid gold sparkling with a thousand precious stones of anguish. I had just eaten four broiled lobsters and drunk a bit of wine – one of those local wines that are unpretentious but in their own right one of the most delicate secrets of the Mediterranean, for they have that unique bouquet in which, along with a great, great deal of unreality, one can almost detect the sentimental prickling taste of tears.

It was very late as we were finishing the meal, and the sun was already low on the horizon. I was barefoot, and one of the girls in our group, who had been an admirer of mine for some time, kept remarking shrilly how beautiful my feet were. This was so true that I found her insistence on this matter stupid. She was sitting on the ground, with her head lightly resting against my knees. Suddenly she put her hand on one of my feet and ventured an almost imperceptible caress with her trembling fingers. I jumped up, my mind clouded by an odd feeling of jealousy toward myself, as though all at once I had become Gala. I pushed away my admirer, knocked her down and trampled on her with all my might, until they had to tear her, bleeding, out of my reach.

IX : I seem destined to a truculent eccentricity, whether I wish it or no.

I was thirty-three. One day in Paris I received a telephone call from a brilliant young psychiatrist. He had just read an article of mine in the review *Le Minotaure* on *The Inner Mechanism of Paranoiac Activity*. He congratulated me and expressed his astonishment at the accuracy of my scientific knowledge of this subject, which was so generally misunderstood. He wished to see me to talk over this whole question. We agreed to meet late that very afternoon in my studio on Rue Gauguet. I spent the whole afternoon in a state of extreme agitation at the prospect of our interview, and I tried to plan in advance the course of our

conversation. My ideas were so often regarded even by my closest friends in the surrealist group as paradoxical whims – tinged with genius, to be sure – that I was flattered finally to be considered seriously in strictly scientific circles. Hence I was anxious that everything about our first exchange of ideas should be perfectly normal and serious. While waiting for the young psychiatrist's arrival I continued working from memory on the portrait of the Vicomtesse de Noailles on which I was then engaged. This painting was executed directly on copper. The highly burnished metal cast mirror-like reflections which made it difficult for me to see my drawing clearly. I noticed as I had before that it was easier to see what I was doing where the reflections were brightest. At once I stuck a piece of white paper half an inch square on the end of my nose. Its reflection made perfectly visible the drawing of the parts on which I was working.

At six o'clock sharp – the appointed time of our meeting – the doorbell rang. I hurriedly put away my copper, Jacques Lacan entered, and we immediately launched into a highly technical discussion. We were surprised to discover that our views were equally opposed, and for the same reasons, to the constitutionalist theories then almost unanimously accepted. We conversed for two hours in a constant dialectical tumult. He left with the promise that we would keep in constant touch with each other and meet periodically. After he had gone I paced up and down my studio, trying to reconstruct the course of our conversation and to weigh more objectively the points on which our rare disagreements might have a real significance. But I grew increasingly puzzled over the rather alarming manner in which the young psychiatrist had scrutinized my face from time to time. It was almost as if the germ of a strange, curious smile would then pierce through his expression.

Was he intently studying the convulsive effects upon my facial morphology of the ideas that stirred my soul?

I found the answer to the enigma when I presently went to wash my hands (this, incidentally, is the moment when one usually sees every kind of question with the greatest lucidity). But this time the answer was given me by my image in the mirror. I had forgotten to remove the square of white paper from the tip of my nose! For two hours I had discussed questions of the most transcendental nature in the most precise, objective and grave tone of voice without being aware of the disconcerting adornment of my nose. What cynic could consciously have played this role through to the end?

X : I was twenty-three, living at my parents' house in Figueras. I was inspired, working on a large cubist painting in my studio, I had lost the belt to my dressing gown, which kept hampering my movements. Reaching for the nearest thing to hand I picked up an electric cord lying on the floor and impatiently wound it round my waist. At the end of the cord, however, there was a small lamp. Not wanting to waste time by looking further, and as the lamp was not very heavy, I used it as a buckle to knot the ends of my improvised belt together.

I was deeply immersed again in my work when my sister, came to

announce that there were some important people in the living-room who wanted to meet me. At this time I had considerable notoriety in Catalonia, less because of my paintings than because of several cataclysms that I had unwittingly precipitated. I tore myself ill-humouredly from my work and went into the living-room. I was immediately aware of my parents' disapproving glance at my paint-spattered dressing-gown, but no one yet noticed the lamp which dangled behind me, right against my buttocks. After a polite introduction I sat down, crushing the lamp against the chair and causing the bulb to burst like a bomb. An unpredictable, faithful and objective hazard seems to have systematically singled out my life to make what are normally uneventful incidents violent, phenomenal and memorable.

XI : In 1928 I was giving a lecture on modern art in my native town of Figueras, with the mayor acting as chairman and a number of local notables in attendance. An unusual crowd had gathered to hear me. I had come to the end of my speech, which had apparently been followed with polite puzzlement, and there was no indication from the audience that the conclusive nature of my last paragraph had been grasped. In a sudden hysterical rage, I shouted, at the top of my lungs: "Ladies and gentlemen, the Lecture is FINISHED!"

At this moment the mayor, who was very popular, who was indeed loved by the whole town, fell dead at my feet. The emotion was indescribable and the event had considerable repercussions. The comic papers claimed that the enormities expressed in the course of my lecture had killed him. It was in fact simply a case of sudden death – angina pectoris, I believe – fortuitously occurring exactly at the end of my speech.

XII : In 1937 I was to give a lecture in Barcelona on the subject: "The Surrealist and Phenomenal Mystery of the Bedside Table". On the very day scheduled for the lecture an anarchist revolt broke out. A part of the public which had come to hear me in spite of this was kept prisoner in the building, for the metal doors to the street had to be hastily lowered in case of shooting. Intermittently could be heard the bursting bombs of the F. A. I. [Iberian Anarchist Federation].

XIII : When I arrived in Turin on my first trip to Italy the sky was blackened by a spectacular aerial display. Through the streets marched torchlight parades: war had just been declared on Abyssinia.

XIV : Another lecture in Barcelona. The theatre in which I was to talk caught fire that same morning. It was quickly put out, but the conflagration was more than enough to give a light of immediacy to the evening lecture.

XV : At still another lecture, also in Barcelona, a doctor with a white beard was seized with a kind of mad fit and tried to kill me. It took several people to subdue him and drag him out of the hall.

XVI : In 1931, in Paris, in the course of the showing of the surrealist film *L'Age d'Or*, on which I had collaborated with Bunuel, the Camelots du Roi[4] threw ink-bottles at the screen, fired revolvers in the air, assaulted the public with bludgeons and wrecked the exhibition of surrealist paintings on display in the theatre lobby. As this was one of the greatest Parisian events of the period, I shall relate it in full detail in its proper place in this book.

XVII : At the age of six, again, I was on the way to Barcelona with my parents. Midway there was a long stop, at the station of El Empalme. We got out. My father said to me: "You see, over there, they're selling rolls – let's see if you're smart enough to buy one. Run along, but don't get any of the ones with an omelet inside; I just want the roll."

I went off and came back with a roll. My father turned pale when he saw it.

"But there was an omelet inside!" he exclaimed, highly aggravated.

"Yes, but you told me you only wanted the roll. So I threw away the omelet."

"Where did you throw it?"

"On the ground."

XVIII : In 1936 in Paris in our apartment at number 7 Rue Becquerel, near the Sacré-Coeur. Gala was to undergo an operation the following morning and had to spend the night at the hospital for preparatory treatments. The operation was considered very serious. Nevertheless, Gala, with her unfailing courage and vitality, seemed not at all worried, and we spent that whole afternoon constructing two surrealist objects. She was happy as a child: with graceful arched movements, reminiscent of Carpaccio's figures, she was assembling an astounding collection of items which she subjected to the little cataclysms of certain mechanical actions. Later I realized that this object was full of unconscious allusions to her impending operation. Its eminently biological character was obvious: membranes ready to be torn by the rhythmic movement of metal antennae, delicate as surgical instruments, a bowl full of flour serving as a shock-absorber for a pair of woman's breasts so placed as to bump against it... The breasts had rooster-feathers budding out of the nipples, so that by brushing against the flour the feathers softened the impact of the breasts, which thus barely grazed the surface and left only an infinitely soft, almost imperceptible imprint of their contours upon the immaculate flour.

I, meanwhile, was putting together a "thing" which I called the "hypnagogic clock". This clock consisted of an enormous loaf of French bread posed on a luxurious pedestal. On the back of this loaf I fastened a dozen

4. *Les Camelots du Roi*, an organization of nationalistic, Catholic and royalist youths belonging to the *Action Française*.

ink-bottles in a row, filled with "Pelican" ink, and each bottle held a pen of a different colour. I was highly enthusiastic over the effect which this produced. At nightfall Gala had completely finished her object, and we decided to take it to André Breton to show to him before going to the hospital. (The making of this kind of object had become an epidemic and was then at its height in surrealist circles.) We hurriedly carried Gala's object into a taxi, but no sooner had we got under way than a sudden stop caused the object, which we were cautiously carrying on our laps, to fall apart, and the pieces scattered all over the floor and seat of the taxi. Worst of all, the bowl containing two pounds of flour was upset along with the rest. We were entirely covered with it. We tried to gather up some of the spilt flour, but it had already become dirty. From time to time the taxi-driver glanced back at us in our agitation with an expression of profound pity and bewilderment. We stopped at a grocery store to buy another two pounds of fresh flour.

All these incidents almost made us forget the hospital, where we arrived very late. Our appearance in the courtyard, which was steeped in a mauve May twilight, must have seemed strange and alarming, to judge from the effect we produced on the nurses who came out to meet us. We kept dusting ourselves, each time raising clouds of flour, especially I, who was covered with it even to my hair. What was one to make of a husband stepping out of a perfectly conventional taxi and bringing in his wife for a serious operation, with his clothes saturated with flour, and seeming to take it all as a lark? This is probably still an unfathomed mystery to those nurses of the clinic on Rue Michel-Ange who witnessed our bizarre appearance, which only the chance reading of these lines is likely to clear up.

I left Gala at the hospital and hurried back home. From time to time and at increasing intervals I continued absent-mindedly to dust off the stubborn flour sticking to my clothes. I dined on a few oysters and a roast pigeon, which I ate with an excellent appetite. After three coffees I went back to work on the object I had begun in the afternoon. As a matter of fact I had cherished this moment the whole time I was gone, and the interruption of taking Gala to the hospital had only heightened the anticipation and increased its delight. I was a little surprised at my almost complete indifference to my wife's operation, which was to be performed the following morning at ten. But I found myself unable, even with a little effort, to bring myself to feel the slightest anxiety or emotion. This complete indifference toward the being whom I believed I adored presented to my intelligence a very interesting philosophical and moral problem to which, however, I found it impossible to give my attention immediately.

Indeed I felt myself inspired, inspired like a musician: new ideas sparkled in the depth of my imagination. To my loaf of bread I added sixty pictures of ink-bottles with their pens respectively painted in watercolour on little squares of paper which I hung by sixty strings under the loaf. A warm breeze blowing in from the street set all these pictures swinging back and forth. I contemplated the absurd and terribly real appearance of my object with genuine ecstasy. Still

engrossed in the importance of the object I had just constructed, I finally went to bed at about two in the morning. With the innocence of an angel I fell immediately into deep, peaceful slumber. At five I awoke like a demon. The greatest anguish I had ever felt held me riveted to my bed.

With painfully slow movements which seemed to me to last two thousand years, I threw back the blankets that were choking me. I was covered with that cold perspiration of remorse which is like the dew that has formed on the landscapes of the human soul since the first gleams of the dawn of morality. Day needled the sky, the shrill and frenzied song of birds, suddenly awakened, pecked, as it were, at the very pupils of my eyes opening to misfortune, deafening my ears, and constricting my heart with the tense and growing web of all the buds bursting with the sap of springtime.

Gala, Galuchka, Galuchkineta! Burning tears welled up one by one into my eyes, awkwardly at first, with spasms and the pangs of childbirth. Presently they flowed – with the sureness and impetuosity of a rushing cavalcade – with sorrow for the beloved one, seen in profile seated in the pearl-studded chariot of despair, swept along triumphantly. Each time the flow of my tears began to subside there would immediately arise before me an instantaneous vision of Gala – Gala leaning against an olive-tree in Cadaqués, beckoning to me; Gala in late summer stooping to pick up a gleaming mica pebble amid the rocks of Cape Creus; Gala swimming out so far that I can distinguish only the smile of her little face – and these fleeting images sufficed to provoke by their painful pressure a fresh jet of tears, as though the hard mechanism of feeling were compressing the muscular diaphragm of my orbits, squeezing and pressing out to the last drop each one of those luminous visions of my love, contained in the acid and livid lemon of memory.

Like one possessed I ran to the hospital, and I clutched at the surgeon's uniform with such a display of animal fear that he treated me with exceptional circumspection, as though I had been myself a patient. For a week I was in an almost constant state of tears and wept in every circumstance in which I found myself, to the complete astonishment of my close friends among the surrealists. A Sunday came when Gala was definitely out of danger, and the hour of death in holiday-clothes respectfully backed away on tiptoe. Galuchka was smiling, and at last I held her hand pressed against my cheek. And with tenderness I thought: "After all this, I could kill you!"

XIX : My three voyages to Vienna were exactly like three drops of water which lacked the reflections to make them glitter. On each of these voyages I did exactly the same things: in the morning I went to see the Vermeer in the Czernin Collection, and in the afternoon I did not go to visit Freud because I invariably learned that he was out of town for reasons of health.

I remember with a gentle melancholy spending those afternoons walking haphazardly along the streets of Austria's ancient capital. The chocolate tart, which I would hurriedly eat between the short intervals of going from one

antiquary to another, had a slightly bitter taste resulting from the antiquities I saw and accentuated by the mockery of the meeting which never took place. In the evening I held long and exhaustive imaginary conversations with Freud; he even came home with me once and stayed all night clinging to the curtains of my room in the Hotel Sacher.

Several years after my last ineffectual attempt to meet Freud, I made a gastronomic excursion into the region of Sens in France. We started the dinner with snails, one of my favourite dishes. The conversation turned to Edgar Allan Poe, a magnificent theme while savouring snails, and concerned itself particularly with a recently published book by the Princess of Greece, Marie Bonaparte, which is a psychoanalytical study of Poe. All of a sudden I saw a photograph of Professor Freud on the front page of a newspaper which someone beside me was reading. I immediately had one brought to me and read that the exiled Freud had just arrived in Paris. We had not yet recovered from the effect of this news when I uttered a loud cry. I had just that instant discovered the morphological secret of Freud! Freud's cranium is a snail! His brain is in the form of a spiral – to be extracted with a needle! This discovery strongly influenced the portrait drawing which I later made from life, a year before his death.

Raphael's skull is exactly the opposite of Freud's; it is octagonal like a carved gem, and his brain is like veins in the stone. The skull of Leonardo is like those nuts that one crushes: that is to say, it looks more like a real brain.

I was to meet Freud at last, in London. I was accompanied by the writer Stefan Zweig and by the poet Edward James. While I was crossing the old professor's yard I saw a bicycle leaning against the wall, and on the saddle, attached by a string, was a red rubber hot-water bottle which looked full of water, and on the back of the hot-water bottle walked a snail! The presence of that assortment seemed strange and inexplicable in the yard of Freud's house.

Contrary to my hopes we spoke little, but we devoured each other with our eyes. Freud knew nothing about me except my painting, which he admired, but suddenly I had the whim of trying to appear in his eyes as a kind of dandy of "universal intellectualism". I learned later that the effect I produced was exactly the opposite.

Before leaving I wanted to give him a magazine containing an article I had written on paranoia. I therefore opened the magazine at the page of my text, begging him to read it if he had time. Freud continued to stare at me without paying the slightest attention to my magazine. Trying to Interest him, I explained that it was not a surrealist diversion, but was really an ambitiously scientific article, and I repeated the title, pointing to it at the same time with my finger. Before his imperturbable indifference, my voice became involuntarily sharper and more insistent. Then, continuing to stare at me with a fixity in which his whole being seemed to converge, Freud exclaimed, addressing Stefan Zweig, "I have never seen a more complete example of a Spaniard. What a fanatic!"

CHAPTER TWO
INTRA-UTERINE MEMORIES

I presume that my readers do not at all remember, or remember only very vaguely, that highly important period of their existence which anteceded their birth and which transpired in their mother's womb. But I – yes, I remember this period, as though it were yesterday. It is for this reason that I propose to begin the book of my secret life at its real and authentic beginning, namely with the memories, so rare and liquid, which I have preserved of that intra-uterine life, and which will undoubtedly be the first of this kind in the world since the beginning of literary history to see the light of day and to be described systematically.[1]

In doing this I am confident of provoking the apparition of similar recollections that will begin timidly to people the memories of my readers, or at least of localizing in their minds a host of sentiments, of ineffable and indefinable impressions, images, moods and physical states which will progressively become incorporated into a kind of adumbration of their memories of pre-natal life. On this subject the quite sensational book by Doctor Otto Rank entitled *The Traumatism Of Birth* cannot fail to enlighten the reader really curious about himself who desires to approach this question more scientifically. As for me, I must declare that my personal memories of the intra-uterine period, so exceptionally lucid and detailed, only corroborate on every point Doctor Otto Rank's thesis, and especially the most general aspects of this thesis, as it connects and identifies the said intra-uterine period with paradise, and birth – the traumatism of birth – with the myth, so decisive in human life, of the "Lost Paradise".

Indeed if you ask me how it was "in there", I shall immediately answer, "It was divine, it was paradise." But what was this paradise like? Have no fear, details will not be lacking. But allow me to begin with a short general description: the intra-uterine paradise was the colour of hell, that is to say, red, orange, yellow and bluish, the colour of flames, of fire; above all it was soft, immobile, warm, symmetrical, double, gluey. Already at that time all pleasure, all enchantment for me was in my eyes, and the most splendid, the most striking vision was that of a pair of eggs fried in a pan, without the pan; to this is probably due that perturbation and that emotion which I have since felt, the whole rest of my life, in the presence of this ever-hallucinatory image. The eggs, fried in the pan, without the pan, which I saw before my birth were grandiose, phosphorescent and very detailed in all the folds of their faintly bluish whites. These two eggs

1. While engaged in the translation of my book Mr. Chevalier has called my attention to another chapter of "intra-uterine" memories discovered by his friend Mr. Vladimir Pozner in Casanova's *Memoirs*.

would approach (toward me), recede, move toward the left, toward the right, upward, downward; they would attain the iridescence and the intensity of mother-of-pearl fires, only to diminish progressively and at last vanish. The fact that I am still able today to reproduce at will a similar image, though much feebler, and shorn of all the grandeur and the magic of that time, by subjecting my pupils to a strong pressure of my fingers, makes me interpret this fulgurating image of the eggs as being a phosphene,[2] originating in similar pressures: those of my fists closed on my orbits, which is characteristic of the foetal posture. It is a common game among all children to press their eyes in order to see circles of colours *"which are sometimes called angels"*. The child would then be seeking to reproduce visual memories of his embryonic period, pressing his already nostalgic eyes till they hurt in order to extract from them the longed-for lights and colours, in order approximately to see again the divine aureole of the spectral angels perceived in his lost paradise.

It seems increasingly true that the whole imaginative life of man tends to reconstitute symbolically by the most similar situations and representations that initial paradisial state, and especially to surmount the horrible "traumatism of birth" by which we are expulsed from the paradise, passing abruptly from that ideally protective and enclosed environment to all the hard dangers of the frightfully real new world, with the concomitant phenomena of asphyxiation, of compression, of blinding by the sudden outer light and of the brutal harshness of the reality of the world, which will remain inscribed in the mind under the sign of anguish, of stupor and of displeasure.

It would seem that the death-wish is often explained by that imperialist and constant compulsion to return where we came from, and that suicides are generally those who have not been able to overcome that traumatism of birth, who, even in a brilliant social midst, and while all the candelabra are sparkling in the drawing room, suddenly decide to return to the house of death. In the same way the man who dies from a bullet on the field of battle with the cry of "Mother!" on his lips expresses with truculence that wish to be born again backwards, and to return to the place from which he emerged. Nothing better illustrates all this than the burial customs of certain tribes, who inter their dead crouching and bound in the exact attitudes of the foetus.

But without requiring this categorical experience of the hour of death, man periodically recovers in sleep something of this artificial death, something of that paradisial state, which he tries to recapture in the minutest details. The attitudes of sleepers are in this regard most instructive: in my own case my attitudes of pre-sleep offer not only the characteristic curling up, but also they constitute a veritable pantomime composed of little gestures, tics, and changes of position which are but the secret ballet required by the almost liturgical ceremonial initiating the act of delivering oneself body and soul to that temporary nirvana of sleep by which we have access to precious fragments of our lost

2. Phosphene: a luminous sensation resulting from pressure on the eye when the eyelids are shut.

paradise. Before sleep I curl up in the embryonic posture, my thumbs pressed by the other fingers so tightly as to hurt, with a tyrannic necessity to feel my back adhere to the symbolic placenta of the bedsheets, which I try, by successive efforts more and more closely approximating perfection, to mould to the posterior part of my body, irrespective of the temperature; thus even during the greatest heat I must be covered in this fashion, however slight the thickness of my envelope. Also my definitive posture as a sleeper must be of a rigorous exactitude. It is necessary, for instance, that my little toe be more to the left, or to the right, that my upper lip be almost imperceptibly pressed to my pillow, in order that the god of sleep, Morpheus, shall have the right to seize me, to possess me completely; as he wins me my body progressively disappears and becomes localized, so to speak, entirely in my head, invading it, filling it with all its weight.

This representation of myself approximates the memory of my intrauterine person, which I might define as: a certain weight around two roundnesses – my eyes, very likely. I have often imagined and represented the monster of sleep as an immense and very heavy head, with a single thread-like reminiscence of the body, which is prodigiously maintained in equilibrium by the multiple crutches of reality, thanks to which we remain in a sense suspended above the earth during sleep. Often these crutches give way and we "fall". Surely most of my readers have experienced that violent sensation of feeling themselves suddenly fall into the void just at the moment of falling asleep, awakening with a start, their hearts tumultuously agitated by a paralyzing fear. You may be sure that this is a case of a brutal and crude recall of birth, reconstituting thus the dazed sensation of the very moment of expulsion and of falling outside. Pre-sleep reconstituting the pre-natal memory, characterized by the absence of movement, prepares the unfolding of that traumatic memory of a fall into the void. These falls of pre-sleep take place each time the individual either by excess of fatigue or by the paroxysmal need for escape from the day's cares prepares for the most delightfully and exceptionally longed-for and refreshing sleep.

We have learned, thanks to Freud, the symbolic significance charged with a well determined erotic meaning that characterizes everything relating to aviation, and especially to its origins.[3] Nothing, indeed, is clearer than the paradisial significance of dreams of "flight",[4] which in the unconscious mythology of our epoch only mask that frenzied and puerile illusion of the "conquest of the sky", the "conquest of paradise" incarnated in the messianic character of elementary ideologies (in which the airplane takes the place of a new divinity), and in the same way that we have just studied in the individual pre-dream the frightful fall that awakens us with a start – as a brutal recall of

3. Leonardo da Vinci's preoccupations in this regard (which became crystallized in the invention of his flying machines) are most instructive from the psychological point of view.

4. A symbol of erection by the contradiction which this phenomenon offers in relation to the laws of gravity: the bird a very frequent popular synonym for the penis, the winged phallus of antiquity – Pegasus, Jacob's ladder, angels, Amor and Psyche, etc.

the precise moment of our birth – so we find in the pre-dream of the present day those parachute jumps which I affirm without any fear of being mistaken are nothing other than the dropping from heaven of the veritable rain of new-born children provoked by the war of 1914, nothing other than the fall of all those who, unable to surmount the frightful traumatism of their first birth, desperately attempt to hurl themselves into the void, with the infantile desire to be reborn at all costs, "and in another way", all the while remaining attached to the umbilical cord which holds them suspended to the silk placenta of their maternal parachute. The stratagem of the parachute is of the same nature as that which is utilized by marsupials; in effect the kangaroo's pocket serves as a shock-absorber for the brusque transition of birth by which one is cruelly expelled from paradise.

The marsupial centauresses recently invented by Salvador Dalí also have this meaning of the parachutes of birth – "parabirths" – for thanks to the "holes"[5] which the centauresses have in the middle of their stomachs their sons can at will enter and leave their own mother, their own paradise, so as to be able to become gradually habituated to the environmental reality, while consoling themselves in the most progressive manner for the memory, unconscious but incrusted in their soul, of that wonderful pre-natal lost paradise, which only death can partly restore to them.

External danger[6] has the virtue of provoking and enhancing the phantasms and representations of our intra-uterine memories. When I was small I remember that at the approach of great summer storms we children would all run frantically with one accord and hide under the tables covered with cloths, or else we would hastily construct huts by means of chairs and blankets that were meant to hide and protect our games. What a joy it was then to hear the thunder and the rain outside! What a delightful memory of our games! All curled up in there, we especially liked to eat sweets, to drink warm sugar-water, all the while trying to make believe our life was then transpiring in another world. I had named that stormy weather game "Playing at making grottoes", or else "Playing at Padre Patufet", and this is the reason for the last appellation: Padre Patufet has been since olden times the most popular childhood hero of Catalonia; he was so small that one day he got lost in the country. An ox swallowed him to protect him. His parents looked for him everywhere, calling, "Patufet, Patufet! Where

5. In my last exhibition a lady asked me, "Why those holes in the stomachs of your centauresses?" To which I answered, "It's exactly the same as a parachute, but it's less dangerous." This, as might have been expected, was loudly greeted as a mystification, but I am convinced that the reader who has attentively read the preceding lines will judge my answer otherwise, while readily understanding that it was not so eccentric as it seemed.

6. The present war has furnished me several striking examples on this subject during the air-raid alarms in Paris I would draw the curled-up and foetus-like attitudes that people would adopt in the shelters. There the external danger was further augmented by the intra-uterine evocations inherent in the darkness, the dimensions, etc. of the cellars. People would often go to sleep with ecstasies of happiness, and a secret illusion was constantly betrayed by smiles appropriate to a satisfaction absolutely unjustified by logic, if one did not admit the presence of secret activities characteristic of unconscious representations.

are you?" And they heard the voice of Patufet answering, "I am in the belly of the ox where it does not snow and it does not rain!"

It was in these artificial ox-belly-grottoes, constructed in the electric tension of stormy days that my Patufet imagination reproduced most of the images corresponding in an unequivocal way to my pre-natal memories. These memory-images that had so determining an influence on the rest of my life would always occur as a consequence of a curious game consisting of the following: I would get down on all fours and in such a way that my knees and hands would touch; I would then let my head droop with its own weight while swinging it in all directions like a pendulum, so as to make all my blood flow into it. I would prolong this exercise until a voluptuous dizziness resulted; then and without having to shut my eyes I would see emerging from the intense darkness (blacker than anything one can see in real darkness) phosphorescent circles in which would be formed the famous fried eggs (without the pan) already described in these pages. These eggs of fire would finally blend with a very soft and amorphous white paste; it seemed to be pulled in all directions, its extreme ductility adapting itself to all forms seemed to grow with my growing desire to see it ground, folded, refolded, curled up and pressed in the most contradictory directions. This appeared to me the height of delight, and I should have liked everything to be always like that!

The mechanical object was to become my worst enemy, and as for watches, they would have to be soft, or not be at all!

CHAPTER THREE
BIRTH OF SALVADOR DALÍ

In the town of Figueras at eleven o'clock on the thirteenth day of the month of May, 1904, Don Salvador Dalí y Cusi, natives of Cadaqués, province of Gerona, 41 years of age, married, a notary, residing in this town at 20 Calle de Monturiol, appeared before Señor Miguel Comas Quintana, the well-read municipal judge of this town, and his secretary, D. Francisco Sala y Sabria, in order to record the birth of a child in the civil register, and to this effect, being known to the aforementioned judge, he declared:

THAT the said child was born at his domicile at forty-five minutes after eight o'clock on the eleventh day of the present month of May, and that he will be given the names of Salvador Felipe y Jacinto; that he is the legitimate son of himself and of his wife, Doña Felipa Dome Domenech, aged thirty, native of Barcelona and residing at the address of the informant. His paternal grandparents are: Don Gab Dalí Vinas, native of Cadaqués, defunct, and Doña Teresa Cusi Marco, native of Rosas; and his maternal grand-parents: Doña Maria Ferres Sadurne and Don Anselmo Domenech Serra, natives of Barcelona.

The witnesses were: Don José Mercader, native of La Bisbal, in the province of Gerona, a tanner residing in this town, at 20 Calzada de Los Monjes, and Don Emilio Baig, native of this town, a musician, domiciled at 5 Calles de Perelada, both having attained the age of their majority.

Let all the bells ring! Let the toiling peasant straighten for a moment the ankylosed curve of his anonymous back, bowed to the soil like the trunk of an olive tree, twisted by the *tramontana*,[1] and let his cheek, furrowed by deep and earth-filled wrinkles, rest in the hollow of his calloused hand in a noble attitude of momentary and meditative repose.

Look! Salvador Dalí has just been born! No wind blows and the May sky is without a single cloud. The Mediterranean sea is motionless and on its back, smooth as a fish's, one can see glistening the silver scales of not more than seven or eight sunbeams by careful count. So much the better! Salvador Dalí would not have wanted more!

It is on mornings such as this that the Greeks and the Phoenicians must have disembarked in the bays of Rosas and of Ampurias, in order to come and prepare the bed of civilization and the clean, white and theatrical sheets of my

1. An extremely violent wind, the equivalent of the mistral in Southern France. It usually blows for three or four days in succession, lasting sometimes as long as two weeks.

birth, settling the whole in the very centre of this plain of Ampurdán, which is the most concrete and the most objective piece of landscape that exists in the world.

Let also the fisherman of Cape Creus slip his oars under his legs, keeping them motionless; and while they drip let him forcefully spit into the sea the bitter butt of a cigar a hundred times chewed over, while with the back of his sleeve he wipes that tear of honey which for several minutes has been forming in the corner of his eye, and let him then look in my direction!

And you, too, Narciso Monturiol, illustrious son of Figueras, inventor and builder of the first submarine, raise your grey and mist-filled eyes toward me. Look at me!

You see nothing? And all of you – do you see nothing either?

Only...

In a house on Calle de Monturiol a new-born babe is being watched closely and with infinite love by his parents, provoking a slight and unaccustomed domestic disorder.

Wretches that you all are! Remember well what I am about to tell you: It will not be so the day I die!

CHAPTER FOUR
FALSE CHILDHOOD MEMORIES

When I was seven years old my father decided to take me to school. He had to resort to force; with great effort he dragged me all the way by the hand, while I screamed and raised such a commotion that all the shopkeepers on the streets we passed through came out on their doorsteps to watch us. My parents had succeeded by this time in teaching me two things: the letters of the alphabet and how to write my name. At the end of one year of school they discovered to their stupefaction that I had totally forgotten these two things.

This was by no means my fault. My teacher had done a great deal to achieve this result – or rather, he had done nothing at all, for he would come to school only to sleep almost continually. This schoolmaster's name was Señor Traite, which in Catalonian is something like the word for "omelet", and he was truly a phantastic character in every respect. He wore a white beard separated into two symmetrical plaits that were so long that when he sat down they hung below his knees. The ivory tint of this beard was stained with yellowish spots shading into brown like those that form a patina on the fingertips and nails of great smokers, and also the keys of certain pianos – which, of course, have never smoked in their lives.

As for Señor Traite, he did not smoke either. It would have interfered with his sleeping. But he made up for this by taking snuff. At each brief awakening he would take a pinch of criminally aromatic snuff, which made him sneeze wholeheartedly, bespattering an immense handkerchief, which he rarely changed, with ochre stains. Señor Traite had a very handsome face of the Tolstoyan type to which something of a Leonardo had been grafted; his blue eyes, very bright, were surely peopled with dreams and a good deal of poetry; he dressed carelessly, he was foul-smelling, and from time to time he wore a top-hat, which was altogether unusual in the region. But with his imposing appearance he could allow himself anything: he lived surrounded by a legendary aureole of intelligence which made him invulnerable. Now and then he would go off on a Sunday excursion and return with his cart filled with bits of church sculpture, Gothic windows and other architectural pieces which he stole from the churches of the countryside or which he bought for next to nothing. Once he discovered a Romanesque capital which particularly appealed to him and which was set in a bell-tower. Señor Traite managed to find his way in at night and break it loose from the wall. He dug and dug so hard that a part of the tower collapsed, and with a noise easy to imagine two large bells fell through the roof of an adjoining house, leaving a gaping hole. By the time the awakened village was able to realize what had happened Señor Traite was already galloping away in his cart, though

it is true that he did not escape a few inhospitable rocks. Although the incident aroused the people of Figueras, it rather enhanced his glory, for he became on this account a kind of martyr to the love of Art. What is certain in this story is that bit by bit Señor Traite was building in the vicinity an outlandish villa in which he lumped together the whole heterogeneous archeological collection gathered in the course of his Sunday pillagings, which had assumed the endemic form of a veritable devastation of the artistic treasures of the countryside.

Why had my parents chosen a school with so sensational a master as Señor Traite? My father, who was a free-thinker, and who had sprung from sentimental Barcelona, the Barcelona of "Clavé choirs",[1] the anarchists and the Ferrer trial,[2] made it a matter of principle not to put me into the Christian schools or those of the Marist brothers, which would have been appropriate for people of our rank, my father being a notary and one of the most esteemed men of the town. In spite of this he was absolutely determined to put me into the communal school – Señor Traite's school. This attitude was regarded as a real eccentricity, only partly justified by the mythical prestige of Señor Traite, of whose pedagogical gifts none of my parents' acquaintances had the slightest personal experience, since they had all raised their children elsewhere.

I therefore spent my first school year living with the poorest children of the town, which was very important, I think, for the development of my natural tendencies to megalomania. Indeed I became more and more used to considering myself, a rich child, as something precious, delicate, and absolutely different from all the ragged children who surrounded me. I was the only one to bring hot milk and cocoa put up in a magnificent thermos bottle wrapped in a cloth embroidered with my initials I alone had an immaculate bandage put on the slightest scratch, I alone wore a sailor suit with insignia embroidered in thick gold on the sleeves, and stars on my cap, I alone had hair that was combed a thousand times and that smelt good of a perfume that must have seemed so troubling to the other children who would take turns coming up to me to get a better sniff of my privileged head. I was the only one, moreover, who wore well-shined shoes with silver buttons. These became, each time one of them got torn off, the occasion of a tussle for its possession among my schoolmates who in spite of the winter went barefoot or half shod with the gaping remnants of foul, unmatched and ill-fitting *espadrilles*. Moreover, and especially, I was the only one who never would play, who never would talk with anyone. For that matter my schoolmates, too, considered me so much apart that they would only come near me with some misgivings in order to admire at close range a lace handkerchief that bloomed from my pocket, or my slender and flexible new bamboo cane adorned with a silver dog's head by way of a handle.

1. José Anselmo Clavé, a Catalan musician, founded choral societies in Barcelona which developed into important musical institutions.

2. A famous anti-anarchist trial.

What, then, did I do during a whole year in this wretched state school? Around my solitary silence the other children disported themselves, possessed by a frenzy of continual turbulence. This spectacle appeared to me wholly incomprehensible. They shouted, played, fought, cried, laughed, hastening with all the obscure avidity of being to tear out pieces of living flesh with their teeth and nails, displaying that common and ancestral dementia which slumbers within every healthy biological specimen and which is the normal nourishment, appropriate to the practical and animal development of the "principle of action". How far I was from this development of the "practical principle of action" – at the other pole, in fact! I was headed, rather, in the opposite direction: each day I knew less well how to do each thing! I admired the ingenuity of all those little beings possessed by the demon of all the wiles and capable of skillfully repairing their broken pencil-boxes with the use of small nails! And the complicated figures they could make by folding a piece of paper! With what dexterity and rapidity they would undo the most stubborn laces of their *espadrilles*, whereas I was capable of remaining locked up in a room a whole afternoon, not knowing how to turn the door-handle to get out; I would get lost as soon as I got into any house, even those I was most familiar with; I couldn't even manage by myself to take off my sailor blouse which slipped over the head, a few experiments in this exercise having convinced me of the danger of dying of suffocation. "Practical activity" was my enemy and the objects of the external world became beings that were daily more terrifying.

Señor Traite, too, seated on the height of his wooden platform, wove his chain of slumbers with a consciousness more and more akin to the vegetable, and if at times his dreams seemed to rock him with the gentleness of reeds bowing in the wind, at other moments he became as heavy as a tree-trunk. He would take advantage of his brief awakenings to reach for a pinch of snuff and to chastise, by pulling their ears till they bled, those going beyond the limit of the usual uproar who either by an adroitly aimed wad of spittle or by a fire kindled with books to roast chestnuts managed to anticipate his normal awakening with a disagreeable jolt.

What, I repeat, did I do during a whole year in this wretched school? One single thing, and this I did with desperate eagerness: I fabricated "false memories". The difference between false memories and true ones is the same as for jewels: it is always the false ones that look the most real, the most brilliant. Already at this period I remembered a scene which, by its improbability, must be considered as my first false memory. I was looking at a naked child who was being washed; I do not remember the child's sex, but I observed on one of its buttocks a horrible swarming mass of ants which seemed to be stationary in a hole the size of an orange. In the midst of the ablutions the child was turned round with its belly upward and I then thought that the ants would be crushed and that the hole would hurt it. The child was once more put back into its original position. My curiosity to see the ants again was enormous, but I was surprised that they were no longer there, just as there was no longer a trace of a

hole. This false memory is very clear, although I cannot localize it in time.

On the other hand, I am perfectly sure that it was between the ages of seven and eight while I was at Señor Traite's school, forgetting the letters of the alphabet and the way to spell my name, that the growing and all-powerful sway of reverie and myth began to mingle in such a continuous and imperious way with the life of every moment that later it has often become impossible for me to know where reality begins and the imaginary ends.

My memory has welded the whole into such a homogeneous and indestructible mass that only a critically objective examination of certain events that are too absurd or clearly impossible obliges me to consider them as authentic false memories. For instance, when one of my memories pertains to events happening in Russia I am after all forced to catalogue it as false, since I have never been in that country in my lift. And it indeed to Russia that certain of my false memories go back.

It was Señor Traite who revealed to me the first images of Russia, and this is how it happened:

When the so-called study-day was over, Señor Traite would sometimes take me to his private apartment. This has remained for me the most mysterious of all the places that still crowd my memory. Such must have been the room where Faust worked. On the shelves of a monumental bookcase, spasmodically depleted, great dusty volumes alternated with incongruous and heterogeneous objects. Some of the latter were covered or half-concealed by cloths, sometimes exposing a part of their enigmatic complexities, which was often just the detail necessary to set off at a gallop the ever-ready Arab cavalry[3] of my "phantastic interpretations", holding themselves in with frenzied impatience, and waiting only for the silver spurs of my mythomania to prod their bruised and bloody flanks in order to dash into an unbridled race.

Señor Traite would seat me on his knees[4] and awkwardly stroke my chin with its fine, glowing skin, grasping it with the forefinger and large thumb of his hand which had the lustreless skin, the smell, the colour, the temperature and the roughness of a potato wrinkled and warmed by the sun and already a little rotten.

Señor Traite always began by saying to me:

"And now I'm going to show you something you have never seen."

Then lie would disappear into a dark room and presently return loaded with a gigantic rosary which he could barely carry on his shoulders and which hung down the whole length of his bent body and trailed two metres behind him on the floor, making an infernal din and raising a cloud of dust.

3. In my family tree my Arab lineage, going back to the time of Cervantes, has been almost definitely established.

4. At about time same time in Russia, in the "Lighted Glade", Tolstoy's country place, another child, Galuchka, toy wife, was seated on the lap of another potato, of another specimen of that kind of earthy, rugged and dreamy old man – Count Leo Tolstoy.

"My wife (God save her!) asked me to bring her back a rosary as a present from my trip to Jerusalem. I bought her this one, which is the largest rosary to be found in the whole world, besides which it is carved out of real olive wood from the Mount of Olives."

So saying, Señor Traite would smile slyly.

Another time Señor Traite pulled out of a large mahogany box lined with garnet-red velvet a statuette of Mephistopheles of a wonderful red colour, as shiny as a fish just out of water, and he lighted an ingenious contrivance in the form of a trident which the demon brandished with his movable arm, and sheafs of multi-coloured fireworks rose to the ceiling while in the almost complete darkness Señor Traite, stroking his immense beard, paternally observed the effects of my amazement.

In Señor Traite's room there was also a desiccated frog hanging from a thread, which he waggishly called *"La meva pubilla"* (my pupil), and at other times, "my dancer". He was fond of saying:

"With her all I have to do to know what the weather is going to be is to look at her."

I would find this frog each day stiffly contracted in a different pose.

It gave me an indefinable sickish feeling which nevertheless did not prevent an irresistible attraction, for it was almost impossible for me to detach my eyes from the horrid little thing. Besides the giant rosary, the explosive Mephistopheles and the dried frog there was a large quantity of objects which were probably medical paraphernalia, whose unknown use tormented me by the scabrous ambiguity of their explicit shapes. But over all this reigned the irresistible glamor of a large square box which was the central object of all my ecstasies. It was a kind of optical theatre, which provided me with the greatest measure of illusion of my childhood. I have never been able to determine or reconstruct in my mind exactly what it was like. As I remember it one saw everything as if at the bottom of and through a very limpid and stereoscopic water, which became successively and continually coloured with the most varied iridescences. The pictures themselves were edged and dotted with coloured holes lighted from behind and were transformed one into another in an incomprehensible way that could be compared only to the metamorphoses of the so-called "hypnagogic" images which appear to us in the state of "half-slumber". It was in this marvelous theatre of Señor Traite that I saw the images which were to stir me most deeply, for the rest of my life; the image of a little Russian girl especially, which I instantly adored, became engraved with the corrosive weight proper to nitric acid in each of the formative moulds of my child's flesh and soul, in an integral way, from the limpid surface of the crystalline lenses of my pupils and my libido to the most delicate murmur of the "chrysalid caress" sleeping hidden behind the silky protection of the pink and ridged skin of my tender fingertips. The Russian girl appeared to me swathed in white furs and deeply ensconced in a sled, pursued by wolves with phosphorescent eyes. This girl would look at me fixedly and her expression, awe-inspiringly proud, oppressed my

heart; her little nostrils were as lively as her glance, which gave her something of the wild look of a small forest animal. This extreme vivacity provided a moving contrast to the infinite sweetness and serenity conveyed by an oval face and a combination of features as miraculously harmonious as those of a Madonna of Raphael. Was it Gala? I am certain it was.

In Señor Traite's theatre I also saw a whole succession of views of Russia and I would remain startled before the mirage of those dazzling cupolas and ermine landscapes in which my eyes "heard", so to speak, beneath each snowflake, the crackling of all the precious fires of the Orient. The visions of that white and distant country corresponded exactly to my pathological desire for the "absolutely extraordinary", progressively assuming reality and weight to the detriment of those streets of Figueras which, on the other hand, each day lost a little more of their everyday corporeality.

Moreover, as on each occasion in my life when I have wanted something with passionate persistence, an obscure but intense expectation that hovered in my consciousness was materialized: it snowed. It was the first time I witnessed this phenomenon. When I awoke, Figueras and the whole countryside appeared before me covered by that ideal shroud, under which everyday reality was indeed buried, and it was as though this were due to the sole and unique autocratic magic of my will. I felt not the slightest astonishment, so intently had I expected and imagined this transformation. But from this moment a calm ecstasy took hold of me, and I lived the moving and extraordinary events which are to follow in a kind of waking dream that was almost continual.

Toward the middle of the morning it stopped snowing. I left the clouded window-pane, against which I had kept my face obstinately flattened during this whole time, to go walking with my mother and sister. Each crunching step in the snow appeared to me to be a miracle, though I was a little angry over the traffic, which continued as usual and which had already stained the whiteness of the streets – I should have liked no one to have the right to touch it except myself.

As we approached the outskirts of town the whiteness became absolute; we went through a small forest and soon reached a glade. I stood motionless before that immaculate expanse. But I had stopped especially because of a small, round brown object that lay exactly in the centre of this expanse of snow. It was a small seed-ball which had fallen there from a plane tree. The outer envelope of this ball had been partly split open and from where I saw it I clearly distinguished a bit of the kind of yellow down which is inside. Suddenly the sun broke through the clouds and everything was illuminated with a maximum of intensity. My eyes remained riveted to the seed-ball which now cast a precise blue shadow on the snow. Its yellow down, especially, seemed to have caught fire and to have become as if "alive". The sudden dazzle mingled with a great emotion filled my eyes with tears. I went over and with infinitely gentle care picked up the little bruised ball. I kissed it in the broken place with the tenderness one owes to something animate, suffering and cherished. I wrapped it in my handkerchief and said to my sister:

"I have found a dwarf-monkey, but I won't show it to you!"

I could feel it moving inside my handkerchief! A sentiment stronger than all else guided me toward a single spot: "the Discovered Fountain". I had to insist with the unflinching exactingness of my tyrannical obstinacy to force the direction of our walk toward this spot. When we had almost reached it (the Discovered Fountain was just to one side; one had to go down several steps and then turn to the right), my mother, meeting some friends, said to me:

"Run along and play for a while. Go as far as the fountain, but be careful not to get hurt. I'll wait for you here."

The friends made room for my mother on a stone bench, which a while ago had been covered with snow and was still all damp. I looked with ferocious contempt at these friends who dared to offer "that" to my mother, for whom I could imagine only the most exceptionally selected comfort, and I found a great satisfaction in the fact that my mother did not sit down, but remained standing on the pretext that she would be able to watch me more easily. I went down the steps and turned to the right: there she was! – the little Russian girl I had seen inside Señor Traite's magic theatre. I shall call her Galuchka, which is the diminutive of my wife's name, and this because of the belief so deeply rooted in my mind that the same feminine image has recurred in the course of my whole love-life, so that this image having, so to speak, never left me, already nourished my false and my true memories. Galuchka was sitting there, facing me, on a stone bench, in the same attitude as in the sled scene, and she seemed to have been looking at me for a long time. The moment I perceived her I instinctively drew back; my heart was so agitated that I thought it would jump out of my mouth. The little seed-ball, too, began to pulsate in my hand, strengthening my feeling that it was alive.

My mother, seeing me come back and noticing my perturbation, exclaimed:

"What is there at the fountain?" And she explained to her friends:

"See how capricious he is: The whole day he's done nothing but ask to come to the fountain, and now that we've reached it he doesn't want to go there any more."

I said I had forgotten my handkerchief, and seeing my mother look at the one I was carrying in my hand I added:

"I'm using this one to wrap up my monkey. I need one to blow my nose."

My mother blew my nose with her handkerchief and I went off again. This time I tried to go down to the fountain from the opposite direction, so as to be able to see Galuchka from behind without being seen myself. In order to do this I had to climb over a tangled clump of prickly shrubs. My mother commented, as usual:

"He's always got to do just the opposite of everyone else – going down the steps was too easy for him!"

On all fours I scrambled over the top of the clump, and there I did in fact see Galuchka from behind. This reassured me as to her reality, for I was

almost convinced that she would no longer be there on my return. The dorsal fixity of her attitude paralyzed me anew, but this time I did not back away – I kneeled in the snow both to affirm my decision to remain and in order to hide myself behind the trunk of an old olive tree; my movement coincided with that of a man leaning over to fill a water jug at the fountain. While the sound of the water re-echoed within the jug I had an "astonishing" impression[5]: it seemed to me that I lived an "infinite time", during which every kind of precise thought or emotion left me. I became like the Biblical statue of salt. But though my mind was as if absent, I nevertheless saw and heard with an acuteness that I have never again experienced. Galuchka's silhouette against the background of snow had contours as curiously and furiously precise as a key hole. I could hear even the faintest syllable of the conversation between my mother and her friends, in spite of the distance that separated me from them.

At the precise moment when the full jug began to overflow my strange enchantment instantaneously came to an end. Time, as if suspended until then, resumed its habitual prerogatives and its normal limits. I got up again, as if cured of all timidity. My knees were completely benumbed from their long contact with the snow; and I felt a new sensation as of "lightness", without knowing whether it came from the emotion of being in love or from my benumbed knees. A precise idea assailed me: I was going to go up and kiss Galuchka on the back of her head with all my might. But instead of realizing this desire I quickly drew a small knife from my pocket, deciding to carry out another idea instead of that of the kiss – the idea which I had already caressed in the course of my walk: with the pocket knife I would completely peel the seed-ball so that it would be all downy, and then I would make a present of it to Galuchka.

But I had not yet had time to begin my operation when already the adored girl got up and in turn ran to the fountain to fill a little jug. I dashed over to the bench to leave my present, just as it was, on a newspaper lying on the seat. But at this moment I was again seized with a mortal shame and I hid my ball under the paper. The possibility and suddenly the hope, more and more violent, that the little girl would come and perhaps sit down again on the newspaper which now concealed my little ball became for me something so upsetting that I was seized by a slight trembling which would not leave me. My mother came down to fetch me. She had been shouting for me for some time without my hearing her in the least. She was afraid I had caught cold and she rolled a great scarf around my neck and chest. She was terrified. When I tried to speak my teeth chattered; at first I followed her, holding her hand, dazed, resigned, although the regret at leaving this spot, just at this moment, devoured my bowels.

5. Picasso one day related to me a similar impression which had greatly struck him. In his château near Paris he went down to the fountain and filled a jug with water; there was a magnificent moonlight. During the time the jug was filling, he had the impression of "living several years", without preserving any precise memory of it.

But the story of my beloved little ball has but just begun. List patiently, therefore, to the account of the amazing and dramatic circumstances which surrounded the new encounter with the fetish of my deliria. It is well worth your while.

The snow disappeared and with it the enchantment of that transfiguration of the town and the landscape which accompanied those three exceptional days when I did not go to school and during which I lived in a kind of waking dream – through the adventures that have already been described so passionately and minutely. The return to the soporific monotony of Señor Traite's school appeared agreeable to me as a rest after all these vicissitudes, but at the same time the return to reality wounded me with the birth of a sadness which, I felt, would be slow to heal and which the loss of my dwarf-monkey, of my beloved little ball, rendered poignant in the extreme.

The great vaulted ceiling which sheltered the four sordid walls of the class was discoloured by large brown moisture stains, whose irregular contours for some time constituted my whole consolation. In the course of my interminable and exhausting reveries, my eyes would untiringly follow the vague irregularities of these mouldy silhouettes and I saw rising from this chaos which was as formless as clouds progressively concrete images which by degrees became endowed with an increasingly precise, detailed and realistic personality.

From day to day, after a certain effort, I succeeded in recovering each of the images which I had seen the day before and I would then continue to perfect my hallucinatory work; when by dint of habit one of the discovered images became too familiar, it would gradually lose its emotive interest and would instantaneously become metamorphosed into "something else", so that the same formal pretext would lend itself just as readily to being interpreted successively by the most diverse and contradictory figurations, and this would go on to infinity.

The astonishing thing about this phenomenon (which was to become the keystone of my future aesthetic) was that having once seen one of these images I could always thereafter see it again at the mere dictate of my will, and not only in its original form but almost always further corrected and augmented in such a manner that its improvement was instantaneous and automatic.

The sled in which Galuchka was seated became the panoramic view of a Russian city, bristling with cupolas, which would change into the bearded and somnolent face of Señor Traite, which in turn would be transformed into a fierce battle of furiously famished wolves in the middle of a clearing of virgin forest, and so on, the stains becoming metamorphosed into a cavalcade of ever-renewed apparitions which served as an illustrative background to the copious and dreamy course of my violent imagination, which would project itself upon the wall with the maximum of its force of luminous materialization, all as if my head had been a real motion picture projector by virtue of which everything that occurred within me was simultaneously seen externally by my own eyes, astonished and absorbed by that great hallucinatory stain from a leaking gutter

produced by the melting of the snow of my fairytale ball in the ruin-menaced vault which protected Señor Traite's dreams and mine within the mouldy curve of its thick walls.

One evening as I was even more absorbed than usual in the contemplation of the spots of moisture, I felt two hands gently placed on my shoulders. I jumped, swallowing my saliva the wrong way, which made me cough convulsively. I welcomed this cough, for it excused my agitation and made it less noticeable. I had in fact just blushed with crimson on identifying the child who was touching me as Buchaques.

He was considerably taller than I and he was nick-named Buchaques because of his extravagant costume which had an exaggerated and unusual number of pockets – pockets in Catalonian being called *buchaques*. For a long time I had noticed Buchaques as being the handsomest of all the boys, and I had only dared to look at him furtively; but each time our glances accidentally crossed, I felt my blood congeal within my veins. Without any doubt I was in love with him, for nothing could justify the emotional disturbance that his presence caused me, much less the preponderant place which his image had occupied for some time in the flow of my reveries, appearing to me now confused with Galuchka and now as her antithesis.

I was not quite aware of what Buchaques said to me because of my dizziness, which filled my ears with that delightful buzzing whose mission it is to efface all the sounds of the surrounding world in order that you may hear more clearly the accelerated beating of your own heart.

Certain it is that Buchaques immediately became my sole friend and that each time we separated we exchanged a long kiss on the mouth.

He was the only one to whom I felt capable of revealing my secret of the dwarf-monkey. He believed, or pretended to believe, in it, taking an interest in my story; and we went on several occasions, at nightfall, to the Discovered Fountain, to try again to "hunt" my dwarf-monkey, my beloved little ball, which in my imagination now appeared endowed with all the most minute attributes of a genuine little living being.

Buchaques was fair-haired (I brought home one of his hairs, which I kept preciously between the pages of a book and which seemed to me to be a thread of real gold), his eyes were blue, very bright, and his pink and smiling flesh contrasted violently with my olive and meditative pallor over which seemed to hover the shadow of that dark bird of meningitis which had already killed my brother.

Buchaques appeared to me beautiful as a little girl, yet his excessively chunky knees gave me a feeling of uneasiness, as did also his buttocks too tightly squeezed into pants that were too excruciatingly narrow. Yet in spite of my embarrassment an invincible curiosity impelled me to look at these tight pants each time a violent movement threatened to split them wide open.

One night I told Buchaques all about my feelings toward Galuchka. His reaction was totally devoid of jealousy and his attitude in regard to her was

absolutely similar to the one he had adopted toward my little ball; like myself, he was going to adore both it and Galuchka.

We spoke constantly and endlessly of these two creatures of delirium, while embracing each other with our caressing arms, but our kiss was always reserved for the end and the very moment of taking leave of each other.

We would await this delightful moment with a growing emotion which we tried to exasperate to the extreme by the tacit conspiracy of our prolonged chatting. Buchaques became everything to me: I began to make him presents of my dearest and most precious toys, which progressively disappeared from my house to go and enhance the stock of my presents which Buchaques amassed with a growing avidity. When my toys were liquidated in this fashion I undertook a veritable rifling of all sorts of other objects, beginning timidly with my father's pipes and a silver medal adorned with a *moiré* silk ribbon which my father had won in an Esperanto congress; the following day I brought a porcelain canary which adorned one of the cabinets of the living room. Buchaques, becoming very quickly accustomed to my generous offerings, began to exact them. Thus one day I ended by bringing him a large china soup-bowl which appeared to me wonderfully poetic – it was adorned with an image of two blue-grey swallows in full flight.

Buchaques' mother must have judged that my gift exceeded the volume that could be allowed to pass unnoticed and brought it back to my mother, who thus discovered the cause of the disappearance of so many objects, until then inexplicable, and which had been stripping our house in such a disturbing and accelerated fashion. I was profoundly unhappy and vexed at having to stop my presents and I wept bitter tears, and cried: "I love Buchaques! I love Buchaques!"

My mother, who was always of an angelic tenderness, consoled me as best she could, then bought me a sumptuous album in which we pasted hundreds of transfer pictures, so that as soon as we had filled it we could make a present of it to my friend, my lover, Buchaques.

Later my mother drew astonishing pictures of fantastic animals on a long strip of paper with coloured pencils. She then carefully folded this strip where each picture stopped, so that the whole could be reduced to a small book which unfolded like an accordion. This was another present for Buchaques!

But the increasing intervals between my gifts, and their diminishing material value, cooled Buchaques' attitude toward me, and he again began to play with all the other children and devoted to me only brief spells between his turbulent games. I felt that I was losing forever the sweetness of my former idyllic confidant who at each new recreation period became as if possessed by the frenzy of the most noisy and violent games; the germinating force of his exuberant health seemed no longer capable of being contained within the limits of that flesh, which was so smooth but which the slightest agitation caused to become quickly congested and disagreeably bloodshot. On the slightest pretext he would come and push me over or brutally pull me by the sleeve to make me run with him. One evening I pretended I had rediscovered my little ball, my dwarf-monkey! I

thought that perhaps by this stratagem I would succeed in winning back his interest. And indeed he absolutely insisted on my showing him my monkey and accompanied me as far as to the entrance to my house where we hid behind the large door in the stairway where it was already dark. With infinite care, and with trembling hands, I unwrapped a plane ball which I had picked up at random in the street and which I had kept hidden inside a handkerchief.

With a single brutal gesture Buchaques tore the ball and the handkerchief from me. He was so much stronger than I that I could never have resisted him. Then, with an abominably mocking gesture, holding up to me the little ball hanging by the tail, he went out into the middle of the street. Whereupon he threw the ball into the air as high as he could. I did not even make an effort to go and pick it up, because I knew perfectly well that it was not my "real" ball. From this time on, however, Buchaques became my enemy. He went off spitting several times into the air in my direction. Painfully I swallowed my saliva and I ran to my room to have a cry. I would show him!

I was convinced that I was in Russia, yet there was no snow. The absence of this phenomenon, which until then seemed to characterize all the visions I had had of that country, did not astonish me. It must have been toward the end of a hot summer afternoon, for they were sprinkling the central avenue of a great park where a fashionable crowd, in which the feminine element predominated, was lining up on either side, settling down slowly and laboriously in the complicated labyrinth of chairs to watch the scheduled military parade.

Myriad-coloured towers and cupolas[6] (like those I had seen inside Señor Traite's theatre) emerged from the great, dark masses of trees, sparkling with all their teeth and with all their gleaming polychrome in the progressively oblique rays of a sun that was beginning to set.

On a platform that seemed to be made entirely of stonework, a military band was parsimoniously beginning to tune its instruments; the brasses intermittently cast savage flashes, blinding as those of the monstrance in country Masses.

Already one heard the cry, now rending, now muffled, of those disparate preliminary notes which with their perfidious prodding have the virtue of exasperating the anticipation of the imminent beginning of the music which cannot delay much longer.

If this anxious expectation is prolonged indefinitely, the bitter-sweet which each new stridence provokes has the purpose of maintaining each heart, with the terribly delicate torture of its repetition, in increasing suspense on the

6. These multi-coloured cupolas which in my false remembrances correspond to Russia or at least to the mirages I had of that country, thanks to Señor Traite's theatre (unless the latter too is a false remembrance), must in all likelihood be localized in the Guell de Gaudí Park in Barcelona, a spot which consists largely of architecture encrusted with violently multi-coloured and fairy-like tiles. I must have attended an open-air festival there. Or, it is possible that my imagination blended a military celebration that took place at the fortified castle of Figueras with the fantastic setting of Guell Park.

edge of the great crystal of the afternoon silence which begins to form as the uneasiness spreads through the crowd.

If at this moment the fragrance of linden trees is wafted over you in gusts to add to your anguish, you will appreciate that what may have been merely a touch of dizziness will have reached the category of nausea and your eyes will be forced to show their whites.

In my case and at the age when all this happened, this anxious state of mind would reach the fainting-point and always resolved itself into a sudden urge to urinate which culminated at the moment when the first inaugural *paso doble* finally came and tore the evening glow into bloody shreds. A tear impossible to hold back would burn in the corner of my eye, seeming to be the same, as irrepressible and hot, as what I felt was at that very moment wetting my pants. That day the sensation, which took hold of me just as the military fanfare struck its first martial notes, was redoubled by the sudden discovery of Galuchka's presence. She had just stood up on a chair to observe the arrival of the parade, placing herself just in front of me ten metres away and on the other side of the avenue.

I was sure that she in turn had just discovered me in the crowd. Seized with an insurmountable shame I immediately hid behind the plump back of a big nurse sitting monumentally on the ground, whose corpulence offered me refuge from Galuchka's unendurable glance.

I felt myself stunned and dumbfounded by the shock of the unforeseen encounter, a shock which the lyrical impact of the music amplified to a state of paroxysm. Everything seemed to melt and vanish around me and I had to lean my little head against the nurse's broad insensitive back, a parapet of my desire.

I shut my eyes. When I reopened them they were fixed on the bare arm of a lady sitting beside me who was parsimoniously lifting a cup of chocolate to her lips. The strange sentiment of absence and of nothingness, which seemed to envelop me more and more, formed a vivid contrast to the sharpness with which I perceived the tiniest details of the skin on the wrist of the lady in question. It was as if my eyes, having become powerful lenses, were exercising their amplifying power on a field of vision that was limited, but endowed with a delirious quality of concreteness; and all this to the detriment of the rest of the world, which was becoming effaced in a more and more total absence, mingling, so to speak, with the music which filled the whole.

This phenomenon of hypervisuality has recurred in a number of diverse circumstances in the course of my life, but always as a consequence of the stupor provoked by a too powerful emotion suddenly taking me unawares. In 1936, among hundreds of photographic documents which I was selecting in a shop on Rue de Seine in Paris, I came across a photo that paralyzed me: it showed a woman lifting a cup to her lips; I recognized her instantly, for she corresponded exactly to the image of my memory. The impression of the 'already seen" was so poignant that I remained haunted for several days by the magic of this picture, convinced that it was exactly the same that I had seen with such great and strange

precision as a child, and which still today stands out with a photographic minuteness of detail among the blurred mists of my most remote false remembrances mingled with lightning images.

I pressed myself closer and closer against the infinitely tender, unconsciously protective, back of the nurse, whose rhythmic breathing seemed to me to come from the sea, and made me think of the deserted beaches of Cadaqués...

My cheek crushed against her white uniform, that stretched over the warm flood of her nutritive flesh, became filled with those thousand ants which a long and dreamy reverie provokes. I wanted, I desired only one thing, which was that evening should fall as quickly as possible!

At twilight and in the growing darkness I would no longer feel ashamed. I could then look Galuchka in the eye, and she would not see me blush.

Each time I stole a furtive glance at Galuchka to assure myself with delight of the persistence of her presence I encountered her intense eyes peering at me. I would immediately hide; but more and more, at each new contact with her penetrating glance, it seemed to me that the latter, with the miracle of its expressive force, actually pierced through the nurse's back, which from moment to moment was losing its corporeality, as though a veritable window were being hollowed out and cut into the flesh of her body, leaving me more and more in the open and gradually and irremissibly exposing me to the devouring activity of that adored though mortally anguishing glance. This sensation became more and more acute and reached the point of a hallucinatory illusion. In fact I suddenly saw a real window transpierce the nurse. Yet through this maddening aperture, of frantically material and real aspect, I no longer saw the crowd which ought to have been there and in the midst of which Galuchka standing on a chair ought to have been in the act of looking at me. On the contrary, through this window opened in the nurse's back, I distinguished only a vast beach, utterly deserted, lighted by the criminally melancholy light of a setting sun.

I suddenly returned to reality, struck by a horrible sight: before me there was no longer a nurse, but in her place a horse in the parade, happening to slip, fell to the ground. I barely had time to draw back and press myself against a wall to avoid being trampled. At each new convulsion of the horse I was in fear of being crushed by one of its furious hooves. One of the metallic shafts of the chariot to which the animal was harnessed had plunged into its flank and a thick spurt of blood splashed in all directions like a wild jet of water dishevelled by the wind.

Two little soldiers fell on the great prostrate body, one of them trying to hold its head still while the other carefully placed a small knife in the center of its brow; after which, with a quick, vigorous thrust of his two hands, he drove the blade of his weapon home.

The horse gave a final quiver and remained motionless, one of its stiffened legs swaying and pointing to the sky, in which I perceived stars beginning to pierce through.

Across the avenue Galuchka was beckoning to me energetically with her arm; I distinctly saw a small brown object in the clenched hand which she held out to me; I could not believe this new miracle, and yet it was true; she was showing me my plane ball! My beloved plane ball which I had lost in the "Discovered Fountain"![7] Overwhelmed with confusion I lowered my eyes. My white sailor suit was already blue-tinged by the deepening twilight, and all spangled with tiny, almost invisible splashes of blood from the dead horse at my feet.

I scratched the spots with my fingernail. The blood was already dry. A warm, heavy air violently exasperated my thirst. The excitement which the brutal and extraordinary violence of the preceding scene had produced in me, and the new situation of feeling myself exposed, looked at by Galuchka, who moreover was motioning to me, all this plunged me into such an unbearable perplexity that I suddenly felt it necessary to resolve my situation by a heroic and utterly incomprehensible act: what I did was to stoop down to the horse's great face and kiss it with my whole soul on the teeth of its half-open mouth contracted in the convulsions of death. Then I climbed nimbly over the animal's body and ran across the avenue that separated me from Galuchka. I headed straight for her, but just as I was one metre away I was seized by a new crisis of timidity even more insurmountable than the previous ones, turning me aside from my objective.

I darted into the crowd, waiting with a more and more frenzied impatience for complete darkness to favour a new plan of approach which I had just conceived.

But this time Galuchka herself came toward me. Again I tried to run away, but she was too near.

Mortally vexed, for I could no longer do anything to conceal my timidity, I nevertheless hid my face in my sailor cap, thinking as I did so that I would choke from the strong odor of violets with which it was soaked. A flush of irritation and indignation rose to my head. I could feel Galuchka brushing against my clothes. Then without looking I kicked her with all my might. She uttered a plaintive cry and reached both hands to one of her knees. I saw her go off limping and sit down at the end of the park between the last row of chairs and an ivy-covered wall. Soon we were sitting face to face, our cold, smooth knees pressing one another with such violence that they hurt; our hurried breathing prevented us from uttering a single word.

From the place where we were seated rose a rather steep ramp which communicated with an upper walk. Children carrying scooters would walk up

7. At the time when I chose the delirious fetish of my plane ball, Galuchka in Moscow projected her whole passion on another fetish, but of a different type; it was a small box of wax matches on the back of which could be seen a glossy picture in colour representing the cathedral in Florence where Galuchka had once been on a short voyage with her father. Each time she wished to console herself for her hyperaesthetic desire to return to Italy, she would light one of her precious matches.

this ramp, and then come down at a dizzy speed on their grinding and horrible contraptions. The menacing din as they periodically came down made us edge closer and closer together. But what was my distress to discover, among those turbulent boys, the red and sweating face of Buchaques! He was ugly, I thought, and I looked at him w mortal hatred. As for Buchaques, he seemed to feel the same hatred for me; he rushed upon me with his scooter and flung himself heavily against my chair, accompanying this act with loathsome little cries and laughs. Galuchka and I tried to barricade ourselves between the wall and the trunk of a large plane tree. She could thus shield herself from the brutal batterings. I, however, who was only half protected, continued to be vulnerable to the malevolent assaults of Buchaques, who after each interval of climbing the slope on foot would come down again at a furious pace with the sole idea of ramming me again with systematic and growing relentlessness. Each of Buchaques' departures was for Galuchka and me a glimpse of heaven; we would immediately take advantage of it to plunge back into the infinitely sweet melancholy of our two glances, united in an inexplicable communion in which the most diverse sentiments were born and melted on the threshold of our souls in an unbroken succession of divine ecstasies. Each sudden new interruption of our romance by the clattering onrush of Buchaques on his scooter would only increase the purity and the passion of our ecstatic contemplation and redouble its delightfully agonizing peril.

As if absent-mindedly Galuchka began to toy with a very delicate chain that she wore round her neck, but soon she seemed to want to indicate to me with gestures of passionate and malicious coquettishness that something precious must be attached to the end of this chain.

Indeed, under her blouse an object sufficiently voluminous to be guessed at would slowly rise toward the delicate white skin above the low neck line on which my eyes remained fastened, hoping to see emerge what I understood was being promised me. But it did not come, for Galuchka, purposely pretending that her toying was involuntary, would let go the chain which again would slip far down into her blouse with the agility of a snake. After which Galuchka would begin the game all over again, and this time she proceeded to pull the chain up with her teeth, lifting her head slowly so that the object attached to the end of the chain would rise from the well of her bosom and at any moment be on the point of emerging from her blouse. At the culminating moment, holding the chain between her clenched teeth, she said to me, "Shut your eyes!" I obeyed, secretly knowing what I would see on reopening them. And there indeed, attached to a handful of tiny medals, hung the beloved ball of my deliria! My dwarf-monkey! But Galuchka let it slip back into her blouse as an instinctive reaction to the move I had just made to take it. She then ordered me once again and with increased energy to shut my eyes. Again I obeyed, shutting my eyes so hard that they hurt and trembling with emotion like a leaf, while Galuchka seizing one of my hands drew it firmly toward her and slipped it, in spite of my resisting stupor, all the way down her bosom. I felt a button of her blouse break loose and my hand,

benumbed by the giddiness provoked by the sudden warmth of an infinitely soft flesh, began to make slow, heavy and clumsy gestures, like those of a drowsy, slumber-swollen lizard.

Finally I seized the handful of burning hot medals among which I could feel the rugged and unmistakable presence of my longed-for ball.

I had not yet had time to savour the miracle of possession with my sense of touch when the grinding noise of Buchaques' lightning approach again made me violently shut my eyes, convulsed this time by rage.

A bestial blow knocked me off the chair and I found myself on the ground next to Galuchka who was on all fours. In my fall I had torn off the chain, which had deeply marked her neck, and whose white and indented traces I could see gradually vanish.

I pretended to be looking for the handful of medals and the ball under the chairs, but an inquisitorial look from Galuchka made me understand that she had guessed my deception and I handed over to her my treasure which I had kept hidden until then in the folds of my sailor collar which I clutched tightly in my hand.

Galuchka walked away from me, went and sat down on the ground near a plane-tree, making believe she was caressing my ball with gestures in which malice mingled with the purest maternal cajoleries.

Cretinized, exhausted by so many moving events, I remained leaning on my elbow against a chair copiously piled with clothes and accessories belonging to two very beautiful ladies sitting beside me, who were laughing gaily and chatting with a soldier who was obviously paying court to one of them. On the same chair there was also, folded several times, the soldier's bright red cape, under which his sword lay flat, partially emerging from the heterogeneous pile of materials, exposing its glittering hilt which in spite of myself insistently drew my attention.

An atrocious idea of vengeance instantly dawned in my brain, appearing with such force that I immediately felt nothing in the world would henceforth be able to prevent the execution of my abominable act; possessed by the unperturbed coolness characteristic of irrevocable verdicts and without the slightest trace of visible emotion, I calmly turned my head toward the top of the ramp to look at Buchaques who had just reached it, painfully dragging his scooter behind him.

At the same moment I slipped my hand on to the hilt of the sword, trying imperceptibly to unsheathe it. The sword slid gently out from its sheath in obedience to my movement; with a furtive glance I saw a piece of its sharp blade glisten. It would work! Buchaques would be horribly punished!!

To succeed in realizing my design it would be necessary to act with an economy of gesture and a dissimulation so monstrous that only my passion for vengeance mingled with the controlled tumult of jealousy could make it possible. To accomplish this frightful chastisement with the maximum of rigour I had to unsheathe the sword entirely without being seen and afterward conceal its naked

blade under the clothes. This preliminary operation would have to be performed without being perceived, especially by Galuchka who would have been horrified to discover my plan; she was the last person to whom I should have wanted to reveal the least of my intentions regarding my cruel decision, and this was all the more difficult as she did not avert her eyes from me for a single moment.

Even when I should succeed in holding this bare weapon in readiness, I would still have to take advantage of a favourable moment just before Buchaques' swift onrush to slip the sword between two chairs in such a way that he would be horribly and irremediably wounded. It was already night, so that Buchaques, with the accelerating speed of his descent and the prevailing darkness, would not be aware of my criminal obstacle. Even if he should catch a momentary glimpse of the shining sword in the dark he would not be able to stop at the last moment. It would be too late!

But I realized that in order to carry through my bloody plan systematically I would first have to distract the attention of Galuchka, who was too much absorbed in looking at me and who could not fail to perceive my slightest move. I therefore got down again, walking on all fours, as though bent on seizing my ball at all costs.

Surprised by my resolute attitude, Galuchka hastily interposed a chair between us. This obstacle rekindled my true desires. I introduced my head and torso between the bars of the chair, pretending that I was going to pass between them, but immediately I felt myself a prisoner in this kind of skeleton shield, which had suddenly become a real and painful trap.

Nevertheless this idyll in the heightened darkness under the chairs appeared to me more and more pleasurable in spite of the growing discomfort of my imprisonment, and I would have been willing to live the rest of my days in this dangerous and confused labyrinth that exasperated my desire to such a point. I had a growing horror of the moment when our unsatisfied romance might come to an end.

Galuchka, visible and invisible, vague in detail but precise in her expression as a whole and tinged more and more with troubling demoniac gleams, became almost immaterial because of the effacement of all the details which presented her to me as if each dimple of her smile, of her elbows or her knees had already been devoured by the supreme softness of the nocturnal shadows in whose depths, through the accents of the dwindling music, I heard the insistent and solitary hooting of an owl. During the intervals in the music both of us suddenly grew more timid. We would then listen to the lazy sound of the footsteps dragging on the wet sand, which became more deafening than the most lyric and strident instrumental sighs which, in turn, inaugurating the ever fresh melancholy of new melodies, would dissolve our shame in the more and more violent audacities of our progressively unequivocal exhibitionist efforts. Galuchka, on the pretext of showing and hiding my ball, ended by entirely unbuttoning her blouse, and her hair, dishevelled by the disorder of her jerky gestures, masked her face where I could half-imagine the gleaming saliva in a

mouth deliciously half-opened by the breathing which her bizarre emotional state accelerated from second to second. As for me, my efforts to approach Galuchka finally brought me forward a few centimetres between the bars as I dragged the chair in her direction. The bars painfully squeezed my sides, bared by the pulling up of my sailor blouse.

Galuchka, who with an exquisite tenderness had reached out the beloved ball till it brushed against my lips suddenly pulled it back cautiously as I made another painful effort to edge forward a little, and a burning pain now bit me to the blood in the hip-bone; my lips were already about to reach my ball once more, but Galuchka pulled it back imperceptibly once more with a gesture so parsimoniously cruel that my eyes drowned in large tears. She remained fixed at that moment in an almost absolute immobility; only the grin of her malicious smile did not vanish from her mouth, but on the contrary it seemed to settle there permanently, assuming a place of honor in the divine oval of her adored face.

However, in spite of her apparent expressive immobility, one would have said that it was rapidly becoming corruptible and without anything external coming to trouble her look of cynical assurance I saw the persistent smile of triumph fade with a rapidity which can only be compared to a reversed and speeded up motion picture of the ephemeral unfolding of a flower.

Galuchka remained thus with the ball dangling from her hand; she was not going to withdraw it, nor was she going to make the slightest movement to bring it closer to me. I knew it. In her fixed glance I read the sureness of a promise, but for this I had to advance still further.

I stretched forward furiously, mad with desire, and by dint of a supreme convulsion I finally succeeded in biting the handful of medals among which my ball was hanging.

At this moment I felt Galuchka's little hand clench like a little bird's tightening claw, enfolding the precious cluster and this time pressing it violently, ferociously even, against my avid mouth in which, mingled with the knife-taste of the medals, I immediately felt the beginning of hat other strong metallic savour, bitter and bloody, of my own wounded gums.

Suddenly a new jolt, more brutal and unforeseen than the preceding ones – for the paroxysm of my sentiments had completely deafened me to Buchaques' arrival – dashed my head to the ground with a bang; my cheek was chafed raw on the sand, my body caught between the bars of the chair seemed to break in two, I uttered a cry of pain and I furiously raised my head toward Buchaques whose purple-stained face, almost on top of me now, was illuminated by jealousy, and had attained the congested ugliness of a cockscomb.

He backed away from me and was about to climb the ramp once more when suddenly, retracing his steps, he sent a contemptuous kick in my direction; raising a clod of earth which struck me and blinded me for a moment. Then lie again started off. Galuchka, too, had received a blow from my chair and had been thrown a metre away from me.

There was a bloody smudge in the exact centre of her brow. She was

wholly given over to feeling this painful spot, dazed by the recent commotion; the abandoned attitude of her half-open legs no longer knew any modesty, and I discovered then for the first time that she was not wearing any pants.

A shadow soft as a dream submerged the upper end of her thighs which were obliterated in the absolute black beneath her little white skirt and in spite of the darkness in which her anatomy completely vanished I felt that she was naked underneath.

She smiled at me, and I got up; this time my vengeance was decided.

I went and sat down on the chair near the one where the sword lay buried between the soldier's cape and the other accessories belonging to the two ladies with whom he continued to chat while he kept looking deep into the eyes of one of them. The other lady, pretending not to take any interest, was directing her attention elsewhere, intervening in the conversation with quick, disconnected remarks. She wore an imperceptible smile of malicious complicity which seemed to me very troubling; from time to time and without apparent reason she would drop back her head heavy with hair, and would then smile with all her teeth at the soldier who at the same moment cast her a polite glance of gratitude, as brief as possible.

I took advantage of the distraction of this absorbing sentimental game that kept these three beings chained to one another to work my way, without being seen by them, by a series of little sliding moves, toward the chair where the sword reposed.

I had to do this in order to reach it from where I was, for I could not change my position without the risk of losing sight of Galuchka who would then be intercepted from me by the plane tree. This tree in turn hid the manipulations full of wile and of sudden skill which I was effecting with my left hand and thanks to which I slowly and by successive stages unsheathed the weapon of my vengeance destined for Buchaques' impending and frightful martyrdom.

I took the precaution of wrapping a handkerchief around my hand so as not to wound myself. I hid the sword behind my back with a slight trembling which did not exclude sureness in my movements, and I used my cap to prevent Galuchka from seeing the hilt project from the other side of my body.

After the success of this first operation, which enabled me to unsheathe the sword without being seen by anyone, I cautiously slipped it back under the materials, but with the blade now bare and pointed in the right direction. All I had left to do was to push it as I wished so that at the right moment the sword would intercept Buchaques' descent.

But my preparations were not yet absolutely completed. A dizzying fever of calculation and of ceremonial in the minutest details took hold of my brain as I felt the irremediable moment approaching. I redoubled the intensity of my amorous gaze in Galuchka's direction to keep her rooted to her place; after the blow she had received in the forehead she remained crouching in a posture of such chilled weariness that my fervent glance, reinforced by the sway which the voluptuous approach of my cruel act gave it, succeeded in maintaining my

Galuchka in a kind of paralysis of which I felt myself the more and more absolute master as the moments passed.

Without moving my sword one millimetre I waited for Buchaques' imminent descent. Against all anticipations, though he came at the same dizzying speed as usual, he did not come crashing against me this time, but got off his scooter and, going over to the plane tree without daring to look at me, asked me, "Where is she?" I did not answer. He knew perfectly well. He went behind the plane tree and for a long time stood stupidly looking at Galuchka.

Without changing her posture, her eyes riveted to mine, she seemed not to see him.

Finally Buchaques said to Galuchka, "If you show me Dalí's dwarf-monkey I won't do it any more." She shuddered and pressed my beloved ball with the handful of medals against her bosom. Buchaques then said, "Let's play!" "Play what?" I answered. He turned toward me and with a repugnant look of gratitude, assuming from my question that I had for. given him, said, almost joyously, yet with something of the social climber's sugar-coated fear, "Let's all three play robbers and civil guard!" I answered "Yes, let's!" And while with one hand I pressed his, with the other I pressed the sword's cold hilt. "Who'll begin?" asked Buchaques. "The taller one of us." Buchaques accepted this absurd condition, for he was clearly taller than I. And suddenly he became very weak, with a weakness which continued to grow in direct ratio to my power of domination.

We measured ourselves against the trunk of the plane tree, marking our heights in the bark by means of a notch made with a pebble.

It was he, then, who would have to go; he would walk up the ramp very slowly in order to give Galuchka and myself time to go and hide.

Once he reached the top he would come down full speed on his scooter and I challenged him to do it faster than he had done the previous times, goading the living and congested flesh of his pride with infallible sureness.

I saw Buchaques start off nonchalently, dragging his scooter behind him and climbing the ramp which was to be fatal to him. At each new furtive glance that I cast in his direction I saw the volume of his buttocks progressively diminishing, with their ungainly movements outline by his tight-fitting pants. My antipathy toward my former lover grew with each of his awkward steps, in whose beatific and nauseating succession I could read the progressive revival of his good conscience, after the troubled waters of remorse which my hypocritical and perverse reconciliation had just calmed.

In my mind there was present the maxim of Philip II, who said on day to his valet, "Dress me slowly because I'm in a great hurry."

I hurried without haste in order to give the last indispensable touches to the scrupulous "finish" of the brilliant painting of my imminent sanguinary creation toward which, with exclusive delight, all the representative force of my imperial imagination was converging

I absorbed myself in a rigorous calculation which called for my utmost

powers of dissimulation so that Galuchka would continue to believe me to be imbued with the simulated ecstasy of my contemplation, when in reality I was occupied solely in coldly calculating Buchaques' stature from the mark of his height in the plane-tree bark, while taking into account the approximate elevation of his scooter, since after all the only thing I wanted to know was the exact location in space of the middle of my rival's throat, in order to be able to dispose my sword in a fashion adequate to a categorical, Doric and pitiless slitting of his throat.

I had to assure myself also of the resistance of the chairs which were to serve as pillars to the sharp-pointed bridge of my sword. For this I brought together several additional chairs which would serve as reinforcement, thus redoubling the fearful efficacy of my trap.

I said to Galuchka, "Buchaques is coming down!" She came up to me so quickly that I did not have time to accomplish my decisive act. I cast an anxious glance toward the top of the ramp which Buchaques was just reaching, already preparing for his run.

I pressed Galuchka against my chest with a tyrannic will, ordering her not to look. While I profited by her obedience to slip the sword between the bars of two chairs, a last glance reassured me as to my task: almost invisible, the weapon shone feebly in the night with all the cold and inhuman nobility of justice.

We could already hear the din of Buchaques' scooter launched on its mad descent. We must run! I dragged Galuchka by the hand in a frenzied chase through the crowd; we struggled like blinded butterflies against the river current of the crowd, which at this moment was slowing its rhythm, obeying the force of the melancholy regret that succeeds the ending of a feast.

A last *paso doble*, executed without conviction, had come to a close. We stopped for a moment just at the spot where, at sunset, I had seen the horse die. On the asphalt sprawled an enormous blood-stain in the form of a great black bird with outspread wings.

Suddenly it was cold and our perspiration made us shiver. We were indescribably dirty, and our clothes were all torn.

I could feel my heart beat in the burning wound of my raw cheek. I touched my head covered with bumps which procured me a sweet and agreeable pain. Galuchka was livid; the clot of blood on her forehead now appeared surrounded by a mauve aureole.

And Buchaques? Where was *his* blood? I shut my eyes.

CHAPTER FIVE
TRUE CHILDHOOD MEMORIES

I shut my eyes and I turn my mind to my most distant memories in order to see the image that will appear to me most spontaneously, with the greatest visual vividness, in order to evoke it as the first and inaugural image of my true remembrances. I see...

I see two cypresses, two large cypresses of almost equal height. The one on the left is the smaller, and its top leans slightly toward the one on the right which is impressively vertical; I see these two cypresses through the window of classroom 1 of the Christian Brothers' School of Figueras, the school which immediately followed my supposedly harmful pedagogical experience at Señor Traite's. The window which served as a frame to my vision was opened only in the afternoon, but from then on I would absorb myself entirely in the contemplation of the changes of light on the two cypresses, along which the slightly sinuous shadow of the rectilinear architecture of our school would slowly rise; at a given moment, just before sunset, the pointed tip of the cypress on the right would appear strongly illuminated with a dark red, as though it had been dipped in wine, while the one on the left, already completely in the shadow, appeared to me to be a deep black. Then we heard the chiming of the Angelus, and the whole class would stand up and we would repeat in chorus the prayer recited with bowed head and folded hands by the superior.

The two cypresses outside, which during the whole afternoon seemed to be consumed and to burn in the sky like two dark flames were for me the infallible clock by which I became in a sense aware of the monotonous rhythm of the events of the class; for as had been the case at Señor Traite's, I was likewise completely absent from this new class, where far from being allowed to enjoy the advantages of my first teacher Señor Traite's blessed sleep to my heart's content, I had now every moment to overcome the resistance which the Brothers of the Christian School with unequalled zeal, and resorting to the cruellest ruses and stratagems, vainly exerted to attract and solicit my attention. But these only accentuated my capacity for annihilating my outer world: I did not want anyone to touch me, to talk to me, to "disturb" what was going on within my head. I lived the reveries begun at Señor Traite's with heightened intensity, but feeling these now to be in peril I clutched at them even more dramatically, digging my nails into them as into a rescue plank.

After the Angelus the two cypresses became almost obliterated in the dark. But if their outlines finally disappeared completely in the night, the immobile presence of their invisible personalities remained firmly localized and their spatial situation, drawing me like a magnet, would force my little

dream-filled head to turn from time to time to look in their exact direction even though I could not see them. After the Angelus and almost at the same moment that the window became black with night, the corridor leading to the classroom would be lighted, and then through the glass-paneled door I could observe the oil paintings which decorated this corridor, wholly covering its walls. From my seat I could see only two of them distinctly: one represented a fox's head emerging from a cavern, carrying a dead goose dangling from its jaws; the other was a copy of Millet's *Angelus*.[1] This painting produced in me an obscure anguish, so poignant that the memory of those two motionless silhouettes pursued me for several years with the constant uneasiness provoked by their continual and ambiguous presence. But this uneasiness was not "all". In spite of these feelings that the *Angelus* aroused in me I had a sense of being somewhat under their protection and a secret and refined pleasure shone in the depth of my fear like a little silvery knife blade gleaming in the sunlight.

During those long winter evenings, while I waited for the bell to announce that the school day was about to come to a close, my imagination was in fact constantly guarded by five sentinels, faithful, frightful and sublime: outside to my left, the two cypresses; to my right the two silhouettes of the *Angelus*; in front of me, God in the person of Jesus Christ – yellow, nailed to a black wooden cross standing on the brother's table. The Redeemer had two horrible wounds, one on each knee, wonderfully imitated by means of a very shiny enamel which revealed the bone through the flesh. The feet of the Christ were dirty with a sickening grey produced by the daily contact of the children's fingers, for after having kissed our superior's hairy hand and before crossing ourselves as we left, each one of us had to touch the pierced feet of the Christ with his ink-blackened fingers.

The brothers of the Christian School noticed the absorption with which I would sit and look out; I was the only child in the class upon whom the window exercised such an absolutist power of fascination. They therefore changed my seat, thus depriving me of the view of my two cypresses; but I continued stubbornly to look in their direction, sensing exactly the spot where they were located. And as if the intensity of my will had endowed my eyes with the power of seeing right through the walls, I was eventually able in my imaginative effort to reconstruct everything according to the hour of the day, which I now had to gauge by what went on in class. I would say to myself, "Now we're about to

1. This painting which made such a deep impression upon me as a child disappeared completely, so to speak, from my imagination for years, its image ceasing to have the same effect upon me. But suddenly in 1929, upon seeing a reproduction of the *Angelus* again, I was violently seized by the same uneasiness and the original emotional upset. I undertook the systematic analysis of a series of the "phenomena" that began to occur around the image referred to, which assumed for me a clearly obsessive character; and after having utilized this image of the *Angelus* in the mast diverse forms, such as objects, paintings, poems, etc., I finally wrote an essay of paranoiac interpretation called *The Tragic Myth Of Millet's Angelus*, a book soon to be published and which I consider one of the fundamental documents of the Dalínian philosophy.

begin the catechism, so that the shadow on the right-hand cypress must have reached that burnt hole with a dry branch coming out of it, from which hangs a bit of white rag; the mountains of the Pyrenees must be mauve, and it is also at this moment, as I noticed several days ago, that a window must be shining in the distant village of Villa Bertran!" An this flash of light would suddenly sparkle with the reality of a fiery diamond in the annihilating darkness produced in my brain by the torture of not being allowed to see that beloved plain of Ampurdán, whose unique geology with its utter vigor was later aesthetic of the philosophy of the Dalínian Landscape.

It was soon realized that moving me to a seat out of sight of the window had not been so effective as might have been expected. Quite to the contrary, my inattention remained so incorruptibly anchored to my pleasure that they began to despair of my case.

One day at dinner, my father created a general consternation by reading aloud a report from my teachers. They alluded to my exemplary discipline and gentleness; they mentioned approvingly that I would spend my recreation periods far from the noisy games, lost in the contemplation of a coloured picture (I knew which one)[2] found in a chocolate wrapping. But they concluded by saying that "I was dominated by a kind of mental laziness so deeply rooted that it made it almost impossible for me to achieve any progress in my studies." I remember that my mother wept that evening. The truth is that after almost a whole additional year of school I had not even learned one-fifth of what all my schoolmates had already devoured during this time. I was forced to remain indefinitely in the same class while the others scurried ahead with the gluttonous frenzy of competition to seize new rungs on the slippery and viscous ladder of hierarchy. My isolation became such a systematic fixed idea that I pretended not to know even the things which, in spite of myself, eventually and little by little became incorporated in my mind. For instance, I still wrote nonchalantly, with thousands of blots and characters of bewildering irregularity. This was done on purpose, for I really knew how to do it well.

One day when I was given a notebook with very silky paper I suddenly discovered the pleasure of writing properly. With a pounding heart, after wetting the new pen-point with my saliva for several minutes, I began, and proceeded to execute a marvel of regularity and elegance, winning the prize in penmanship, and my page was framed and put tinder glass.

The astonishment which the sudden, miraculous change in my handwriting produced encouraged me in the path of mystification and simulation, which were my first methods of "social contact". In order to avoid a recitation when I felt that the Brother would inevitably question me during the lesson, I would leap up and fling away my book which for the past hour I had been pretending to study with the deepest attention, though I really had not read a single line.

2. A religious picture representing the martyrdom of the Maccabees.

After this act which appeared to proceed from an unshakable decision, I would stand up on the bench, then get down again as if seized with panic and while protecting myself with my arms extended before me from some invisible danger, I would fall back on my desk, my head pressed between my hands, seemingly shaken with fright. This pantomime won me the permission to go out all by myself and walk in the garden. When I returned to the classroom I was given a drink of hot herb tea with highly aromatic drops that smelled of pine oil. My parents, who had apparently been informed of this false hallucinatory phenomenon, must have recommended to the superiors of the school redoubled and very special attentions to my person. Thus a more and more exceptional atmosphere surrounded my school days and finally the superiors ceased altogether to attempt to teach me anything.

I was, moreover, frequently taken to the doctor's (the same one whose glasses I had broken several years before when he was about to pierce my sister's ears). At this time I was subject to real dizzy spells after having run up or down the stairs too fast. Also I had frequent nosebleeds, and was periodically confined to my bed with angina. This always took the same course: one day of fever and a week of convalescence with slightly abnormal temperatures. During this time I would perform my natural functions in my room, after which a purple-coloured Armenian paper redolent of incense would be burned to remove the bad smell; sometimes the Armenian paper ran out and then they would burn sugar, which was even more delicious. I loved to have angina! I would look forward impatiently to its recurrence – what paradises those convalescences were! Llucia, my old nurse, would come and keep me company every afternoon, and my grandmother would come and settle down to her knitting near the window of my room: my mother herself would also sometimes have her visiting acquaintances sent into my room, and I would listen with one ear to Llucia's stories while with the other I would follow the more measured background of the murmurs and conversations of the "grown-ups", continuous as a well-fed fire. And if the fever rose a little all this would mingle in a kind of foggy reality which merely lulled my heart and benumbed my head within which that white-winged Angel in silvery robes who, according to Llucia's song, was none other than the angel of sleep began to gleam with a tired splendor.

Llucia and my grandmother were two of the neatest old women, with the whitest hair and the most delicate and wrinkled skin I have ever seen. The first was immense in stature and looked like a pope. The second was tiny and resembled a small spool of white thread. I adored old age! What a contrast between these two "fairy-tale" creatures, between that parchment-like flesh on which the effaced and complete manuscripts of their life were written and that other crude, brand new and apathetically unconscious flesh of my schoolmates, who no longer even remembered that they too had already been old a while ago when they were embryos; old people, on the other hand, had learned how to become old again by their own experience and, moreover, they also remembered having been children. I became, I was and I continue to be the living incarnation

of the Anti-Faust. As a child I adored that noble prestige of old people, and I would have given all my body to become like them, to grow old immediately! I was the Anti-Faust. Wretched was he who, having acquired the supreme science of old age, sold his soul to unwrinkle his brow and recapture the unconscious youth of his flesh! Let the labyrinth of wrinkles be furrowed in my brow with the red-hot iron of my own life, let my hair whiten and my step become vacillating, on condition that I can save the intelligence of my soul – let my unformed childhood soul, as it ages, assume the rational and aesthetic forms of an architecture, let me learn just everything that others cannot teach me, what only life would be capable of marking deeply in my skin! The smooth-skinned animal of my childhood was repugnant to me and I should have liked to crush it with my own feet provided with little bluish metallic heels. For in my mind desire and science were but one single and unique thing and I already knew that only the wear and decline of the flesh could bring me illuminations of resurrection. In each of Llucia's or my grandmother's wrinkles I read this force of intuitive knowledge brought to the surface by the painful sum of experienced pleasures and which was already the force of those germs of premature old age that crumples the embryo, an unfathomable force, a subterranean and Bacchic force of Minerva, a force that twists the hundreds of tendrils of the shoots of old age on the young vine-stalk and that soon effaces the strident laughter of the ageless and retarded face of the child of genius.

To be sure, I did not advance in that painful upward climb of arithmetic, I did not succeed in the sickly and exhausting calculation of multiplications. On the other hand I, Salvador Dalí, at the age of nine, discovered not only the phenomenon of mimesis,[3] but also a general and complete theory to explain it!

At Cadaqués that summer I had observed a species of plant that grows in great profusion along the seashore. These plants when seen at close range are composed of small, very irregular leaves supported on stems so fine that the slightest breath of air animates them in a kind of constant quivering. One day, however, some of these leaves struck me as moving independently of the rest, and what was not my stupor when I perceived that they walked! Thereupon I isolated that curious and tiny leaf-insect from the rest to observe it at leisure and examine it minutely. Seen from behind it was impossible to distinguish from the other leaves among which it lived, but if one turned it over its abdomen appeared no different from that of any other beetle, except for its legs which were perhaps unusually delicate and were in any case invisible in their normal position. The discovery of this insect made an inordinate impression on me for I believed I had just discovered one of the most mysterious and magic secrets of nature.[4] And there is no shadow of a doubt that this sensational discovery of mimesis

3. Mimesis: a resemblance which certain living beings assume, either to the environment in which they find themselves, or to the better protected species or to those at whose expense they live.

4. The invisible image of Voltaire may be compared in every respect to the mimesis of the leaf-insect rendered invisible by the resemblance and the confusion established between Figure and Background.

influenced from then on the crystallization of the invisible and paranoiac images which people most of my present paintings with their phantasmal presence. Proud, haughty, ecstatic even over my discovery, I immediately utilized it for purposes of mystification. I proceeded to claim that by virtue of my personal magic I had acquired the ability to animate the inanimate. I would tear a leaf from a mass of these plants, I would substitute my leaf-insect for the leaf by a sleight-of-hand and, placing it on the dining-room table, I would begin to strike violently all around it with a rounded stone which I presented as the object endowed with magic virtue which was going to bring the leaf to life.

At the beginning of my performance everyone thought the little leaf moved solely because of the agitation which I created around it. But the I would begin to diminish the intensity of my blows until I reduced them to such feeble taps that they could no longer account for the movements of the little leaf-insect which were already clearly independent and differentiated.

At this moment I completely stopped knocking the table and people then uttered a cry of admiration and general stupefaction upon seeing the leaf really walk. I kept repeating my experiment, especially before fishermen. Everyone was familiar with the plant in question, but no on had ever noticed the phenomenon discovered by me, in spite of the fact that this kind of leaf-insect is to be found in profusion on the plant. When, much later, at the outbreak of the war of 1914, I saw the first camouflaged ships cross the horizon of Cadaqués, I jotted down in my notebook of personal impressions and reminiscences something like the following – "Today I found the explanation of my *'morros de con'*[5] [for this was what I called my leaf-insect] when I saw a melancholy convoy of camouflaged ships pass by. Against what was my insect protecting himself in adopting this camouflage, this disguise?"

Disguise was one of my strongest passions as a child. Just as there had been a snowfall on the day when I wished so hard that the landscape of Figueras would be transformed into that of Russia, so on the day when I intensely longed to grow old quickly I received (as if by chance) a gift from one of my uncles in Barcelona – a gift which consisted of a king's ermine cape, a gold sceptre and a crown from which hung a solemn and abundant white wig. That evening I looked at myself in the mirror, wearing my crown, the cape just draped over my shoulders, and the rest of my body completely naked. Then I pushed my sexual parts back out of sight and squeezed them between my thighs so as to look as much as possible like a girl. Already at this period I adored three things: weakness, old age and luxury. But above these three representations of the "ego", the "imperialist sentiment of utter solitude" held sway, more and more powerful, and always accompanied by that other sentiment which was to serve as its frame, its ritual, so to speak – the sentiment of "height", of the "summit".

5. This name in Catalonian has a highly pornographic meaning, impossible to translate. It designates a part of the female pudenda and is used by fishermen and peasants to refer to someone or something prodigiously cunning and sly.

For some time my mother had been asking me, "Sweetheart, what do you wish? Sweetheart, what do you want?" I knew what I wanted. I wanted one of the two laundry rooms located on the roof of our house, which opened on the terrace and which, as they were no longer being used, merely served as storage rooms. And one day I got it, and was allowed to use it as a studio. The maids went up and took out all the things, putting them in a nearby chicken-coop. And the following day I was able to take possession of the little laundry room which was so small that the cement tray took up almost all the space except for the area strictly indispensable for the woman who washed the clothes to stand in. But the extremely restricted proportions of my first studio corresponded perfectly to those reminiscences of the intra-uterine pleasures which I have already described in my memories of this period.

I accordingly installed myself there in the following fashion: I placed my chair inside the cement tray, and the vertical wooden board (serving to protect the washerwoman's dress from the water) I put horizontally across the top so that it half covered the tray. This was my work table! Occasionally on very hot days I would take off my clothes. I then had only to open the faucet and the water filling the tray would rise along my body high up my waist. This water, coming from a reservoir on which the sun would beat down all day long, was tepid. It was somewhat like Marat's bathtub. The whole empty space between the laundry tray and the wall was given over to the arrangement of the most varied objects and the walls were covered with pictures that I painted on the covers of hat boxes of very pliable wood which I stole from my aunt Catalina's millinery shop. The two oil paintings which I did sitting in the tray were the following: one represented the scene of "Joseph meeting his Brethren", and was entirely imaginary; the second was to a certain extent plagiarized from an illustration in a little book in colours which was a summary of the *Iliad* and showed Helen of Troy[6] in profile looking at the horizon. The title was "And the slumbering heart of Helen was filled with memories..." In this picture (about which I dreamed a great deal), almost on the edge of the horizon I painted an infinitely high tower with a tiny figure on its summit. It was surely myself! Aside from the paintings there were also objects which already were embryos of those surrealist objects invented later on in 1929 in Paris. I also made at this period a copy of the *Venus de Milo* in clay; I derived from this my first attempt at sculpture an unmistakable and delightful erotic pleasure.

I had brought up to my laundry the whole collection of "Art Govens"; these little monographs which my father had so prematurely given me as a present produced an effect on me that was one of the most decisive in my life. I came to know by heart all those pictures of the history of art, which have been familiar to me since my earliest childhood, for I would spend entire days contemplating them. The nudes attracted me above all else, and Ingres' *Golden*

6. Helen was to be the name of my wife.

Age appeared to me the most beautiful picture in the world and I fell in love with the naked girl symbolizing the fountain.

It would be interminable for me to narrate all that I lived through inside my laundry tray, but one thing is certain, namely that the first pinches of salt and the first grains of pepper of my humour were born there. I began already to test and to observe myself while accompanying lily voluptuous eye-winks with a faint malicious smile, and I was vaguely, confusedly aware that I was in the process of playing at being a genius. O, Salvador Dalí! You know it now! If you play at genius you become one!

My parents did not tire of answering the invariable question which their friends would ask in the course of a visit, "And Salvador?" "Salvador has gone up on the roof. He says he has set up his painter's studio in the laundry! He spends hours and hours up there by himself!" "Up there!" That is the wonderful phrase! My whole life has been determined by those two antagonistic ideas, the top and the bottom. Since my earliest childhood I have desperately striven to be at the "top." I have reached it, and now that I am there I shall remain there till I die.

I have always felt the greatest moral uneasiness before the anonymity of names in cemeteries, engraved as far as the eye can see in a symmetrical vista to be found only in cemeteries.

What a palpitating magic it was to be able to escape the parental dining-room and run madly up the stairs leading to the roof of the house and, having arrived, to lock the door behind me and feel invulnerable and protected in the total refuge of my solitude. Once I had reached the roof I felt myself become unique again; the panoramic view of the town of Figueras, outstretched at my feet, served in the most propitious way to stimulate the limitless pride and ambition of my ruling imagination. My parents' house was one of the highest in the town. The whole panorama as far as to the Bay of Rosas seemed to obey me and to depend upon my glance. I could also see coming out of the College of the French Sisters those same little girls who gave me feelings of shame when I passed them on the street, and who now did not intimidate me, even if they were there before me, looking straight at me.

There were times when I would bitterly long to run out into the streets and participate in the confused aphrodisiac mingling of night games. I could hear the joyous cries of all the other children, of those anonymous ones, fools, ugly and handsome, of the boys and especially the girls, rising toward me from below and fastening like a martyr's arrow in the center of the hot flesh of my chest composed of massive pride! But no! no! and again NO! Not for anything in the world! I, Salvador, knew that I must remain there, sitting in the damp interior of my laundry tray, I, the most solitary child, surrounded only by the wavering and embittered chimera of my forbidding personality. Besides, I was already so old! And to prove it to myself I would forcibly pull down that king's crown with its fringe of white hair upon my head, seaming my brow with blood-red dents, for I would not admit that my head was growing!

When twilight had fallen I would come out of my laundry, and this was my favourite moment! The smooth and soundless flight of the swallows was already interwoven with that other antagonistic flight, awkward and vacillating – the flight of the bats; I would further wait for the voluptuous moment when I would remove my crown which was becoming so tight that a violent pain on my temples would be added to the real headache produced by that pitiless continual pressure. I would walk up and down the length of the terrace saying to myself, "Just a little longer!", trying to prolong the course of my meditations by some sublime thought. In such moments, exasperated by pain, I would deliver speeches aloud with such grandiloquent verve and intonation that I became imbued with a fantastic and passionate tenderness toward myself.[7]

My speeches would succeed one another in a purely automatic fashion and often my words would in no way correspond to the stream of my thoughts. The latter would seem to me to attain the summit of the sublime and I had the impression of discovering each second, in a more and more inspired and unerring fashion, the enigma, the origin and the destiny of each thing. The city lights would progressively turn on, and for each new star a tiny flute would be born. The monotone and rhythmic song of the crickets and the frogs would stir me sentimentally by superposing upon the present twilight anguish evocative memories of former spring-times. The sudden apparition of the moon only served to exacerbate my ecstasy to a paroxysm and the megalomaniac tumult would reach such a height of delirious egocentricity that I felt myself rising to the very summit of the most inaccessible stars, the whirl of my narcissism having attained the proportions of a cosmic reverie; at this moment a calm, ungrimacing, intelligent flow of tears would come and appease my soul. For some time I had felt within my caressing hand something small, moist, bizarre. I looked in surprise: it was my penis.

I finally removed my crown and pleasurably rubbed the quickly soothed pain of the bruise which the crown had made with its long embrace. I went down to the dining room dead with fatigue, I was not hungry and I looked so ill that my parents were terrified. My mother looked at me questioningly. "Why aren't you hungry? What does my darling want? I can't bear to look at the little darling! He isn't yellow, he's green!"

Green or not, I would go up again on all occasions to the top of the roof, and one day I even went up on the roof of the little laundry where I felt for the first time in my life the sensation of dizziness when I realized that nothing stood between me and the empty space below. I had to remain for several minutes flat on my belly with my eyes shut to resist the almost invincible attraction that I felt sucking me toward the void.

7. Subsequently I have realized that in all my lectures I would seat myself in such a way as to have my foot so uncomfortably twisted that it hurt and that this pain could be accentuated at will. One day when this characteristic contraction coincided with my wearing of shoes that were painfully tight my eloquence reached its height. In my own case physical pain certainly augments eloquence; thus a tooth-ache often releases in me an oratorical outburst.

Since then I never again repeated this experiment; but my long sessions within the laundry tray were enhanced by that sensation of dizziness which I felt localized just above my head and from which the laundry ceiling protected me while at the same time reinforcing in a royal fashion the vertiginous awareness of the height of my cement throne which I felt to be even higher above everything since my experience with dizziness.

And what is the high? The high is exactly the contrary of the low: and there you have a fine definition of dizziness! What is the low? The low is: chaos, the mass, the collective, promiscuity, the child, the common fund of the obscure folly of humanity, anarchy; the low is the left. To the right, above, one finds monarchy, the cupola, hierarchy, architecture and the angel. All poets have sought one single thing: the angel. But their vice of congenital negativism has confused and perverted their taste and turned them to evil angels, and if it is true that it is always the spirit of evil that animates the Rimbaudian and Maldororian angels this is due to the sole and unique fact of the inadaptation to reality that is consubstantial with poets. Painters, on the other hand, having their feet much more securely on the ground, do not need to grope blindly and, possessing a means of inspiration far superior to that of poets – namely the eye – do not need to have recourse to the viscous confusion of the mental collapse into which poets must inevitably fall. This is why only painters are and will be able to show you true angels and true gods, as Raphael did with so much reality and good sense from the height of his imperial Olympus of divine genius. As for me, the more delirious I became the more alert was my eye.

Thus, to summarize what I have said, there I was at the beginning of my ninth year, I, a solitary child, a King, seated within the tray and frequently bleeding from the nose, at the top of the roof, on the summit! Below, all the rest, all that cannon-flesh composed of biology devoid of anguish, all the nose-hairs, the mayonnaise, the spinning tops, the souls of purgatory, the imbecile children that learned anything you please, boiled fish, etc. etc. I would never again go down into the street of the spirit to learn anything whatever. For that matter, I too was mad ages ago, and even this confounded spelling, why learn it again when I already forgot it at least two thousand years ago!*

I was persevering and I still am. My mania for solitude grew, with pathological flashes, my eagerness to climb up to the roof became so intense that before the end of the meals, unable to remain in my seat any longer, I would have to run out several times and lock myself in the toilet on the pretext that I had a stomach-ache. My sole object in doing this was to remain a few moments alone,

* Mr. Dali's manuscript, as to handwriting, spelling and syntax, is probably one of the most fantastically indecipherable documents ever to have come from the pen of a person having a real feeling for the value and the weight of words, for verbal images, for style. The manuscript is written on yellow foolscap in a well-nigh illegible hand-writing, almost without punctuation, without paragraphing, in a deliriously fanciful spelling that would bring beads of perspiration to a lexicographer's brow. Gala is the only one who does not get lost in the labyrinthian chaos of this manuscript. –Translator's Note.

which lightened the torture of having to wait until dinner was over and I was allowed to rush upstairs and shut myself up in the laundry.

In school my state of mind became aggressive toward anything or anyone who deliberately or otherwise challenged my solitude. The children who ventured to come near me – growing progressively fewer to be sure – I received with a look and an attitude so hateful that I was safe from intrusion during the long recreation periods from then on, plunged in an intact and untroubled world of my own. But it so happened that the immaculate purity of this world was destroyed with a single stroke, and this came about, as might easily have been foreseen, by the intervention of that feminine image which is always there to demolish every cerebral construction from which one tries, at nightfall, to spirit away the anguishing presence of the soft and smiling butterfly of the flesh because of which man begins to fear death and by virtue of which will end by believing in the Catholic myth *par excellence* of the triumphant resurrection of his own body.

It was a little girl whom I saw one day from behind, walking in front of me the whole length of the street, on my way home from school. She had a waist so slender and so fragile that it seemed to separate her body into two independent parts and her extremely arched manner of walking threatened to break her in two; she wore a very tight silver belt. This little girl was accompanied by two girl friends, one on each side, who had their arms around her waist while they caressed and cajoled her with the most seductive smiles that they were capable of offering her. The two girls turned their heads several times to look back. I walked very close to them and was able to pick up the remnants of those smiles, that were slow to vanish from their faces. The one in the middle did not turn round and I knew, though seeing her only from behind walking so proudly, that she was different from all other girls in the world, that she was a queen. The same sentiment of never-extinguished love that I had had for Galuchka was born anew; her name was Dullita, for that is what her two fervent and adoring friends called her ceaselessly and in every tone of tenderness and passion. I returned home without having seen her face and without its having occurred to me to look at it. It was indeed she – Dullita, Dullita! Galuchka "Rediviva"!

I went directly up to my rooftop, feeling my aching ears tightly imprisoned in my sailor cap as if ready to catch on fire; I released them and the cool twilight air came and caressed them delightfully; I felt the whole invincible power of love take hold of me anew, and this time it began with my ears.

Since this encounter I had but one single desire, which was that Dullita should come and find me up there in my laundry, that Dullita should come up to me on the roof! And I knew that this must inevitably happen – but how? And when? Nothing would appease my mad impatience and the boiled potatoes became a torture to swallow. One afternoon I had such a violent nosebleed that the doctor was called and I remained several hours with my head down, looking up toward the ceiling, with napkins dipped in vinegar, the shutters drawn. At the beginning of my hemorrhage the maid placed a large cold key at the nape of my

neck, and now it dug into my flesh, causing me great pain; but I was so exhausted that I did not even try to lift myself up.

I saw reduced images pass back and forth – carts and people walking along the street – projected upside down on the ceiling,[8] and I knew that these images corresponded to real people who were in the street in the bright glare of the sun. But in my weak state these distorted figures which came into focus only for a moment all appeared to me to be real angels. I then thought: if Dullita with her two friends should happen to pass by I would see her on my ceiling. This, however, was very unlikely, for she always or almost always came home from school by way of the street running parallel to ours; but even the slightest glimmer of the possibility that she might pass by deeply stirred me by the most contradictory representations, in which displeasure, expectation, hope, pride and illusion dimly mingled in an agony of uneasiness. Two thoughts stronger than the rest came to light, nevertheless, in the chaos of my anxiety:

1. If she should happen to pass across the ceiling I would be the one to be below.

2. If her head was down she would fall down into empty space.

I always saw her from behind, with her delicate waist, fall back into the black void, where she would break in two, like a white porcelain egg-cup. She deserved this, for not having been willing to come up to my roof top, but at the last moment I wanted to save her. I stirred on my bed, torn by a frightful remorse, and I then felt the burning pain of the key of torture encrusted with all the force of my weight in the bones of my neck, and I then felt my love for Dullita, for Galuchka Rediviva, once more become localized there, just where I felt the pain!

The following day my parents decided to send me to the country for a rest; I was to visit the Pitchot family[9] who had a property situated in the plain, two hours from Figueras. The property was called *"El Muli de la Torre"* (The Tower Mill). I had never yet been there, but this name struck me as wonderful. I accordingly consented to go, with a stoic resignation in which the image of the tower, one of my favourite myths, played a tempting role.

Also my departure for the Muli de la Torre would serve me as a means of vengeance against Dullita, since she did not come up to my roof as I had hoped, and as I still expected her to every evening; at the same time my trip would

8. I had on other occasions observed and reproduced at will this phenomenon due to small holes in the shutters which made my room act as a photographic camera.

9. This family has played an important role in my life and has had a great influence on it; my parents before me had already undergone the influence of the personality of the Pitchot family. All of them were artists and possessed great gifts and an unerring taste. Ramon Pitchot was a painter, Ricardo a cellist, Luis a violinist, Maria a contralto who sang in opera. Pepito was, perhaps, the most artistic of all without, however, having cultivated any of the fine arts in particular. But it was he who created the house at Cadaqués, and who had a unique sense of the garden and of life in general. Mercedes, too, was a Pitchot one hundred per cent, and she was possessed of a mystical and fanatical sense of the house. She married that great Spanish poet, Eduardo Marquina, who brought to the picturesque realism of the Catalonian family the Castillian note of austerity and of delicacy which was necessary for the climate of civilization of the Pitchot family to achieve its exact point of maturity.

enable me to soften my rancour, while encouraging my hope of recovering with all my former fanaticism that beloved solitude which had just been shaken and compromised by the encounter with Dullita in a way so disconcerting to my spirit.

I started off in a cart with Señor and Señora Pitchot and Julia, their adopted daughter of sixteen, who had long black hair. Señor Pitchot drove the cart himself. He was one of the handsomest men I have ever seen, with an ebony beard and moustache and long curly hair. To enliven the horse at the moment when the latter seemed about to sink into laziness, he had merely to produce a curious sound with his tongue, and for this he had to keep his teeth pressed together while at the same time opening and distending his lips as much as possible with a grimacing contraction of his cheeks.

The sun glistened on his perfect white teeth as on petrified gardenias moistened with saliva. The horse, responsive to the noise Señor Pitchot made with his mouth, would start off again at a gentle gallop, giving a new note to the monotonous tinkling of the bells. We arrived just after sunset. The Muli de la Torre impressed me as a magic spot,[10] it was "made on purpose" for the continuation of my waking fantasies and dreams.[11] I felt as if I had miraculously recovered my health in a single instant, and nothing remained of my anxious and melancholy lassitude of the preceding days. On the contrary, a delirious joy unpredictably and repeatedly took hold of me. The boiled potato, well sprinkled with olive oil and a rapid pinch of salt, made my mouth water, and a sentiment of uninterrupted satisfaction gave me a constant thrill of well-being that each of the minute events inherent in the progressive adaptation to and discovery of the place only accentuated, with the marinated red pimento that this kind of small surprise always constitutes when the place to which you have arrived gives you the certainty that it is "for you" and that reciprocally, for your part, your loyalty toward it, from the first decisive contact of the threshold, can never henceforth know any limits.

The next day the sun rose, the countryside was deafening with greenery and the song of insects. The month of May beat in my temples the "caressing and fluorescent drums" of nuptial palpitations. My love for Dullita, while it grew, mingled with the frenzied pantheism of the landscape and became impregnated with that viscous and digestive sap which is the very same that lifts toward the summer sky the slow and convulsed stalk of the plant, forming a transparent drop upon its uttermost tip tense with the glorious pain of growth.

My love for Dullita (whose face I had not yet seen) spread over all things and became a sentiment so general that the idea of the slightest possibility of her

10. This spot was objectively one of the richest properties in the countryside, and contained a large number of pictures painted by Señor R. Pitchot.

11. It is in this spot of the Muli de la Torre that most of my reveries during the whole rest of my life have taken place, especially those of an erotic character, which I wrote down in 1932; one of these having as protagonists Gala and Dullita was published in *Le Surréalisme au Service de la Revolution*. But the very special character of the text prevents including it in the present work.

real presence would have horrified and disappointed me; I would adore her, and at the same time remain more alone, more ferociously alone than ever!

The mechanical side of the mill interested me very little, but its monotonous noise quickly became assimilated to my imagination, and I immediately considered it as the continual presence of the memory of something absent serving, with its majestic recall, to protect the solemn side of my solitude. The tower, on the other hand, as the reader of this book already initiated to my tastes will readily understand, became the sacred spot, the tabernacle, the "mansion of sacrifice" – and it was, in fact, up in the tower that I perpetrated the sacrifice!

This will be recounted minutely and as well as my own emotion will allow me, at the exact end of this chapter. I had to wait two days before I was able to climb "up there". Someone was always going to bring the key. Finally on the third day they opened the door which gave access to the upper terrace of the tower, and from this moment the clear and rotting water of my impatience could flow tumultuously, just as cascades of dizziness succeed stagnant emotions, long contained by the dam of censorship which regulates the melancholy course of the majestic canal of life. The height of the summit of the tower where I found myself exceeded everything I had imagined; I leaned over the edge and spat; I saw my spittle become smaller and disappear in a mass of dark vegetation from which emerged the remnants of an old chicken-coop. Beyond one saw the slow course of a little stream running into the mill-dam; still farther on began the limits of those earthly paradises of kitchen gardens which served as foreground and were like garlands to a whole theory of landscape which was crowned by the successive planes of the mountains, whose Leonardoesque geology rivaled in rigour of structure the hard analytical silhouettes of the admirably drawn clouds of the Catalonian sky.

If Dullita had been there I would have made her lean very far over the edge, at the same time holding her back so she would not fall. This would have given her an awful scare.

The following day I determined the methodical distribution of the events of my future days, for with my avidity for all things, resulting from my new and bubbling vitality, I felt that I needed a minimum of order so as not to destroy my enthusiasm in contradictory and simultaneous desires. For I now wanted to take frenzied advantage of everything all at once, to be everywhere at the same moment. I understood very quickly that with the disorder in which I went about wanting to enjoy and bite and touch everything I would in the end not be able to taste or savour anything at all and that the more I clutched at pleasure, attempting to profit by the gluttonous economy of a single gesture, the more this pleasure would slip and escape from my too avid hands.

The systematic principle which has been the glory of Salvador Dalí began thus to manifest itself at this time in the meditated program in which all my impulses were weighed, a jesuitical and meticulous program whereby I traced out for myself in advance the plan not only of the events but also of the kind of

emotion I was to derive from them during the whole length of my days to follow that promised to be so substantial. But my systematic principle of action consisted as much in the perverse premeditation of this program as in the rigour and discipline which, once the plan was adopted, I devoted to making its execution strictly and severely exacting.

Already at this age I learned an essential truth, namely, that an inquisition was necessary to give a "form" to the bacchic multiplicity and promiscuity of my desires. This inquisition I invented myself, for the sole use of the discipline of my own spirit. Here in its main outlines, is the program of my auto-inquisitorial days of the Muli de la Torre.

My rising had always to involve an exhibitionistic ritual, inspired by my nakedness. To carry this out I always had to be awake before Julia came into my room to open my window in the morning. This awakening, which I effected by the sheer force of my will, was a torture because of the exhausting events that filled my days. Every morning I was devoured by sleep. I succeeded nevertheless in waking up with great punctuality, that is to say fifteen minutes before Julia came in. I used this interval to savour the erotic emotion which I was going to derive from my act, and especially to invent the pose which varied daily, and which each morning had to correspond to the renewed desire of "showing myself naked", in the attitude that would appear most troubling to myself and at the same time be capable of producing the greatest effect upon Julia. I tried out my gestures until the last moment when I heard Julia's approaching footsteps. Then I definitely had to make up my mind, and this last moment of bewilderment was one of the most voluptuous in my incipient exhibitionism. The moment I heard the door open I remained frozen in a tense immobility, simulating peaceful slumber. But anyone who had looked at me attentively would readily have noticed my agitation; for my body was seized with such violent trembling that I had to clench my teeth firmly to prevent them from chattering. Julia would open the two shutters of the window, come over to my bed, and cover my nakedness with the sheets which I had let drop to the floor or piled at my feet as if by the restless movements I might have made in the course of my sleep. Having done this she would kiss me on the brow to wake me up. At that age I thought myself ideally beautiful, and the pleasure which I experienced at feeling myself looked at was so vivid that I could not resign myself to getting dressed before this pleasure had been repeated once more. To this end I had to invent a new pretext and I would frantically review in my mind the list of such projects carefully worked out the previous evening before going to sleep and which constituted the thousand and one manners of my morning exhibitionism. "Julia, these buttons are all gone! Julia, put some iodine here on my upper thigh! Julia!..."

After which came breakfast, which was served on the large table of the dining room, for me alone. Two large pieces of toast drenched with honey and a glass of very hot coffee and milk. The walls of the dining room were entirely covered with oil paintings and coloured etchings, most of them originals, by Ramon Pitchot, who at this time lived in Paris, and who was the brother of Pepito

Pitchot.

These breakfasts were my discovery of French impressionism, the school of painting which has in fact made the deepest impression on me in my life because it represented my first contact with an anti-academic and revolutionary aesthetic theory. I did not have eyes enough to see all that I wanted to see in those thick and formless daubs of paint, which seemed to splash the canvas as if by chance, in the most capricious and nonchalant fashion. Yet as one looked at them from a certain distance and squinting one's eyes, suddenly there occurred that incomprehensible miracle of vision by virtue of which this musically coloured medley became organized, transformed into pure reality. The air, the distances, the instantaneous luminous moment, the entire world of phenomena sprang from the chaos! R. Pitchot's oldest painting recalled the stylistic and iconographic formulae characteristic of Toulouse-Lautrec. I squeezed from these pictures all the literary residue of 1900, the eroticism of which burned deep in my throat like a drop of Armagnac swallowed the wrong way. I remember especially a dancer of the Bal Tabarin dressing. Her face was perversely naïve and she had red hairs under her arms.

But the paintings that filled me with the greatest wonder were the most recent ones, in which deliquescent impressionism ended in certain canvases by frankly adopting in an almost uniform manner the *pointilliste* formula. The systematic juxtaposition of orange and violet produced in me a kind of illusion and sentimental joy like that which I had always experienced in looking at objects through a prism, which edged them with the colours of the rainbow. There happened to be in the dining room a crystal carafe stopper, through which everything became "impressionistic". Often I would carry this stopper in my pocket to observe the scene through the crystal and see it "impressionistically".

Suddenly I would realize that I had exceeded the time allotted to breakfast, and my contemplation would always end with a "shock of violent remorse" which caused me to swallow my last mouthful of coffee-and-milk the wrong way, and it would spill down my neck and wet my chest inside my clothes. I found a singular pleasure in feeling this hot coffee dry on my skin, cooling slowly and leaving a slight sticky and agreeable moisture. I became so fond of this moisture that I finally purposely produced it. With a quick glance I would assure myself that Julia was not looking, and then just before she went out I would pour directly from the cup a sufficient quantity of coffee-and-milk, which would wet me down to my belly. One day I was caught red-handed doing this, and for years the story was told by Señor and Señora Pitchot as one of the thousand bizarre anecdotes relating to my alarming personality which they adored to collect. They would always begin by asking, "Do you know what Salvador has done now?" Everyone would prick up his ears, prepared to hear about one of those strange fantasies which were utterly incomprehensible, but always had the power to make everyone laugh till the tears rolled. The sole exception was my father, who by his worried smile could not but betray the anguish of menacing doubts about my future.

After the honey and the coffee-and-milk poured inside my shirt I would run over to a large white-washed room where ears of corn and rows of sacks filled with grains of corn were drying on the floor. This room was my studio, and it was Señor Pitchot himself who had decided this, because, he said, "the sun came in the whole morning". I had set up a big box of oil colours on a large table where each day a pile of drawings would accumulate. The walls too, before long, were soon filled with my paintings which I put up with thumb tacks as soon as they were finished.

One day when I had finished my roll of canvas I decided to do something with a large unmounted old door which was not in use. I placed it horizontally on two chairs, against the wall. It was made of very handsome old wood, and I decided to paint only the panel so that the door. frame would serve as the frame for my picture. On it I started to paint a picture which had obsessed me for several days – a still life of an immense pile of cherries. I spilled out a whole basket of them on my table to use as a model. The sun, streaming through the window, struck the cherries, exalting my inspiration with all the fire of their tantalizing uniformity. I set to work, and this is how I proceeded: I decided to paint the whole picture solely with three colours, which I would apply by squeezing them directly from the tube. For this I placed between the fingers of my left hand a tube of vermilion intended for the lighted side of the cherries, and another tube of carmine for their shade. In my right hand I held a tube of white just for the highlight on each cherry.

Thus armed I began the attack on my picture, the assault on the cherries. Each cherry – three touches of colour! Tock, tock, tock – bright, shade, highlight, bright, shade, highlight... Almost immediately I adjusted the rhythm of my work to that of the sound of the mill – tock, tock, tock... tock, tock, tock... tock, tock, tock... My picture became a fascinating game of skill, in which the aim was to succeed better at each "tock, tock, tock", that is to say with each new cherry. My progress became so sensational, and I felt myself at each "tock" becoming master and sorcerer in the almost identical imitation of this tempting cherry. Growing quickly accustomed to my increasing skill, I tried to complicate my game, inwardly repeating to myself the circus phrase, "Now something even more difficult."

And so, instead of piling my cherries one on top of the other as I had done so far, I began to make isolated cherries, as far separated from one another as possible, now in one corner, now in the most distant opposite corner. But as the severe rules of my new experiment required that I continue to follow the same rhythm of the sound of the mill, I was forced to rush from one spot to another with such agility and rapidity of gestures that one would have thought that, instead of painting a picture I was being carried away by the most disconcerting kind of dancing incantation, making agile leaps for the cherries above and falling back on my knees for the cherries below; "tock" here, "tock" there, "tock" here... tock, tock, tock, tock, tock, tock. And I kept lighting up the old door which served as my canvas with the new and fresh fires of my painted

cherries which were joyously born at each monotonous "tock" of the mill as if by an art of enchantment of which "in reality of truth" I was the sole master, lord and inventor.

This picture really astonished everyone who saw it, and Señor Pitchot bitterly regretted that it was painted on an object so cumbersome, so heavy and difficult to transport as a door, and which moreover was riddled with wormholes in certain places.

All the peasants came and stared in open-mouthed admiration at my monumental still life, in which the cherries stood out in such relief that it seemed as though one could pluck them. But it was pointed out to me that I had forgotten to paint the stems of the cherries. This was true – I had not painted a single one. Suddenly I had an idea. I took a handful of cherries and began to eat them. As soon as one of them was swallowed I would glue the stem directly to my painting in the appropriate place. This gluing on of cherry stems produced an unforeseen effect of startling "finish" which chance was once more to heighten with a delirious effect of realism. I have already said that the door on which I painted my picture was riddled with worms. The holes these had made in the wood now looked as though they belonged to the painted pictures, of the cherries. The cherries, the real ones, which I had used as models, were also filled with worm-infested holes! This suggested an idea which still today strikes me as unbelievably refined: armed with a limitless patience, I began the minute operation (with the aid of a hairpin which I used as tweezers) of picking the worms out of the door – that is to say, the worms of the painted cherries – and putting them into the holes of the true cherries and vice versa.

I had already effected four or five of these bizarre and mad transmutations, when I was surprised by the presence of Señor Pitchot, who must have been there behind me for some time, silently observing what I was doing. The effect of the cherry stems must have struck him as quite astonishing, but I understood immediately that it was my manipulations with the worms that kept him standing there so motionless and absorbed. This time he did not laugh, as he usually did about my things; after what appeared to be an intense reflection, I remember that he finally muttered between his teeth, and as if to himself, "That shows genius," and left.

I sat down on the floor on a pile of ears of corn, feeling very hot in the sun and thinking over Señor Pitchot's words, which remained deeply engraved in my heart. I was convinced that I could really achieve "extraordinary" things, much more extraordinary than "that". I was determined to achieve them, and I would, at no matter what cost! On day everyone would be astonished by my art! And you, too, Dullita Galuchka Rediviva, even more than all the rest!

The contact with the hot ears of corn had felt very agreeable, and I changed places to find another hotter pile. I dreamt of glory, and should have liked to put on my king's crown. But I would have had to go up to my room and fetch it, and it was so comfortable here on the corn! I took my crystal carafe stopper out of my pocket, and looked through the prismatic facets at my picture,

then at the cherries, then at the ears of corn scattered on the floor. The ears of corn especially produced an extremely languorous effect seen in this manner, set off by all the colours of the spectrum. An infinite laziness came over me, and with slow movements I took off my pants. I wanted my flesh to touch the burning corn directly. I slowly poured a sack of grain over myself. The grains trickled over my body, soon forming a pyramid that entirely covered my belly and my thighs.

I was under the impression that Señor Pitchot had just started off or his morning inspection tour and would as usual not be back before the lunch hour. I therefore had plenty of time to put back all the spilled corn in the sack. This thought encouraged me and I poured out still another sack of corn in order to feel the weight of the pyramid of grain progressively increase on top of me. But I had erred in my calculations as to the duration of Señor Pitchot's walk, for the latter suddenly reappeared on the threshold. This time I thought I would die of shame at seeing myself caught in my voluptuous attitude. I saw consternation contract his features and, backing away without saying a word, he disappeared, this time for good. I did not see him again before lunch time.

At least an hour must have gone by meanwhile, for the sun had long since left the spot where I remained without moving from the moment of Señor Pitchot's unexpected reappearance. I was stiff and ached all over from having kept the same half-lying position for so long. I began to pick up all the corn I had spilled, putting it back in the sack. This operation took a long time, for I was only using my two hands. Because of the unusual size of the sacks I did not seem to be making any headway; I was several times tempted to leave my work unfinished, but immediately a violent sense of guilt seized me in the center of my solar plexus, and then I would begin again with fresh courage to put the grains of corn back into the sack. As I neared the end my work became more painful because of the constant temptation to leave everything as it was. I would say to myself, "It's good enough as it is," but an insuperable force pressed me to keep right on. The last ten handfuls were a real torture, and the last grain seemed almost too heavy to lift from the ground. Once my task was finished to the end I felt my spirit suddenly calmed, but the weariness that had come over my body was even greater. When I was called to lunch I thought I would never be able to climb the stairs.

An ominous silence greeted me as I entered the dining room, and I immediately realized that I had just been the subject of a long conversation. Señor Pitchot said to me in a grave tone,

"I have decided to speak to your father, so that he will get you a drawing teacher." As though I felt outraged by this idea, I indignantly answered,

"No! I don't want any drawing teacher, because I'm an 'impressionist' painter!"

I did not know very well the meaning of the word "impressionist" but my answer struck me as having an unassailable logic. Señora Pitchot, dumbfounded, broke into a great peal of laughter.

"Well, will you look at that child, coolly announcing that he's an 'impressionist' painter!"

And with this she went off into an immense, fat and generous laugh. I became timid again, and continued to suck the marrow of the second joint of a chicken, noticing that the marrow had exactly the colour of Venetian red. Señor Pitchot launched into a conversation on the necessity of picking the linden blossoms toward the end of the week. This linden blossom-picking was to have consequences of considerable moment for me.

But before I enter into the absorbing, cruel and romantic story which is to follow, let me first continue, as I had promised, to describe the rigorous apportioning of the precious time of my days lived in that unforgettable Muli de la Torre. This is necessary, moreover, to situate precisely, against a chronological, ordered and clear setting, the vertiginous love scenes which I am about to unfold to you. Here, then, is the neurotic program of my intense spring days.

I excuse myself for repeating once more in summary the manner in which these began, so that the reader may more readily connect this part with the rest of my program and be in a position to obtain the necessary view of the whole.

Ten o'clock in the morning – awakening, "varied exhibitionism", aesthetic breakfast before Ramon Pitchot's impressionistic paintings, hot coffee-and-milk poured down my chest before leaving for the studio. Eleven to half past twelve – pictorial inventions, reinvention of impressionism, reaffirmation and rebirth of my aesthetic megalomania.

At lunch I collected all my budding and redoubtable "social possibilities", in order to understand everything that was going on at the mill through the conversations sprinkled with euphemisms of Señor and Señora Pitchot and Julia. This information was precious in that it revealed to me plans of future events by which I could regulate the delights of my solitude while establishing an opportunistic compromise between these and the marvels of seduction offered me by the whole series of activities connected with the agricultural developments of the place. These events always brought with them not only the flowering of new myths but also the apparitions (in their natural setting) of their protagonists who were heretofore unknown to me – the linden blossom-picking (in this connection only women were mentioned), the wheat threshing, performed by rough men who came from far away, the honey gathering, etc.

The afternoon was dedicated almost exclusively to my animals which I kept in a large chicken-coop, the wire mesh of which was so fine that I could even confine lizards there. The animals in my collection included two hedgehogs, one very large and one very small, several varieties of spiders, two hoopoes, a turtle, a small mouse caught in the wheat bin of the mill where it had fallen, unable to get out. This mouse was shut up inside a tin biscuit box on which there happened to be a picture of a whole row of little mice, each one eating a biscuit. For the spiders I had made a complicated structure out of cardboard shoe boxes so as to give each kind of spider a separate compartment, which facilitated the

course of my long meditative experiments. I managed to collect some twenty varieties of this insect, and my observations on them were sensational.

The monster of my zoological garden was a lizard with two tails, on very long and normal and the other shorter. This phenomenon was connected in my mind with the myth of bifurcation, which appeared to me even more enigmatic when it manifested itself in a soft and living being – for the bifurcated form had obsessed me long before this. Each time chance placed me in the presence of a fine sample of bifurcation, generally offered by the trunk or the branches of a tree, my spirit remained in suspense, as if paralyzed by a succession of ideas difficult to link together, that never succeeded in crystallizing in any kind of even poetically provisional form. What was the meaning of that problem of the bifurcated line, and especially of the bifurcated object? There was something extremely practical in this problem, which I could not take hold of yet, something which I felt would be useful for life and at the same time for death, something to push with and to lean on: a weapon and a protection, an embrace and a caress, containing and at the same time contained by the thing contained! Who knows, who knows! Wrapped in thought, I would caress it with my finger in the middle where the two tails of the lizard bifurcated, went off in two different directions, leaving between them that void which alone the madness peculiar to my imagination would perhaps some day be able to fill. I looked at my hand with its fingers spread out, and their four bifurcations disappeared in the imaginative and infinite prolongation of my fingers which, reaching toward death, would never be able to meet again. But who knows? And the resurrection of the flesh?

Suddenly I became aware that the afternoon was vanishing in the ritualistic apotheosis of a bloody glow. These philosophic meditations had as their principal virtue that of devouring time, while leaving at the bottom of its empty bottle the reddish, thick and wine-smelling lees of the setting sun.

Sunset, the time for running out to the kitchen-garden! The time propitious for pressing out the guilty juices of terrestrial gardens invaded by the evening breezes of original sins. I would bite into everything – sugar beets, peaches, onions tender as a new moon. I was so fearful of becoming satiated, of letting my temptations lose their edge too quickly by the debauched prodigality of my gluttony, that I would only bite the desired fruit with a single impatient crunch of my teeth, and after having extracted from it the strict taste of desire, I would throwaway the object of my seduction, the more quickly to grasp the rest of these fruits of the moment, whose taste was for my palate as ephemeral as the fugitive flicker of the fireflies that already began to shine in the deepest shadows of the growing vegetational darkness. At times I would take a fruit and be content to touch it with my lips or press it softly against my burning cheek. I liked to feel on my own skin the serene calm of the temperature of that other taut, cool-steeped skin, especially that of a plum, black and wet like a dog's nose having the texture of a plum rather than that of a truffle. I had allowed myself the possible prolonging of this whole gustatory and vegetal promiscuity of the kitchen garden until mid-twilight, but I had anticipated exceptions to this. That

is to say, I could linger on there a little if the gathering of glow-worms with which I concluded the delights of the kitchen garden promised to be fruitful. I wanted in fact to make a necklace[12] of glow-worms strung on a silk thread, which in the phosphorescent convulsions of their death agony would produce a singular effect on Julia's neck. But she would be horrified by this. Perhaps Dullita, then? I could imagine her standing thus adorned, consumed with pride.

When twilight deepened, the Muli de la Torre was already calling me with the whole irresistible attraction of its dizzy height, and I raised my eyes toward the top of this tower with an ardent gaze of promise and fidelity. I said to it in a low voice, "I'm coming!" It was still flushed with a faint rose tinge, even though the sun had long since set. And always above those proud walls three great black birds hovered majestically. My daily twilight visit to the terrace at the top of the tower was by all means the most eagerly awaited and the most solemn moment of my days. Nevertheless, as the hour of my ascent approached, the impatience which I felt growing within me blended with a kind of indeterminate and infinitely voluptuous fear. On reaching the top of the tower my glance would delight in losing its way as it wandered along the mountain tops, whose successive planes appeared still at this late hour to be etched with the gold and scarlet line of the last glimmer of daylight which by virtue of the limpidity of the air rendered that prenocturnal landscape precise and stereoscopic.

From the summit of this tower I was able to continue to develop the kinds of grandiose reveries which I had begun previously on the roof of my parents' house in Figueras. But now my exhausting imaginings assumed a much clearer "social and moral" content, in spite of the persistence of a continually paradoxical ambiguity. My moral ideas in fact constantly plunged from one extreme to the other: Now I would imagine myself set up as a bloody tyrant, reducing all contemporary peoples to slavery for the sole satisfaction of my luxurious and fantastic egocentric caprices; again, on the other hand, I would abase myself to the humble and degrading condition of the pariah, animated by an inextinguishable thirst for cosmic redemption and justice, who would uselessly sacrifice himself in the most romantic of deaths. From the cruel demi-god to the humble worker, passing through the stages of the artist to the total genius, I have always arrived at the savior... Salvador, Salvador, Salvador! I could repeat my own name tirelessly... I knew that a sacrifice was inevitable, and with a repugnant cowardice I would look around me in the dark. For of only one thing was I absolutely sure: I was not going to be the one sacrificed!

In the large dining room bathed in a very feeble light, dinner was a kind of gentle convalescence after the great nocturnal eloquence at the top of the tower. Sleep was there, right close to me, seated in the empty chair at my side; sometimes it would take hold of my foot under the table, and then I would let it

12. The making of this kind of necklace is not a Dalínian invention as it seems, but on the contrary was a frequent game among the peasant children in the region where the Muli de la Torre was located.

rise along the whole length of my body, just as coffee rises in a lump of sugar. One evening, almost asleep at the end of the meal, I heard Señor Pitchot bring up again the subject of the linden blossom-picking. It was finally set for the day after the following. This day arrived, and here now is the story that you have been waiting for so impatiently.

The Story Of The Linden Blossom-Picking And The Crutch
A story filled with burning sun and tempest, a story seething with love and fear, a story full of linden blossoms and a crutch, in which the spectre of death does not leave me, so to speak, for a single moment.

Shortly after dawn, having got up earlier than usual, I went up with Julia and two men to the tower attic to fetch the ladders needed for the linden blossom-picking. This attic was immense and dark, cluttered with miscellaneous objects. It had been locked before this, so that I entered it now for the first time. I immediately discovered two objects which stood out with a surprising personality from the indifferent and anonymous pile of the remaining things. One was a heavy crown[13] of golden laurel that stood as high as my head, and from which hung two immense faded silk ribbons on which were embroidered inscriptions in a language and characters unknown to me. The second object, which struck me as being terribly personal and overshadowing everything else, was a crutch! It was the first time in my life that I saw a crutch, or at least I thought it was. Its aspect appeared to me at once as something extremely untoward and prodigiously striking.

I immediately took possession of the crutch, and I felt that I should never again in my life be able to separate myself from it, such was the fetishistic fanaticism which seized me at the very first without my being able to explain it. The superb crutch! Already it appeared to me as the object possessing the height of authority and solemnity. It immediately replaced the old mattress beater with leather fringes which I had adopted a long time ago as a scepter and which I had lost one day on dropping it behind a wall out of my reach. The upper bifurcated part of the crutch intended for the armpit was covered by a kind of felt cloth, extremely fine, worn, brown-stained, in whose suave curve I would by turns pleasurably place my caressing cheek and drop my pensive brow. Then I victoriously descended into the garden, hobbling solemnly with my crutch in one hand. This object communicated to me an assurance, an arrogance even, which I had never been capable of until then.

They had just set up the double ladders under the tall linden trees growing in the centre of the garden. At their bases large white sheets had been stretched out to receive the flowers that were to be gathered and on which a few blossom-laden branches were already beginning to drop. Three ladders had been

13. I learned much later that far from having the mortuary character which I attributed to it, this crown was a gift that had been offered as a tribute to Maria Gay at the Moscow Opera after one of her successes in the role of Bizet's *Carmen*.

set up, and on each one stood an unknown woman, two of whom were very beautiful and greatly resembled each other. One of these had large breasts, extremely beautiful and turgescent, of which the eye could follow the slightest details beneath her white knitted wool sweater that was perfectly molded to their curves. The third girl was ugly. Her teeth were the colour of mayonnaise and so large that they overflowed from her tumefied gums, making her look as though she were constantly laughing. There was also a fourth person with one foot on the ground, her back arched on one of her hips. This was a little girl of twelve, who stood looking up and motioning to her mother, who was precisely the one with the beautiful breasts. This girl had also come to help with the gathering. I fell in love with her instantly, and I think that the view of her from behind, reminding me of Dullita, was very favourable to this first impulse of my heart. Besides, never having seen Dullita face to face, it was extremely easy for me to blend these two beings, just as I had already once done with Galuchka, of my false memories, and Dullita Rediviva! With my crutch I imperceptibly touched the girl's back. She quickly turned round, and I then said to her, with a sureness and a force of conviction that came close to rage, "You shall be Dullita!"

The condensed images of Galuchka and of Dullita had just become incorporated and fused by the force of my desire for this new child whose sun-blackened but angelically beautiful face I had just discovered. This face instantly took the place of Dullita's, which I had never seen, so that the three images of my delirium mingled in the indestructible amalgam of a single and unique love-being. My passion charged the enhance,, reality of the reincarnated image of my love with a new potential, more irresistible than ever. And my libidinous anxiety, stored up in the course of several years of solitary and anxious waiting, now became crystallized into a kind of precious stone, transparent, homogeneous and hard, cut into a tetrahedron, and in whose facets I saw the virginal splendor of my three unassuaged loves sparkling beneath the sun of the most radiant day of the year.

Besides, was I quite sure that she was not Dullita herself in reality? I tried to find in this country girl's calcinated face the vestiges of Galuchka's former pallor, whose face seemed to begin to resemble hers from minute to minute. I struck a violent blow with my crutch on the ground and repeated to her in a hoarse voice choking with emotion at the very start, "You shall be Dullita." She drew back, startled by the uncouthness of my emotional state, and did not answer. The exteriorization of my first urge toward her must indeed have betrayed such tyrannical intentions that I understood it would be difficult for me now to regain the child's confidence. I drew one step nearer to her. But she, dominated by an almost animal-like fear, climbed as if for protection up two rungs of the ladder on which her mother was perched, and did this with such lightness and agility that I did not have time gently to touch her head with the tip of my crutch as I had intended to do to calm her fear, and to prove to her the gentleness of my sentiments.

But my beautiful Dullita was quite right in being afraid of me. She would

realize it only too well later, for all this had but just begun! I myself at that age already felt the clutch of a vague presentiment of the danger that was involved in the more and more pronounced features of my impulsive character. How many times, walking peaceably in the country, lulled by the nostalgic weaving back and forth of my reveries, had I suddenly felt the irresistible desire to jump from the top of a wall or a rock whose height was too great for me; but knowing that nothing could prevent this impulse I would shut my eyes and throw myself into the void.[14] I would often remain half stunned, but with a calmed heart I said to myself, "The danger is past for today," and this would give me a new and frenzied taste for the most trivial surrounding realities.

Understanding that for the moment I could not regain my new Dullita's confidence I decided to leave, but not without having cast her a glance of infinite tenderness by which I wanted to tell her, "Don't worry, I'll come back again." Then I left and I wandered at random in the garden. It was just the time when I should have devoted myself to painting, shut up in my studio with the ears of corn. But the day had begun in such an unaccustomed way, and with such exceptional encounters, like that of my crutch, and of Dullita, that I said to myself, dizzy with the whirl of the magic of the linden blossom-gathering, "I might perhaps make an exception to the pre-established plan of my habits," for already at this period these reigned as supreme mistresses of my destiny, and every infraction of these rules had to be paid for immediately by a dose of anguish and of guilty feeling so painful that when I felt them already begin to gnaw at the root of my soul I made an about-face and went back and shut myself up in my studio. There my unhappiness was not appeased, for I wanted to be elsewhere that morning, and after the short but intense scene of my encounter with Dullita I should have liked to walk about freely in the most out-of-the-way corners of the garden in order to be able to think of her without any other distraction and at the same time to begin to build the imaginary and idyllic foundations of my impending encounter.

But no! My self-inquisition imprisoned me there! And as time passed without any brilliant ideas springing forth in my head, which was supposed to happen each morning at that hour for the satisfaction of my ego, feelings of guilt clutched me more and more tightly in the spiny irons of a horrible moral torture.

I was assailed without respite by seductive representations of my Dullita. But at the same time an invisible rancour against her rumbled in the blue cloudless sky, with dull reverberations of a storm. Again, and for the second time, Dullita with a single moment of her presence had come to trouble, annihilate and ruin the architecture of the narcissistic temple of my divine solitude which I had been engaged in rebuilding with so much rigour and cerebral intensity since

14. A farmer who witnessed one of these voluntary falls reported the event to Señor Pitchot. But no one would believe that I was able to jump thus without being killed. I became, indeed, extremely accomplished in high jumping. Later on in the gymnastics class of Figueras, I was to win the championship in high and broad jumping almost without effort. Still today I am a rather remarkable jumper.

my arrival at the Muli de la Torre. I felt that only a bold stratagem, based on a lie capable of fooling myself, could liberate me for a few moments from the four walls of my studio where I felt myself so pitilessly shut in. I therefore convinced myself that it was urgent for me to begin today, and no later, my long projected drawings from life of animals in movement. There was no better way to start than to go and fetch my little mouse, which would make an ideal model. With it I could undertake to do a large picture in the style of the one with the cherries. But instead of representing the same static element I would repeat it to infinity in different movements. It occurred to me that since mice also had tails, I might perhaps find an original idea for effecting a *collage* on this subject.

Although the project for my new work did not greatly interest me. and I felt that I was going to repeat the picture of the cherries, I tried nevertheless to convince myself by a thousand arguments that I must at all costs go to the chicken-coop in the garden and fetch my box containing the grey mouse which was to be my model. I thought I might perhaps take advantage of the state of anxiety and nervousness in which I had been submerged since the vision of Dullita and attune it to the extremely febrile movements and attitudes of the mouse, thus making the most of my anguish and canalizing it toward the success of my projected work of art and thereby sublimating the "anecdote" of my state of anxiety to the "category" of an aesthetic fulfillment.

I accordingly ran to the chicken-coop to fetch my little model of the grey mouse. But the moment I arrived I found the latter in a curious state. It was as if swollen; its body usually so slim and agile was now completely round, as round as a cherry miraculously turned grey and hairy. Its unwonted immobility frightened me. It was alive, since I could see it breathe, and I would even have said that its breathing had an accelerated and unusual rhythm. I lifted it cautiously by its tail and the resemblance to my cherry was complete, with its paws all folded up and making no movement. I put it back with the same precaution in the bottom of the box, when all at once it made a single vertical bound, hitting my face that was maternally bowed over it. Then it fell back into the same motionless attitude. This unforeseen leap provoked in me such a frightful start that it took my heart a long time to recover its rhythm

An intolerable moral uneasiness made me cover my mouse's box with the top, leaving a little space for it to breathe. I had not yet had time to recover from these painful impressions when I made a new discovery which is one of the most fearful of its kind that people my memories.

The large hedgehog, which I had been unable to find for more than a week, and which I thought had miraculously escaped, suddenly appeared to me in a corner of the chicken-coop behind a pile of bricks and nettles: it was dead. Full of repulsion I drew near it. The thick skin of its bristle-covered back was stirring with the ceaseless to-and-fro movement of a frenzied mass of wriggling worms. Near the head this crawling was so intense that one would have said that a veritable inner volcano of putrefaction was at any moment about to burst through this skin torn by the horror of death in an imminent eruption of final

ignominy. A slight trembling accompanied by an extreme feebleness seized my legs, and delicate cold shudders rising vertically along my back spread fanwise in the back of my neck, from which they fell back, branching outward through my whole body like a veritable burst of fireworks at a feast of the apotheosis of my terror. Involuntarily I drew still closer to this foul ball which continued to attract me with a revolting fascination. I had to get a really good look at it.

But a staggering whiff of stench made me draw back. I ran from the chicken-coop as fast as my legs would carry me; coming close to the linden blossoms I took a deep breath of the fragrance with the idea of purifying my lungs; but presently I retraced my steps to continue the attentive observation of my putrefied hedgehog. During the time that I remained near it I completely stopped breathing, and when I could no longer hold my breath I dashed off again toward the linden blossom-pickers, who by this time had accumulated great piles humming with bees. I took advantage of these breathing-spells to pour out the dark water of my glance into the sunny well of Dullita's celestial eyes. Once more I rushed back to my horror-bristling ball, and again came back to breathe the perfumed air that surrounded my Dullita.

These goings and comings between Dullita and the dead hedgehog became so exalted and hysterical that I felt myself gradually losing control of my movements, and indeed at each new approach to the hedgehog I found myself almost on the point of committing an irreparable act, seized with a more and more irresistible longing to throw myself upon it and touch it, just as each time I returned toward the lindens, at the very last limit of the asphyxiating retention of my breath, it seemed as though it would be impossible for me to repress the decisive gesture of embracing Dullita with all my might, to tear the salivary savour of her soul and of her rustic and timid angel's face from her mouth half-opened like a wound.

In one of my dizzy returns toward the hedgehog I came so fast and close to it that just at the last second, no longer able to control inertia of my blind chase, I decided to jump on its body. I stumbled the last moment with a clumsiness so skillful from the point of view of my subconscious intentions that I came within a millimetre of falling on the dark and repugnant mass.

After this awkward act, which sharpened the fevered stimulant of my desire while it redoubled my disgust, I finally had an idea which was provisionally to procure me a deep satisfaction: I would touch the stinking ball of my hedgehog with my crutch. I could in this manner move the foul ball at will, and without having to come too close to it. I had already tried, before this, to toss several stones in order to observe the mechanical effects of their impact on the decomposed softness of the nauseating body. But these experiments, in spite of the emotion which I derived from them, especially at the moment of throwing the stone, did not appear to me to assume the expected frightful character which I could consider altogether satisfying. Accordingly I advanced, holding my crutch by its lower end, and pressed its other "bifurcated" end against the roundness of the hedgehog's black heart ripe with death. My crutch's bifurcation adapted itself

so well to the stiffened and pasty ball that one would have thought they were made for each other, so much so that it was impossible to tell whether it was the crutch that held the hedgehog or the hedgehog that held the crutch.

I stirred this nightmare-bristling pile with such terrifying intensity and such morbid voluptuousness that for a moment I thought I was going to faint. Especially when, under the exploratory proddings of my crutch impelled by my curiosity, the hedgehog was finally turned upside down. Between its four stiffened paws I saw a mass of gesticulating worms, big as my fist, that oozed in an abominable fashion after having burst and pierced through the very delicate and violet-coloured ventral membrane which until then had maintained them in a compact, devouring and impatient mixture. I fled, leaving my crutch on the spot. This time it was more than I could stand.

Sitting on the ground I watched the linden blossoms fall. I realized that because of the momentary waywardness of my desire I had just doomed my crutch, and I could no longer be attended by the security which it afforded me. For, contaminated as it now was by the gluey contact of the hedgehog's mass of worms, from being a favourable fetish it had become transformed into a frightful object synonymous with death.

But I could not resign myself to the idea of getting along wholly and forever without my crutch, toward which my fetishistic sentiments had only grown and become consolidated in the course of the morning. I finally found a fairly satisfying solution, which would allow me to resume possession of my crutch after performing some preliminary ceremonies. I would go back and, without looking at the hedgehog this time, rescue my crutch. I would go and dip its soiled end in the clear water of the mill-stream, at the point where the current was strongest and formed little whirls of white foam. After a prolonged immersion I would let my crutch dry, and finally after laying it horizontally on the great pile of linden blossoms warmed with sunshine, I would take my crutch up to the top of the tower at twilight, so that night, and dawn with the heavy dew of my repentance, would effect its complete purification.

I proceeded to carry out this plan, and already my crutch was resting buried under the blossoms while in my calm spirit I could feel the black ball of death still stirring. After an unmemorable lunch came the afternoon. Now my listless glance followed the various incidents of the blossom gathering. Dullita, on the other hand, was looking continually at me, just like Galuchka. Her fixed eyes did not leave me a single moment, and I was so sure that she would now obey me in all that my will was prepared to command her that I could savour with delight that voluptuousness which is the whole luxury of love, and which consists in being able nonchalantly to direct your attention and your glance elsewhere while feeling the passionate proximity of the unique being, thanks to whom each minute becomes a bit of paradise, but whom your perversity commands you to ignore, while keeping her in leash like a dog; and before whom, nevertheless, you would be ready to grovel with the cowardice and the fawning of a real dog the moment you found yourself in danger of losing that loved being

whom you pretended up to that point to treat with the inattentive dandyism characteristic of morbid sentimentalism.

Knowing my Dullita to be solidly attached to the end of the shiny yellow leather leash of my seduction, I looked elsewhere, I looked especially up at the under part of the naked arm of the woman with the turgescent breasts. Her armpit presented a hollow of great softness; the untanned skin of this part of her body was of an extreme paleness, pearly and glorious, serving as a dream frame to the burst of sudden blackness of the hairs. My glance was engaged in straying alternately from this strange nest of ebony hair surrounded by pearly flesh to her two plethoric breasts, whose divine volume I felt weighing upon each of my eyelids half closed with the mingled voluptuousness of my visions and my digestion. And presently, through my benumbed laziness, I felt the budding of a new invincible fantasy, and once again the little quicksilver horses of my anguish galloped within my heart. This is what Salvador wanted now! I wanted to disinter my crutch from its tomb beneath the linden blossoms, and with this same "bifurcation" with which I had touched and stirred the hedgehog I now wanted delicately to touch the breasts of the blossom-picker, while adapting the perfumed bifurcation of the crutch with infinite precaution, and with an ever so slight pressure, the carnal globes of those sun-warmed breasts.

All my life has been made up of caprices of this kind, and I am constantly ready to abandon the most luxurious voyage to the Indies for a little pantomime as childish and innocent as the one I have just described. Yet are these things as simple as they appear? My experience had convinced me of exactly the contrary, and my head was crowded with competing strategic plans by the force, skill, hypocrisy and ruse of which I might perhaps win this preliminary battle against reality which, with victory, would bring me the heroic realization of my fantasy: to touch those breasts with the bifurcation of my crutch. After that, my crutch could again become my kingly sceptre!

The sun was setting, the pyramid of flowers was growing, the moon "mooned", Dullita lay on the flowers. The fantasy of touching the breasts with my crutch grew sharper, became a desire so strong that would have preferred to die rather than deny it to myself. In any case the best thing would be to go quickly and put on my kingly disguise; when I was thus clad, my plans always became coloured with a new and inspiring audacity. I would come out again in this garb and lie down beside Dullita on the pile of linden blossoms, and I could then continue to look at the blossom-picker's breasts. Dullita seeing me thus bedecked, with all the trappings of a king, would feel herself dying of love.

I went quickly up to my room, took the ermine cape out of the closet, placed my crown on my head, with the long white "Anti-Faustian" wig falling delicately over my shoulders. Never in my life had I thought myself so handsome as that afternoon. A waxen pallor pierced through my browned skin, and the circles around my eyes had that same enticingly bruised brown colour that I had just observed wearilessly for over an hour in the folds of the linden blossom-picker's armpit just where three little creases formed each time she

lowered her arm. I left my room intending to go down again into the garden, animated with the serene calm that comes with the feeling of being irresistibly handsome.

Just before reaching the main stairway I had to cross a kind of closed vestibule situated on the second floor and overlooking the garden through a small window brightly lighted by the sun. In this window there were three melons in the process of ripening, hanging from the ceiling by strings. I stopped to observe them, and with the rapidity and the blinding luminousness of lightning I had an idea which was going to solve and render possible my new fantasy involving the blossom-picker's breasts. The vestibule was steeped in semi-darkness, in spite of the strong light from the small window. If the blossom-picker were to set up her ladder close to this window and climb up to a given height, I should be able to see her breasts set in the frame of the window as if altogether isolated from the rest of her body, and I would then be in a position to observe them with all the voracity of my glance without feeling any shame lest my desire be discovered or observed by anyone. While I looked at the breasts I would exercise a caressing pressure by means of my crutch's bifurcation upon one of the hanging melons, while attempting to have a perfect consciousness of its weight by slightly lifting it. This operation suddenly appeared to me as a hundred times more distracting and desirable than the first version of my fantasy, which simply consisted in directly touching the breasts. Indeed the weight of this hanging melon seemed to me now to have absorbed all the ripening gravity of my desire, and the supposition that this melon must be marvelously sweet and fragrant blended in my imagination in so paradisial a fashion with the turgescence of the blossom-picker's real breasts that it already seemed to me that by virtue of the subterfuge of my substitution I could now not only press them tenderly with my crutch's bifurcation, but also and especially I could "eat" them and press from them that sugared and fragrant liquid which they too, like the melons, must have within them.

To bring the blossom-picker close to the window, as much as was necessary for the realization of my stratagem, I went up to the third floor and then out on the balcony. I accomplished the difficult feat of letting my "diabolo" game fall in such a way that its string got caught in a given spot on the rose vine climbing up the front of the house. Whereupon, using a reed-stalk, I tried to tangle this string as much as possible among the thorny branches in order to make its removal as long and painful as possible. This operation was most successful, and I took all the necessary time. Anyone observing me from the garden might have thought what I was doing was precisely to try to get it free.

Having prepared the bait of my trap, I ran out into the garden. I went over to the ladder on which the blossom-picker with the beautiful breasts was perched, and in a whimpering voice begged her to go and untangle my "diabolo". And I pointed to it with the tip of my crutch which I had previously unearthed from the pile of flowers where it had been purifying since noon. The blossom-picker stopped her work and looked in the direction where my diabolo

was caught. In doing so she assumed an attitude expressing the pleasurable relief that goes with a long awaited rest; she distributed the whole weight of her body between the support of one of her robust elbows and the opposite leg in such a way that her hips were violently arched, in a divinely beautiful pose which was further enhanced by the motions of her free arm which she lifted to tidy her dishevelled hair. Just then a drop of sweat fell from her moist arm pit and struck me right in the middle of my forehead, like one of those large warm raindrops that usher in the great summer storms, a drop of sweat which was "in reality of truth" like the oracle and the harbinger of the storm of nature combined with that of my soul, which destiny held in store for me the next day at about the same hour.

The peasant woman did not have to be asked a second time, for in the domain of the Muli de la Torre it was well known (by the express orders of Señor Pitchot himself) that my slightest whims were to a obeyed on the spot, and that the carrying out of my desires was a law for everyone. After having savoured a short rest, during which she abandoned her whole body to the light, like a piece of sculpture, she came down from her ladder and with Dullita's help dragged it to the foot of the wall beneath the window, which was the place I had chosen. This operation was a rather long one, for the ladder was some distance away and it had to be pushed to the designated spot in short spurts. In addition it was necessary, once it was near the wall, to brace it well before venturing to climb up on it.

I took advantage of the delay to run into my room and strip to the skin. This was the occasion in my life on which I remember thinking myself most handsome as I looked at my reflection in the mirror. I ardently wished at that moment that the whole world could have admire my supreme beauty, or at least that the lovely blossom-picker and my new Dullita could have done so. But I could not think of appearing thus all of a sudden, and I covered my nakedness with the ermine cape. In spite of the fact that it was deeply tanned by the sun, my face now reveal a spectral pallor which was due to the greenish light reflected by the linden trees in the garden. I went down into the dark vestibule where the melons hung, and almost as soon as I reached it the body of the blossom-picker appeared behind the frame of the little window. I had taken good measurements! The lower part of the window intercepted her body just where the thighs began, while her upper part was entirely cut off at the head. By the movements of her shoulders with her arms uplifted I could judge the fruitless and absorbed efforts that she was making to undo the tangled string of my diabolo which I had deliberately entwined in the thorny interlaced branches of wild rose that climbed up the front of the Muli de la Torre.

The woman's body, as I have just described, filled the entire space of the window and threw the feebly lighted vestibule in which I stood into greater shadow. The heat under my thick ermine cape was stifling. Wringing wet, I let the cape slip to the floor, and a soft warmth barely touched with coolness came over my body and caressed its nakedness. I thought: she cannot see me thus, and

the moment she gets ready to come down the ladder I shall know it and be able to dress hurriedly or run and hide against the wall.

For the moment I could give myself over fearlessly to the fantasy of my game. Delicately I placed the bifurcation of my crutch under the lower part of the hanging melon, pressing it with all the sentimental tenderness of which I was capable. An acute lyricism drowned my eyes with tears. The softness of the melon exceeded all my hopes. It was so ripe that in spite of the gentleness of my pressure my crutch sank into it with a delightful lapping sound. Then I turned my glance upward to glue it to the bosom of the woman who was struggling to untangle the labyrinthian snares of my diabolo. I could not see her breasts very clearly, but their confused mass, seen against the light, only exasperated my unsatisfied libido. I accentuated my proddings while communicating a special rhythm to my crutch. Soon the juice of the melon began to drip on me, sprinkling me with its sticky fluid, at first only in occasional drops, but presently more and more copiously. At this moment I placed my face beneath the melon, opening my mouth and reaching out my tongue, which was thirsty, dry with heat and desire; in this manner I caught the spatterings of the juice, which was prodigiously sweet, but with prickling accents of ammonia interspersed. These few drops, quickly annihilated in my mouth, made me mad with thirst, while my glance ran dizzily from the melon to the window, from the window to the melon, and back again, and so on, in a veritable growing frenzy which soon culminated in a kind of delirium in which the whole consciousness of my acts and movements seemed to become obliterated. To my crutch I imparted gestures of increasing brutality, calculated to dig it in the most effective and deeply anchored way into the melon's flesh, in order to make the maximum of its life and its juice burst forth from the depths of its bowels. Toward the end the alternate rhythm of my glance became accentuated: Melon, window! Melon, window! Window, melon!...

My gestures had by now become so deeply and hysterically tumultuous that suddenly the melon broke loose and fell on my head, almost at the same time that the beautiful blossom-picker, having finally succeeded in untangling my diabolo, began to come down the ladder. I barely had time to throw myself to the floor and get out of her sight when her face appeared. I fell on my ermine cape which lay at my feet, drenched with the melon's yellow liquid. Panting, weary, trying to hold my breath, I waited for the peasant woman, upon discovering me naked, to climb up again a few rungs to look at me; without needing to turn my head I would be able to tell whether she came up again by the shadow which her body would produce, just as it had a while ago when it intercepted the window-frame.

But this maddening and tensely awaited moment did not come. Instead of the cherished shadow of eclipse, the oblique and orange light of the setting sun slowly penetrated and rose the whole length of the thickly whitewashed wall, on which the shadow of the two intact hanging melons now stood out. But I had no inclination to play with them. My enchantment had passed. This could not be repeated. An extreme weariness took hold of all my muscles, making my

movements painful. The two black shadows of the melons appeared to me as a sinister symbol, and they no longer evoked the beautiful blossom-gatherer's two breasts, sunny with afternoon. Instead they too now seemed to stir like two dead things rolled into balls, like two putrefied hedgehogs. I shuddered. I went up into my room and slowly put on my clothes again, stopping several times to take a rest, during which I would stretch out on the bed with my eyes shut. Darkness overtook me thus, in my room.

I had to hurry if I still wanted to take advantage of the summit of the tower. I went up, holding my crutch. The sky was all starry and I felt it weigh so heavily on my weariness that I did not have the courage to undertake any of the grandiose reveries which the place usually had the virtue of provoking in my mind. Just in the centre of the terrace of this tower there was a small cement cube provided with a hole which was presumably intended to hold a banner or a weather vane. The base of my crutch was a little too slender to fit it perfectly. Nevertheless I placed it there, upright, slightly leaning toward the right. This attitude of my crutch was much more satisfying to me than a perfect vertical, and I went away, leaving it thus placed. If I should wake up in the night I would immediately think of my crutch, motionless at the top of the tower, and this would fill me with a protective illusion. But would I wake up? A sleep heavy as lead already hummed in my head, after a day so filled with emotions that I no longer wanted to think of anything. I wanted before and above all to sleep!

I went down the stairs like a somnambulist, bumping myself several times against the walls at the turns, and each time I uttered in a low voice, through which pierced the whole force of my will,

"You shall be Dullita! You shall be Dullita! Tomorrow!"

I knew that the linden blossom-picking was to last another day. The following morning Dullita was again there. The sun rose, the blossom-picker picked, the breasts hung, and the melons hung, but this morning it was as though all the attraction I had felt for the breasts the day before had totally disappeared, thanks to the realization of my fantasy with the melon. Not only could I not recapture even the traces of a desire which after all had been extremely vivid, but a real disgust seized me as I reconstructed the scene in my mind. The ermine cape soiled with melon juice, the prickly and excessively sweet taste of the latter, and even the breasts no longer seemed so beautiful as I looked at them again, and in any case I was far indeed from according them that element of sentimental poetry which on the previous afternoon had made the mere sight of them bring tears to my eyes.

Today I felt myself fascinated exclusively by the slimness of Dullita's waist, which seemed to diminish in diameter as the sun advanced toward the zenith, the increasingly vertical shadows accentuating the vulnerable fragility of the hour-glass whose form her body was assuming for me – the slimmest and proudest body of them all, the body of my new Dullita, of my Galuchka Rediviva.

I said nothing to her in the morning on seeing her again, but to myself I

said, "Today there shall be no one but she! I have all the time I want!"

And I began to play with my diabolo. I was extremely skilful at this game. After having made it whirl and glide in all directions, with a most capricious dexterity, I tossed it up into the air to great heights, always catching it on the string drawn taut between my two sticks. I felt myself admired by Dullita, and the ease with which I played allowed me to adopt attitudes which I was sure must be of great beauty to Dullita's eyes. I tossed my diabolo higher and higher, and finally it got away from me and fell on a flowery shrub. Dullita, amused and smiling, ran to pick it up, and she hesitated a little to give it back to me, asking me to let her play too. I took back my diabolo, without answering her, and went on with my game.

But each time I tossed it into the air I felt myself seized with a violent anguish, arising from the sudden fear of missing my catch (which in fact happened quite frequently from then on), and Dullita's attempts to recover my diabolo each time occasioned little races between us, leading to hostile demonstrations on my part. Dullita would always yield smilingly, but with her demand to which I had not acceded and which my pride rendered each time more unacceptable, she had created in my mind a germ of remorse which I quickly transformed into rancour. Instead of admiring me play, instead of watching the prodigies of my movements addressed exclusively to her, Dullita preferred to play herself! Violently I whirled my diabolo up into the sky, which was an "immaculate conception" blue, and the anguishing fear of not catching it made me tremble. But again this time I victoriously caught it. And no sooner had I caught it than I threw it up once more and with greater force, but so clumsily this time that it landed far away.

Dullita promptly broke into a laugh that wounded me in all the fibres of my being. She ran to pick up my diabolo, and I let her, since I still had the sticks and she could not play without them. I went slowly toward her, my eyes charged with repressed anger. She immediately understood my attitude, and seemed this time to be preparing for a long resistance. We walked one behind the other in a calm persecution, and as soon as I increased my pace she would increase hers, but just enough to keep herself always at the same distance; we went round the garden in this way several times.

Finally she went and lay down on one of the piles of linden blossoms which had been sorted out as bad, for the flowers were yellow, bruised, and consumed by bees. Mollified, I went up close to Dullita, thinking she was going to give me back my diabolo. I took a large pile of white, fresh linden blossoms in my arms, and let them fall on Dullita. She turned over on her stomach at this moment, hiding the diabolo under her body, showing me in this manner that she wanted to keep it at all costs. Seen thus from behind, Dullita was extraordinarily beautiful. Between her round, delicate buttocks and her back one saw hollowed out the abyss of her deep waist half-buried in flowers. I got down on my knees on top of her, and encircling her queenly waist with an almost imperceptible gentleness, with the caressing embrace of my two arms I said to her in a low

voice,

"Give me the diabolo!..."

"No!" she answered, already suppliant...

"Give me the diabolo!. .."

"No!" she repeated.

"Give me the diabolo!" And I pressed her tighter. "Give me the diabolo!..."

"No!"

"Give me the diabolo!..."

"No!"

I then pressed her with all the savage might of which I was capable. "Give me the diabolo!..."

"Aïe!"

An incipient sob already shook her little shoulders, and pulling out my diabolo, which she was holding clutched to her bosom, she let it drop. I picked it up and went away a short distance. Dullita too got up and went to seek refuge under the ladder where her mother was working. The two slopes of this ladder were united by a taut cord which prevented them from slipping apart. With angelic grace Dullita went over and, holding on to the two slopes of the ladder with her arms, leaned against the ladder's taut cord with the slenderest portion of her waist which I had just so savagely squeezed. I could feel burning into my own flesh the pain which I assumed the pressure of this cord must produce on Dullita's back. She was weeping without grimacing, and with absolute nobility; I could see very well that she was holding back even this so that no one would notice anything. But I felt ashamed and was looking for a way to escape Dullita's tear-drenched glance.

A hegemonic desire for total solitude took violent hold of me, and I felt myself ready to run away no matter where, when a mad plan assailed my brain with that tyrannic force which already then no power in the world could modify. What I planned to do was to go up and play with my diabolo at the top of the tower, so as to throw it as high up as possible; and if it should fall outside the tower, it would be lost! This danger made my heart beat wildly.

Just then I heard Julia come and call me to lunch. I pretended not to have heard and ran full speed up into the tower, for I absolutely had to experience the emotion of my game at least once before going down into the dining room.

As soon as I had reached the top of the tower I tossed my diabolo with all my might into the air, and it fell beyond the edge of the tower. But by a miracle of skill and a gesture of great suppleness, I leaned over the rampart, with half my body over the edge of the sheer drop. Thus I was able to catch my diabolo. The mortal danger of this act to save my diabolo made me so dizzy that I had to sit down on the terrace to recover myself. The whole flag-stone terrace of the tower, and the crutch itself, planted in the centre, seemed to reel around me. Someone below kept calling me. I went down into the dining room feeling a kind of seasickness which had robbed me of all inclination to eat. Señor Pitchot too

had a severe head-ache, and he had wrapped a tight white band around his head. In spite of the terror I had just undergone I promised myself to go back, after eating, and get my diabolo which I had left on the tower terrace, so that I could continue the same game. I promised myself, however, that I would be more careful next time. I would go and play immediately after lunch, and again in the evening, and I was already thinking of the sunset. I wanted to avoid Dullita this afternoon, I wanted evening to come quickly!

Do not be impatient, Salvador, this evening there will occur one of the most moving experiences in your life, aureoled by a fantastic sunset – wait, wait!

When luncheon was over Señor Pitchot headed for the balcony and, drawing the shutters himself, ordered that the same be done for all the rest of the windows and balconies of the Muli de la Torre. He added, "We are in for a storm." I looked with astonishment at the sky, which appeared as blue and smooth as before. But Señor Pitchot took me out on the balcony and pointed out to me, far down on the horizon, some tiny cumulus clouds, white as snow, and which seemed to be rising vertically. He said, pointing to them with his finger,

"You see those 'towers'? Before tea-time we're going to have lightning and thunder, if it doesn't hail."

I remained clutching the iron railing of the balcony, watching those clouds grow in a steady absorption and wonderment. It was as though the spots of moisture on the vaulted ceiling of Señor Traite's school where I had seen the procession of all the first fantasies of my childhood, which had since been obliterated by my memory's layers of forgetfulness, had suddenly revived in the glory of the flesh and of the immaculate foam of those towers of flashing clouds which rose on several points of the horizon.

Winged horses swelled their chests, from which began to bloom all the breasts, all the melons and all the wasp-waisted diabolos of my delirious desire. Presently one of the clouds, which had rapidly swollen to the point of assuming the form of a colossal elephant with a human face, would divide into two big pieces, which in turn would quickly, before one had time to anticipate it, be transformed into the muscle-bound bodies of two immense bearded wrestlers, one of whom bore an enormous rooster attached to his back. These two fighters now came together violently, and the space of cobalt-blue sky which still separated them in their definitive struggle rapidly diminished. The shock was of such ferocity that the slow motion of the gestures which they adopted made their clinch only more inhuman. I saw the two bodies simultaneously penetrate each other with an unconscious force of inertia which destroyed them instantly, mingling them in a single and unique conglomeration, in which both of them obliterated their personalities now confused in formlessness.

Immediately the latter began to reorganize itself into the whirl of a new image! I recognized it right away! It was the bust of Beethoven, an immense bust of Beethoven which grew so fast that it seemed presently to fill the entire sky. Beethoven's cranium, bowed in melancholy over the plain, augmented in volume while at the same time it turned grey, that dirty "storm" colour which is proper

to and characteristic of the deposits of dust that darken pieces of plaster sculpture that have long been forgotten. Soon Beethoven's entire face was reabsorbed by his immense brow which, growing at an accelerated speed, became an incommensurable and apotheotic leaden skull. A streak of lightning flashed, splitting it in two, and it was as though for the duration of a second one had seen the quicksilver brain of the sky itself through the suture of the frontal lobes of his skull.

Almost simultaneously a clap of thunder shook the Muli de la Torre to its foundations for a half minute. The leaves and the linden blossoms were lifted by a whirl of dry and choking wind. The swallows grazed the earth, uttering cries of paroxysm, and all at once, after a few heavy drops of rain, like great Roman coins, a compact and pitiless downpour flagellated the fearful and avid garden, from which rose a fragrant gust of moss and wet bricks, a gust which seemed already to pacify the fury of the first brutal shock, the erotic, long-contained consequence of the prolonged, anxious, electrified and unsatisfying Platonic contemplation of the sky and the earth which had lasted for two long months! The propitious darkness in which that afternoon of continuous rain remained plunged was one of the accomplices in the drama of which Dullita and I were destined to become the protagonists at the end of that long day marked by the unleashed violence of the elements mingled with that of our own souls.

Dullita and I had run, suddenly and tacitly in accord, to lie down together and play in the tower attic where almost total darkness reigned. The very low ceiling, the solitary location of the spot and the absence of light were most propitious to the anxiously awaited unfolding of our dangerous intimacy. The fear with which the place usually inspired me (even when I merely stood before the door, and especially since I had discovered two days previously the huge laurel crown given to Nini Pitchot), this fear had completely vanished, and in the company of Dullita, whom I felt at last to be quite alone with me, with the torrential rain outside, which isolated us from the rest of the world, this attic which had appeared lugubrious to me until then, became suddenly the most desirable place in the world. The gilded laurel of the crown itself, in spite of the mortuary sense which I continued to attach to it, glowed with a kind of appetizing coquettishness at each new flash of lightning which blinded us intermittently through the heavy closed shutters. My new Dullita, my Galuchka Rediviva, stepped into the hole of the crown and lay down inside it like a corpse; she shut her eyes. The bursts of thunder and lightning succeeded one another around our tower in a growing din, while a swelling presentiment oppressed my chest. Something – I did not know what – but something frightful was about to happen between us.

I kneeled before her, and looked at her fixedly. Becoming gradually accustomed to the half-light, and holding myself so near her that I could see her face in the tiniest detail, pressed on all sides by blackness, I drew even closer and leaned my head on hers. Dullita opened her eyes and said, "Let's play at touching

each other's tongues," and she raised her head slightly, bringing it even a little closer to me, while sticking out the tip of her tongue from her deliciously moist, half-opened mouth. I was paralyzed by a mortal fear, and in spite of my desire to kiss her I pulled back my head and with a brutal gesture of my hand I threw her head back, causing it to strike the laurel crown noisily. I got to my feet again, and my attitude must have struck her as so menacing and resolute that I could feel by her absent look that she was ready to submit to any kind of treatment without offering the slightest resistance. This stoicism in which I felt in addition the presence of a principle of acquiescence on her part accentuated my growing desire to hurt her. With a bound I got behind her; Dullita raised herself up, lifted by the springs of an instinctive fear, but immediately repressing this first gesture of alarm did not turn toward me and remained immobilized in her attitude, proudly seated in the centre of the crown.

At this moment a flash of lightning longer and more penetrating than the others sharply illuminated and pierced through the slits of the closed shutters, and for the space of a second I saw the slim silhouette of Dullita's back outlined in black against that sudden blinding light. I threw myself on Dullita's body and I again squeezed her waist with all my might, as I had done in the morning on the pile of flowers. She resisted my brutality feebly and all at once our struggle became slow, for I suddenly began to calculate everything. Dullita interpreted the gentleness which I now imparted to my gestures as a symptom of tenderness, and in turn wound her caressing arms all around my waist.

We lay thus sprawling on the floor, mingled in a more and more indolent embrace. I felt that it would be easy for me to choke the least of her cries, crushing her little face against my chest. But her attitude did not correspond to my fantasy. What I wanted to do was precisely to turn her over completely on her other side, for it was just in the hollow of her back that I wanted to hurt her; I might, for example, have crushed her, just there, with the crown; the leaves of those metallic laurels would have nailed themselves like blades into her smooth skin. I could then have brought progressively heavier objects to keep her pinned clown there. And when I finally freed her from this torture I would kiss her on the mouth and on her bruised back, and we would weep together. I therefore continued to feign more and more gentle caresses while I recovered my breath for the coming struggle, and I looked around avidly at the heaviest objects, establishing a quick choice among those which crowded the half-light of the attic with their phantasmal contours. My eyes were finally caught by an immense decrepit chest of drawers towering above us and slightly tilted forward. But was I capable of budging it? I felt an intense pain clutching me behind my legs, the back of my neck and my calves. A violent gust of wind caused the attic door to bang open, revealing at the other end of the tower stairway another door, likewise open. It stopped raining and a brand new sky appeared, yellow and livid as a dream lemon.

My fantasy of "Dullita's crushing" instantly melted away in that sky in which I felt the gleams of a delirious sunset flutter.

"Let's go up to the top of the tower!"

And already I was climbing the stairway. Dullita, probably disappointed at the sudden interruption of our caresses, did not obey me instantly. I was forced to interpret her delay as a refusal, and in a fury I went down again to fetch her. She seemed to want to run away. Then, seized with an all-powerful anger, I felt the blood rise to my head, unleashing the wild beast of my wrath. With my two hands I seized Dullita's hair and dragged her toward me. She fell on her knees on the edge of one of the steps and uttered a little plaintive cry of pain; pulling her with all my might, I succeeded in raising her and I dragged her up three or four steps. I let go of her hair for a moment to rest, prepared to continue right on pulling her thus. Then, with a determined movement, she got to her feet, ran up the rest of the steps, and disappeared on the terrace of the tower.

Recovering a supernatural calm and poise I continued slowly up the stairs, making this last as long as I could, for now I knew that she could no longer escape me! This long, persevering and fanatical desire that the Dullita of Figueras should come up to my laundry on the rooftop had just been fulfilled by this new Dullita, Galuchka Rediviva, whom I saw with my own eyes at this very moment crossing the threshold of that dizzy summit of the Muli de la Torre! I should have liked my ascension never to end, so that I might prolong and profit by each of the unique hallucinating moments which I felt I was about to live. For my happiness to have been perfect I would only have had to be wearing my king's crown on my head; for a second I thought of going down to fetch it, but my climb, though deliberately slow, could not be turned aside by anything, not even by death.

I reached the threshold of the door at the top! In the centre of the terrace was standing, slightly leaning toward the right, my rain-soaked crutch which now projected an elongated and sinister shadow on the tiling lighted by red sun-rays. Beside the crutch, my upright diabolo also projected a disturbing shadow strangulated at the centre; across the fine waist of the diabolo a little metal ring shone savagely. At the very top of the sky before me the immense silhouette of a mauve cloud lined with flashing gold was vanishing, resembling an imposing storm-Napoleon; still higher yet, a rainbow cut in two showed in its centre a large piece of Prussian blue sky, which corresponded to the space on the tower that separated me from Dullita. No longer weeping she was waiting for me, seated on the ramparts of the tower.

With an inspired hypocrisy, which never fails me in the supreme moments of my life, I said to her,

"I shall make you a present of my diabolo on condition that you don't lean over the edge of the tower any more, for you might fall."

She immediately came and picked up the diabolo, after which she went back and once more leaned over the edge, exclaiming,

"Oh, how pretty it is!" She turned her face toward me and looked at me with a mocking smile, thinking I had finally become gentle and dominated by her recent tears. I made a gesture of terror and hid my face, as though unable

to stand seeing her lean over in this way. This stimulated her coquettishness, as I had foreseen, and straddling the ramparts of the tower, she let her two legs hang over the edge. I said to her then,

"Wait a minute and I'll go and get you another present!"

And taking my crutch with me I pretended to leave. But I immediately came up again on tip-toe the few steps I had just gone down. My emotion reached its climax. I said to myself, "Now it's up to me!" On all fours I began to crawl toward her, without making any noise, preceded by my crutch which I held by its tip. There was Dullita, still seated with her back to me, her legs over the drop, the palms of her hands resting on the rampart, and completely absorbed in the contemplation of the clouds, torn by the rain, broken up into fantastic fragments of the great vertical Napoleon of a while ago, now transformed into a kind of immense and horizontal sanguinary crocodile.

Soon it would be dark. With infinite precautions I advanced the bifurcation of my crutch toward just the slenderest part of Dullita's waist; I effected this operation with such attention that as I approached I bit my lower lip hard, and a tiny trickle of blood began to flow down my chin. What was I going to do? As though sensing in advance the contact of my crutch, Dullita turned toward me, in no wise frightened, and of her own accord leaned her back against my crutch. At this moment her face was the face of the most beautiful angel in heaven, and then I felt the rainbow of her smile form a bridge to me across the whole distance by which the crutch separated us. I lowered my eyes and pretended to prop the end of my crutch in the space between two paving-tiles. Rising abruptly, with my eyes full of tears, I approached Dullita, tore the diabolo from her hand and screamed with a hoarse tear-choked voice,

"Neither for you nor for me!"

And I hurled our diabolo into empty space.

The sacrifice was at last accomplished![15] And since then that anonymous crutch was and will remain for me, till the end of my days, the "symbol of death" and the "symbol of resurrection"!

15. The diabolo in my story assumed in every respect the substitutive role typical of sacrifices, and takes the place of Abraham's sacrificial ram. In my case it symbolizes without euphemism the death of Dullita, of Galuchka Rediviva, and also the possibility of their resurrection.

CHAPTER SIX
1916-1918

Adolescence is the birth of body hairs. In my case this phenomenon seemed to occur all at once, one summer morning, on the Bay of Rosas. I had been swimming naked with some other children, and I was drying myself in the sun. Suddenly, on looking at my body with my habitual narcissistic complacency, I saw some hairs unevenly covering the very white and delicate skin of my pubic parts. These hairs were very slender and widely scattered, though they had grown to their full length, and they rose in a straight line toward my navel. One of these, which much longer than the rest, had grown on the very edge of my navel.

I took this hair between my thumb and forefinger and tried to pull it out. It resisted, painfully. I pulled harder and when I at last succeeded, I was able to contemplate and to marvel at the length of my hair.

How had it been able to grow without my realizing it on my adored body, so often observed that it seemed as though it could never hide a secret from me?

A sweet and imperceptible feeling of jealousy began to bud all around that hair. I looked at it against the sky, and brought it close to the rays of the sun; it then appeared as if gilded, edged with all the colours, just as when, half shutting my eyelids, I saw multitudes of rainbows form between the hairs of my gleaming eyelashes.

While my mind flew elsewhere, I began automatically to play a game of forming a little ring with my hair. This little ring had a tail which I formed by means of the two ends of the hair curled together into a single stem which I used to hold my ring. I then wet this ring, carefully introducing it into my mouth and taking it out with my saliva clinging to it like a transparent membrane and adapting itself perfectly to the empty circle of my ring, which thus resembled a lorgnette, with my pubic hair as the frame and my saliva as the crystal. Through my hair thus transformed I would look with delight at the beach and the distant landscape. From time to time I would play a different game. With the hand which remained free I would take hold of another of my pubic hairs in such a way that the end of it could be used as the pricking point of a needle. Then I would slowly lower the ring with my saliva stretched across it till it touched the point of my pubic hair. The lorgnette would break, disappear and an infinitesimal drop would land with a splash on my belly.

I kept repeating this performance indefinitely, but the pleasure which I derived from the explosion of the fabric of my saliva stretched across the ring of my hair did not wear off – quite the contrary. For without knowing it the anxiety of my incipient adolescence had already caused me to explore obscurely the very

enigma of the semblance of virginity in the accomplishment of this perforation of my transparent saliva in which, as we have just seen, shone all the summer sunlight.

My adolescence was marked by a conscious reinforcement of all myths, of all manias, of all my deficiencies, of all the gifts, the traits of genius and character adumbrated in my early childhood.

I did not want to correct myself in any way, I did not want to change; more and more I was swayed by the desire to impose and to exalt my manner of being by every means.

Instead of continuing to enjoy the stagnant water of my early narcissism, I canalized it; the growing, violent affirmation of my personality soon became sublimated in a new social content of action which, given the heterogeneous, well characterized tendencies of my mind, could not but be anti-social and anarchistic.

The Child-King became an anarchist. I was against everything, systematically and on principle. In my childhood I always did things "differently from others", but almost without being aware of it. Now, having finally understood the exceptional and phenomenal side of my pattern of behavior I "did it on purpose". It was only necessary for someone to say "black" to make me counter "white!". It was only necessary for someone to bow with respect to make me spit. My continual and ferocious need to feel myself "different" made me weep with rage if some coincidence should bring me even fortuitously into the same category as others. Before all and at whatever cost: myself – myself alone! Myself alone! Myself alone!

And in truth, in the shadow of the invisible flag on which these two words were ideally inscribed my adolescence constructed walls of anguish and systems of spiritual fortifications which for long years seemed to me impregnable and capable until my old age of protecting the sacred security of my solitude's bloody frontiers.

I ran away from girls, for since the criminal memory of the Muli de la Torre, I felt in them the greatest danger for my soul, so vulnerable to the storms of passion. I made a plan, nevertheless, for being "uninterruptedly in love"; but this was organized with a total bad faith and a refined jesuitical spirit that enabled me to avoid beforehand every material possibility of a real encounter with the beings whom I took as protagonists of my loves.

I always chose girls whom I had seen only once, in Barcelona or in nearby towns, and whom it was doubtful or impossible that I should ever see again. The unreality of these beings, becoming accentuated with the fading of my recollections, made it easy to transmute my passion into new protagonists.

One of my greatest loves of this kind was born in the course of a traditional picnic in the country near Figueras. The little hills were sprinkled with clusters of people preparing their meals under the olive trees. Immediately I chose as the object of my love a young girl who was lighting a fire on the opposite hill. The distance that separated me from her was so great that I could not clearly

make out her face; I knew already, however, that she was the incomparable and most beautiful being on earth. My love burned in my bosom, consuming my heart in a continual torment.

And each time a festival gathered together a multitude of people, I would imagine I caught glimpses of her in the milling throng.

This kind of apparition, in which doubt played the leading role, would come and cast fresh branches on the fire which the chimerical creature of my passion had lighted on the opposite hill-slope that first day when I had seen her from afar.

Loves of this kind, ever more unreal and unfulfilled, allowed my feelings to overflow from one girl's image to another, even in the midst of the worst tempests of my soul, progressively strengthening my idea of continuity and reincarnation which had come to light for the first time in my encounter with my first Dullita. That is to say, I reached by degrees the conviction that I was really always in love with the same unique, obsessing feminine image, which merely multiplied itself and successively assumed different aspects, depending more and more on the all-powerful autocracy of my royal and anarchic will.

Just as it had been easy for me, since Señor Traite's school, to repeat the experience of seeing "anything I wished" in the moisture stains on the vaults, and as I was able later to repeat this experience in the forms of the moving clouds of the summer storm at the Muli de la Torre, so even at the beginning of my adolescence this magic power of transforming the world beyond the limits of "visual images" burst through to the sentimental domains of my own life, so that I became master of that thaumaturgical faculty of being able at any moment and in any circumstance *always, always to see something else*, or on the other hand – what amounts to the same – "always to see the identical thing" in things that were different.

Galuchka, Dullita, second Dullita, Galuchka Rediviva, the fire-lighter, Galuchka's Dullita Rediviva! Thus in the realm of sentiment, love was at the dictate of the police of my imagination!

I have said at the beginning of this chapter that the exasperated hyper-individualism which I displayed as a child became crystallized in my adolescence in the development of violently anti-social tendencies. These became manifest at the very beginning of my study for the *baccalaureate*, and they took the form of "absolute dandyism", based on a spirit of irrational mystification and systematic contradiction.

I must confess that the most catastrophic hazards kept occurring to enhance the theatrical character of my most trivial actions, contributing in a decisive way to the myth which already at the time of my adolescence began to surround the initial obscurity of my person with its mists of divine renown.

I was to begin my secondary studies, and for this I was sent to another religious school, that of the Marist Brothers. At this time I claimed to have made sensational discoveries in the field of mathematics which would enable me to make money. My method was simple. It was this: I would buy five-*centimo* pieces

with ten-*centimo* pieces – for each five that I was offered I would give ten in exchange! All the money that I could obtain from my parents I would immediately spend in this way taking a frenzied delight in the game which was incomprehensible to everyone and inevitably ruinous. One day when my father made me a present of a *duro* (five *pesetas*), I rushed out to change it into ten-*centimo* pieces, which made several marvelous piles! As soon as I got to school I triumphantly announced that on this very day I would open my market to buy five-*centimo* pieces on my usual conditions.

So at the first recreation period I took up my post behind a little table, and with great delight I arranged the coins in several piles. All my schoolmates gathered round me, eager to realize the promised exchange. To the consternation of everyone I actually gave back ten *centimos* for every five I was offered! My money spent, I pretended to go over my accounts in a secret little book which I put back preciously in my pocket, securing it with several safety pins. After which I exclaimed, rubbing my hands with satisfaction, "Again I've made a profit!" I then got up from my counter table and strode off, not without having first cast a contemptuous glance around at my schoolmates, with an expression which poorly concealed my joy, as if to say, "Once more I've put one over on you! What idiots!"

This money-buying game began to fascinate me in an obsessing way, and from then on I canalized all my activity toward obtaining as much money as possible from my parents on the most varied pretexts – for buying books or paint; or else, by displaying such exemplary and unusual conduct that it warranted my asking for some monetary reward. My financial needs grew, for in order to consolidate my prestige it was necessary for me to exchange more and more considerable sums: it was the only sure way of amplifying the sensational astonishment which steadily spread around me at each new exchange.

One day I arrived at school, out of breath, barely holding back my joy – I was bringing fifteen *pesetas* which I had finally got together after a thousand tortures and sacrifices of sweetness toward my parents! I was going to be able to exchange fifteen *pesetas* all at once. I went about this with the utmost ceremony and deliberation, interrupting my exchanges from time to time to consult my account book. I succeeded in making my pleasure last several hours, and my success exceeded all my ambitions. My schoolmates repeated from mouth to mouth, "You know how much money Dalí has just exchanged? Fifteen *pesetas*!..." "Not really!" Everyone was amazed, and they kept exclaiming, "He is really mad!"

For as long as I could remember I had savoured that phrase with delight. In the evenings after school I would go strolling about the town all by myself; it was then that I thought up what I would do the next day to astonish my schoolmates. But I also took advantage of these strolls to indulge in my "aggressions", for I usually came upon suitable victims, which this "sport" required, and whom I chose among children smaller than myself. My first aggression was perpetrated on a boy of thirteen. I had been watching him for

some time stupidly eating a large piece of bread with some chocolate – a mouthful of bread, a mouthful of chocolate. These alternate, almost mechanical gestures, appeared to me to reveal a profound lack of intelligence. Moreover he was ugly, and the chocolate he was eating, which was of atrocious quality, inspired me with an immense contempt for its consumer. I approached the boy furtively, pretending to be absorbed in the reading of a book by Prince Kropotkin[1] which I always carried with me on my walks. My victim saw me coming, but he had no suspicions of me and continued to devour his bread and his chocolate while looking in another direction. I sized him up and planned what I was going to do, indulging at leisure in the great luxury of premeditation as I approached him. After having closely observed his horrible, idiotic, uncouth manner of eating, and especially of swallowing, I slapped him hard right in the face, making his bread and chocolate fly into the air. After which I dashed off in frenzied flight as fast as my legs would carry me. It took the lad a long time to realize what had happened to him, and when he understood it and tried to run after me I was already so far away that he immediately abandoned his angry impulse to clash after me. I saw him stoop down and pick up his piece of bread and his chocolate.

My unpunished success immediately caused such acts of aggression to assume the endemic character of a real vice which I could no longer forego. I would be on the look-out for every propitious occasion to commit similar acts, and I grew more and more reckless. Soon I noticed that the sympathetic or antipathetic character of my victims no longer played an essential role, and that my pleasure arose solely from the anguish inherent in the execution and the vicissitudes of the assault itself.

On one occasion I chose as my victim a violin student whom I knew very slightly and toward whom I had rather a feeling of admiration because of his artistic vocation. He was very tall, much bigger than I, but so thin, so pale and sickly that his look of frailness made me regard him as unlikely to react violently to what I would do. I had been following him for several minutes, but no favourable occasion arose: he was still in the midst of several groups of students, busily chatting. Presently he left one of these groups, put his violin on the ground, and kneeled down to tie a shoelace that had come undone. His posture at this moment could not have been more propitious. Without hesitating, I went up to him and gave him a terrific kick on the buttocks. After which I jumped with both feet upon his violin, crushing it into a hundred pieces and immediately after dashed away like a rabbit. But this time my victim, recovering quickly from my attack, ran after me and did not give up the chase. His legs were so long, and he ran so well that I immediately felt I was lost. Then, judging all resistance useless, and seized with an insurmountable fit of cowardice, I stopped short, got down on my knees, and begged him tremblingly to forgive me. I immediately thought

1. I have never read this book, but Kropotkin's portrait on the cover, and the title, *The Conquest Of Bread*, appeared to me of great subversive value, and were intended to make me appear interesting in the eyes of the people who saw me pass through the streets of the town.

of offering him money, and with my eyes full of tears volunteered to give him twenty-five *pesetas* if he did not touch me, if he did not hurt me. But the boy violinist's lust for vengeance was so aroused that I understood my pleas were in vain and that no amount of wailing could stop him. Then I concealed my head between my arms to protect myself from the blows I was about to receive. With a savage kick in my chest he knocked me over, punched me several times, seized a lock of my long hair, and pulled and twisted it at the same time, tearing out several handfuls. I uttered piercing and hysterical shrieks of pain and my terror was so theatrically manifest in the quivering of my whole body, by which I made it seem that I was about to succumb to a kind of attack, that the boy violinist, suddenly startled, stopped beating me and fled in turn.

A compact group of students had just gathered round us; the professor of literature who happened to be nearby asserted his authority to intervene, and breaking his way through the crowd he asked for an explanation of what had occurred. Then an astonishing lie was suddenly born in my head, and I said to him all in one breath,

"I have just crushed his violin to give a final irrefutable proof of the superiority of painting over music!"

My explanation was greeted with mingled murmurs and laughter. The professor, indignant though his curiosity was aroused, said,

"How did you do this?"

"With my shoes," I answered, after a moment's pause.

Everyone laughed, this time, creating a great hubbub. The professor restored silence, came over to me, put one hand on my shoulder and said in an almost paternal tone of reproach,

"That doesn't prove anything. It makes no sense!"

Looking him straight in the eye, with an assurance that verged on solemnity, and hammering out each syllable with the utmost dignity of which I was capable, I answered,

"I know very well that it makes no sense for most of my schoolmates and even for most of my professors; on the other hand I can assure you that my shoes[2] [and I pointed to them with my finger] have quite a different view of the matter!"

A stifling silence fell around us after I had finished uttering my last words. All my schoolmates expected a dressing down and a severe punishment

2. All my life I have been preoccupied with shoes, which I have utilized in several surrealist objects and pictures, to the point of making a kind of divinity of them. In 1936 I went so far as to put shoes on heads; and Elsa Schiaparelli created a hat after my idea. Daisy Fellowes appeared in Venice with this shoe-hat on her head. The shoe, in fact, appeals to me to be the object most charged with realistic virtues as opposed to musical objects which I have always tried to represent as demolished, crushed, soft-cellos of rotten meat, etc. One of my latest pictures represents a pair of shoes. I spent two long months copying them from a model, and I worked over them with the same love and the same objectivity as Raphael painting a Madonna. It is therefore extremely instructive to observe how in an improvised lie, produced in ultra-anecdotic circumstances, I anticipated the formulation of a durable and integrated philosophic platform, which was only to become consolidated with time.

for my stupefying insolence. On the contrary the literature professor became suddenly meditative and made, to the surprise and disappointment of everyone, an impatient and categorical gesture with his arm indicating that he considered the incident closed, at least for the moment.

From that day on there began to grow around my personality an aureole of "audacity", which the events I am now about to describe were only to consolidate and raise to the status of a legendary category. None of my companions had ever dared to answer a professor with the assurance which I had shown, and all were agreed in recognizing that the vigor of my tone had left the professor breathless. This sudden energy which flashed like a streak of lightning through the haze of my habitual timidity brought me a certain prestige, which happily counterbalanced the mingled contempt and stupefaction which my monetary exchanges and other continual eccentricities had eventually attached to my reputation.

I began now to be a subject of intriguing controversy: Is he mad? Is he not mad? Is he half-mad? Does he show the beginnings of an extraordinary but abnormal personality? The last opinion was shared by several professors – those of drawing, handwriting and psychology. The mathematics professor, on the other hand, maintained that my intelligence was much below the average. One thing at any rate was more and more certain: everything abnormal or phenomenal that occurred was automatically attributed to me; and as I became more "alone" and more "unique", I became by that very fact each day more "visible" – the more occult I made myself the more I was noticed. For that matter I began to exhibit my solitude, to take pride in it as though it were my mistress whom I was cynically parading, loaded with all the aggressive jewels of my continual homage.

One day a skull from a "mounted skeleton" which was used in the natural history class disappeared. I was immediately suspected, and they came to search my desk which, since it was locked, was forced open. Already at that time skeletons filled me with a horrible uneasiness, and for nothing in the world would I have touched one. How little they knew me! The next day the enigma was solved: it was simply the professor himself who had needed the skull and who had unmounted it to take it home with him.

One morning, after I had been absent from the institute several days because of my habitual anginas, I went back to resume my studies. When I arrived I noticed an excited crowd of students gathered in a circle, all shouting at the top of their lungs. Suddenly I saw a flame dart up from the centre of their excited group, followed by a whirl of black smoke. This is what had happened: at this time there was developing an important separatist movement connected with certain contemporary political events which had just been announced in the newspapers of the day before, and the students had done nothing less than to burn a Spanish flag!

Just as I was heading toward the group to try to find out what was happening I was surprised to see everyone suddenly scatter, and for a moment I

thought my hurried arrival might have caused this. Before I knew, I was left standing alone with the remnants of the burned and smoking flag at my feet; the runaways looked at me from a distance with an expression both of terror and admiration which puzzled me. Yet the reason for the sudden dispersal was perfectly obvious, for it was motivated simply by the arrival of a group of soldiers who happened to be passing by the scene of the incident and to have witnessed what had occurred, and who now were already beginning to investigate the anti-patriotic sacrilege which had just been perpetrated. I declared repeatedly that my presence here was purely accidental, but no one paid the slightest attention to my protests of innocence; on the contrary, the picture that everyone had already formed of me required that I become the principal hero of this demonstration in which I had not even participated. The story immediately went round that the moment the soldiers appeared on the scene everyone had run away except myself, who in remaining glued to the spot had given a proof and example of revolutionary stoicism and admirable presence of mind. I had to appear before the judges, but fortunately I was not yet old enough to be held responsible for acts of a political nature; I was acquitted without being brought to trial. Nevertheless the event made a deep impression on public opinion, which was beginning to have to take notice of my person.

I had let my hair grow as long as a girl's, and looking at myself in the mirror I would often adopt the pose and the melancholy look which so fascinated me in Raphael's self-portrait, and whom I should have liked to resemble as much as possible. I was also waiting impatiently for the down on my face to grow, so that I could shave and have long side-whiskers. As soon as possible I wanted to make myself "look unusual", to compose a masterpiece with my head; often I would run into my mother's room – very fast so as not to be caught by surprise – and hurriedly powder my face, after which I would exaggeratedly darken the area around my eyes with a pencil. Out in the street I would bite my lips very hard to make them as red as possible. These vanities became accentuated after I became aware of the first curious glances directed toward me, glances by which people would attract one another's attention to me, and which said, "That's the son of Dalí the notary. He's the one who burned the flag!"

The ideas which had made me into a hero were deeply repugnant to me. To begin with, they were those of most of my schoolmates and because of my irrepressible spirit of contradiction were disqualified by that very fact; besides, the lack of universality of that small and wretched local patriotism appeared unendurably mediocre to my eyes which thirsted for sublimity. At this period I felt myself to be an "integral anarchist", but it was an anarchy of my own, quite special and anti-sentimental, an anarchy in which I could have reigned as the supreme and capricious disorganizer – an anarchic monarchy,[3] with myself at

3. In 1922, in Madrid, I developed this idea of an anarchic monarchy, mingling the most caustic humour with a whole series of anti-social and apolitical paradoxes which at least had the virtue of being a convincing polemic weapon by which I could amuse myself, scattering seeds of doubt and ruining my friends' political convictions.

the head as an absolute king; I composed at this time several hymns that could be sung to tunes currently popular, in which the incoherent praises of anarchic and Dalínian monarchy were described in a dithyrambic manner. All my schoolmates knew songs of this kind, and they tried unsuccessfully to imitate them; the idea of influencing my schoolmates began to appeal to me and the "principle of action" gradually awakened in my brain.

On the other hand I was utterly backward in the matter of "solitary pleasure", which my friends practiced as a regular habit. I heard their conversations sprinkled with allusions, euphemisms and hidden meanings, but in spite of the efforts of my imagination I was unable to understand exactly whereof "it" consisted; I would have died of shame rather than dare to ask how one went about doing "it", or even to broach the matter indirectly, for I was afraid it might be found out that I did not know all about "it", and had never done "it". One day I reached the conclusion that one could do "it" all by oneself, and that "it" could also be done mutually, even by several at a time, to see who could do it fastest. I would sometimes see two of my friends go off after exchanging a look that haunted me for several days. They would disappear to some solitary spot, and when they came back they seemed transfigured – they were more handsome! I meditated for days on what "it" might well be and would lose my way in the labyrinth of false and empty childish theories, all of which constituted a gross anomaly in view of my already advanced adolescence.

I passed all my first year examinations without distinction, but I failed in none – this would have spoiled my summer, for I should have had to prepare to take the examinations over again in the fall. My summers were sacred, and I imposed a painful constraint upon myself in order to keep them free from the blemish of displeasure.

I was waiting frantically for vacation to begin. This was always a little before Saint John's Day; and since my earliest childhood I remembered having always spent this day in the same place, in a white-washed village on the edge of the Mediterranean, the village of Cadaqués! This is the spot which all my life I have adored with a fanatical fidelity which grows with each passing day. I can say without fear of falling into the slightest exaggeration that I know by heart each contour of the rocks and beaches of Cadaqués, each geological anomaly of its unique landscape and light, for in the course of my wandering solitudes these outlines of rocks and these flashes of light clinging to the structure and the aesthetic substance of the landscape were the unique protagonists on whose mineral impassiveness, day after day, I projected all the accumulated and chronically unsatisfied tension of my erotic and sentimental life. I alone knew the exact itinerary of the shadows as they traced their anguishing course around the bosom of the rocks, whose tops would be reached and submerged by the softly lapping tides of the waxing moon when the moment came. I would leave signals and enigmas along my trail. A black, dried olive placed upright on a piece of old cork served to designate the limit of the setting sun – I placed it on the very tip of a rock pointed like an eagle's beak. By experimenting I found that this

stone beak was the point that received the sun's last rays and I knew that at a given moment my black olive would stand out alone in the powerful flood of purple light, just as the whole rest of the landscape appeared suddenly submerged in the deep shadow of the mountains.

As soon as this effect of light occurred, I would run and get a drink out of a fountain from which I could still see the olive, and without letting it out of my sight for a second I would slowly swallow the cold water from the spring, quenching my thirst which I had held back until this long anticipated moment in obedience to an abscure personal liturgy which enabled me, as I quenched my thirst, to observe that black olive, poised upon the ultimate point of day, which the blazing sunset rendered for a moment as vivid as an ephemeral twilight cherry! After this I went and fetched my miraculous olive and, inserting it in one of my nostrils, I continued on my way. As I walked, and occasionally broke into a run, I liked to feel my more and more accelerated breathing encounter the resistance of my olive; I would purposely blow harder and harder, stopping up my other nostril until I succeeded in expelling it, with considerable force. Then I would pick it up, carefully brushing off the little grains of dirt and sand which had fastened themselves on its sweating surface, and would even put it in my mouth, sucking its faint taste of rancid oil with delight. Then I would put it back in my nostril and begin all over again the respiratory exercises that were to result in its expulsion. I could not decide which I liked better, the smell of the rancid oil or its taste when I sucked it.[4]

My summers were wholly taken up with my body, myself and the landscape, and it was the landscape that I liked best. I, who know you so well, Salvador, know that you could not love that landscape of Cadaqués so much if in reality it was not the most beautiful landscape in the world – for it is the most beautiful landscape in the world, isn't it?

I can already see the sceptical though kindly smile of most of my readers. Nothing can put me into such a rage as that smile! The reader thinks: *the world is so big, there are so many beautiful and varied landscapes everywhere, on every continent, in every latitude. Why does Dalí try to convince us by a mere gratuitous statement that he cannot prove (except on the subjective ground of his own taste)? For this would require an experiment, which is humanly impossible, especially for Dalí who, not having travelled very extensively, is and will continue to be ignorant of considerable areas of the terrestrial globe, and cannot judge and deliver an opinion of such unqualified finality.*

I am sorry for anyone who reasons in this way, giving flagrant proof of his aesthetic and philosophic short-sightedness. Take a potato in your hands, examine it carefully. It may have a spot that has rotted, and if you bring your nose close to it it has a different smell. Imagine for a moment that this spot of decomposition is the landscape – then on this potato that I have just respectfully

4. In this game with my olive I frequently ended by repeatedly inserting or pressing it into other parts of my body, under my arms, etc., after first wetting it with my saliva.

offered you to hold between your fingers there would be one landscape, a single one and not thirty-six. Now on the other hand imagine that there are no moldy spots at all on the potato in question – then, if we continue to assume that the above-mentioned spot is the equivalent of the landscape, there will result the fact that the potato now has no landscape at all. This may very well happen! An this has happened to planets like the moon, where I assure you there not a single landscape worth seeing – and I can affirm this, even though have never been there, and even though the moon is not exactly a potato.

Just as on a human head, which is more or less round, there is only one nose, and not hundreds of noses growing in all directions and on all its surfaces, so on the terrestrial globe that phenomenal thing which a few of the most cultivated and discriminating minds in this world have agreed to call a "landscape", knowing exactly what they mean by this word, is so rare that innumerable miraculous and imponderable circumstances – a combination of geological mold and of the mold of civilization – must conspire to produce it. That thing, then – and I repeat it once again – that thing which is called and which I call a "landscape", exists uniquely on the shores of the Mediterranean Sea and not elsewhere. But the most curious of all is that where this landscape becomes best most beautiful, most excellent and most intelligent is precisely in the vicinity of Cadaqués, which by my great good fortune (I am the first to recognize it) is the exact spot where Salvador Dalí since his earliest childhood was periodically and successively to pass the "aesthetic courses" of all his summers.

And what are the primordial beauty and excellence of that miraculously beautiful landscape of Cadaqués? The "structure", and that alone! Each hill, each rocky contour might have been drawn by Leonardo himself! Aside from the structure there is practically nothing. The vegetation is almost non-existent. Only the olive trees, very tiny, whose yellow-tinged silver, like greying and venerable hair, crowns the philosophic brows of the hills, wrinkled with dried-up hollows and rudimentary trails half-effaced by thistles. Before the discovery of America this was a land of vines. Then the American insect, the phyloxera, came and devastated them, contributing by its ravages to make the structure of the soil emerge again even more clearly, with the lines formed by the retaining walls that terraced the vines accentuating and shading it, having aesthetically the function of geodetic lines marking, giving emphasis and architectonic compass to the splendor of that shore, which seems to descend in multiple and irregular stairways adapted to the soil; serpentine or rectilinear tiers, hard and structural reflections of the splendor of the soul of the earth itself; tiers of civilization encrusted on the back of the landscape; tiers now smiling, now taciturn, now excited by Dionysian sentiments on the bruised summits of divine nostalgias; Raphaelesque or chivalric tiers which, descending from the warm and silvery Olympuses of slate, burst into bloom on the water's fringe in the svelte and classic song of stone, of every kind of stone down to the granite of the last retaining walls of that unfertilized and solitary earth (its teeming vines having long since

disappeared) and on whose dry and elegiac roughness, even today, rest the two bare colossal feet of that grandiose phantom, silent, serene, vertical and pungent, which incarnates and personifies all the different bloods and all the absent wines of antiquity.

When you are thinking of it least, the grasshopper springs? Horror of horrors! And it was always thus. At the heightened moment of my most ecstatic contemplations and visualizations, the grasshopper would spring! Heavy, unconscious, anguishing, its frightfully paralyzing leap reflected in a start of terror that shook my whole being to its depths. Grasshopper – loathsome insect! Horror, nightmare, martyrizer and hallucinating folly of Salvador Dalí's life.

I am thirty-seven years old, and the fright which grasshoppers cause me has not diminished since my adolescence. On the contrary. If possible I should say it has perhaps become still greater. Even today, if I were on the edge of a precipice and a large grasshopper sprang upon me and fastened itself to my face, I should prefer to fling myself over the edge rather than endure this frightful "thing".

The story of this terror remains for me one of the great enigmas of my life. When I was very small I actually adored grasshoppers. With my aunt and my sister I would chase them with eager delight. I would unfold their wings, which seemed to me to have graduated colours like the pink, mauve and blue-tinted twilight skies that crowned the end of the hot days in Cadaqués.

One morning I had caught a very slimy little fish, called a "slobberer" because of this. I pressed it very hard in my hand so as to be able to hold it without its slipping away, and only its small head emerged from my hand. I brought it close to my face to get a good look at it, but immediately I uttered a shrill cry of terror, and threw the fish far away, while tears welled into my eyes. My father, who was sitting on a rock nearby, came and consoled me, trying to understand what had upset me so. "I have just looked at the face of the 'slobberer'," I told him, in a voice broken by sobs, "and it was exactly the same as a grasshopper's!" Since I found this association between the two faces, the fish's and the grasshopper's, the latter became a thing of horror to me, and the sudden and unexpected sight of one was likely to throw me into such a spectacular nervous fit that my parents absolutely forbade the other children to throw grasshoppers at me, as they were constantly trying to do in order to enjoy my terror. My parents, however, often said, "What a strange thing! He loved them so much before!"

On one occasion my girl cousin purposely crushed a large grasshopper on my neck. I felt the same unnamable and slobbery sliminess that I had noticed in the fish; and though it was eviscerated and abundantly sticky with a loathsome fluid, it still stirred, half destroyed, between my shirt-collar and my flesh, and its jagged legs clutched my neck with such force that I felt they would be torn off sooner than relax their death-grip. I remained for a moment in a half faint, after which my parents succeeded in detaching that "horrible half-living nightmare"

from me. I spent the afternoon frantically rubbing my neck and washing it with sea-water. Still tonight, as I write these lines, shudders of horror shoot through my back, while in spite of myself my mouth keeps contracting into a grimace of repugnance mingled with the bitterest moral malaise, which (to the eyes of an imaginary observer) must make my facial expression as sickly and horrible to behold as that of the half-crushed grasshopper which I have just described and which I am probably imitating, identifying myself with its martyrdom by the irresistible reflexes and mimicry of my facial muscles.

But my own martyrdom awaited me on my return to Figueras. For there, once my terror was discovered, and my parents not being constantly present to protect me, I was the victim of the most refined cruelty on the part of my schoolmates, who would think of nothing but catching grasshoppers to make me run – and how I ran! – like a real madman, possessed by all the demons. But I rarely escaped the sacrifice – the grasshopper would land on me, half-dead, cadaverous, hideous! At times it was on opening my book that I would find it, crushed, bathed in a yellow juice, its heavy horse-head separated from its body, its legs still stirring, hi hi hi hi!!

Even in this state it was still capable of jumping on me! Once after such a discovery I flung my book away, breaking a pane of glass in the door, right in the midst of class while everyone was listening to the teacher expounding a geometry problem. That day the teacher made me leave class, and for two days I was afraid that my parents would receive a communication on the subject.

In Figueras the grasshoppers attain much greater dimensions than those of Cadaqués, and this species terrified me much more. Those horrible grasshoppers of Figueras, half-crushed on the edges of the sidewalks, dragging a long foul string tied to their legs and subjected to the slow and fierce martyrdom of the games which the children inflict on them – I can see them now! There they are, there they are, those grasshoppers – motionless, convulsed with pain and terror, covered with dust like loathsome croquettes of pure fear. There they are, clutching at the edge of the sidewalk, their heads lowered, their heavy horse-heads, their inexpressive, impassive, unintelligent, frightful heads, with their blind, concentrated look, swollen with pain; there they are, motionless, motionless... And suddenly – hi hi hi hi hi! – they jump, released with all the explosive unconsciousness of their long contained waiting, as if all of a sudden the spring of their capacity for suffering had reached the breaking-point, and they had to fling themselves, no matter where – on me!

In school my fear of grasshoppers finally took up all the space of my imagination. I saw them everywhere, even where there were none: a greyish paper, suddenly seen, and looking to me like a grasshopper, would make me utter a shrill cry which delighted everyone; a simple pellet of bread or gum thrown from behind that struck me in the head would make me jump up on my desk with both feet, trembling, looking around me, mortally anguished by the fear of discovering the horrible insect, ever ready to spring.

My nervous state became so alarming that I decided on a stratagem in

order to liberate myself, not of this fear, which I knew to be all-powerful, but at least of my schoolmates' plaguing. I accordingly invented the "counter-grasshopper". This consisted of a simple *cocotte* made by folding a sheet of white paper into the shape of a rooster, and I pretended one day that this paper rooster frightened me much more than grasshoppers, and begged everyone never to show me such a thing. When I saw a grasshopper I did my utmost to repress the display of my fear But when they showed me a *cocotte* I would utter screams and simulate such a wild fit that one might have thought I was being murdered. This false phobia had an immense success, not only by its novelty and it doubly scandalous effect but also and especially because it was infinitely easier to make a little *cocotte* of white paper than to go and hunt a grasshopper; moreover the fear produced by the white *cocotte* appeared more spectacular. Thanks to this stratagem I was almost freed of the grasshoppers, to which I was less and less exposed as they were replaced by the white *cocottes*. For a real terror I had thus succeeded in substituting its simulation, which amused and tyrannized me at the same time, for I had constantly to play my role to perfection, otherwise I risked being assailed again by a new period of real grasshoppers, and consequently of authentic terrors.

But the disorder into which my hysterical reactions to each apparition of the white *cocottes* plunged the class became so spectacular and constant that the teachers began to be seriously concerned about my case; they decided to punish the pupils severely each time they showed me one of those white *cocottes*, explaining to them that my reaction was the result of a nervous state which was peculiar to me and which it was criminal to exasperate.

Not all the teachers, however, interpreted my simulation so generously. One day we were in a class with our Superior, who did not know very much about my case, when I found a large white paper *cocotte* inside my cap. I knew that all the pupils were just waiting for my reaction, and I therefore had to utter a cry that would measure up to my supposed irremediable repugnance. Outraged by my scream, the teacher asked me to bring him the *cocotte* that had created the disturbance, but I answered, "Not for all the world!" His patience getting out of bounds, he began to insist and peremptorily called upon me to obey him. Then, going up to a stand on which stood an immense bottle of ink from which all the inkwells in the class were periodically filled, I took the bottle with both hands and let it drop on the paper *cocotte*. The bottle shattered into a thousand pieces and the flood of ink dyed the *cocotte* a deep blue. Delicately picking up the soaked *cocotte* still dripping with ink between my thumb and forefinger, I threw it on the teacher's desk, and said, "Now I can obey you. Since it isn't white it doesn't frighten me any more!"

The consequence of this new Dalínian performance was that I expelled from school the following day.

My memories of the war were all agreeable memories, for Spain's neutrality led my country into a period of euphoria and rapid economic prosperity. Catalonia

produced a truculent and succulent flora and fauna of *nouveaux-riches* who, when they grew in Figueras, "an agricultural region of Ampurdán where madness blends most gracefully with reality", produced a whole harvest of picturesque types whose exploits blossomed forth in a living and burning folklore and constituted a kind of piping-hot spiritual nourishment for the elite of our fellow-citizens which supplemented, and was served together with, the everyday terrestrial nourishment – which, it must be said, was very good. I remember well that during this war of 1914 everyone in Figueras was deeply concerned over the question of cooking. There was a French family that was very intimate with my parents and whose members were confirmed *gourmets*; hence a woodcock, served "high" with brandy burned over it, had no secrets for me, and I knew by heart the whole ritual for drinking a good Pernod out in the sun with a sugar-lump clipped into it, while listening to the thousand and one comic anecdotes about our *nouveaux-riches*. These anecdotes became as famous as those of Marseille. But in crossing the frontier they lose their fine effervescent flavor. They have to be consumed on the spot.

Every evening there was a large gathering of grown-ups in the back of the French family's shop. People came there ostensibly to talk about the war and the European situation, but mostly they told endless anecdotes. Looking out on the street through the shop-window they could watch their fellow citizens passing by, the sight of whom was a lively stimulant that kept the conversation welded to the immediacy of happenings in the town. Hilarity hovered over this predominantly masculine gathering like a whirlwind of hysteria. At times the strident roar of their paroxysms of laughter could even be heard out in the street, mingled with the choking coughs and the plaintive screams of those who exceeded all bounds and went into such convulsions that one might have thought they would die of laughing, and, with tears rolling down their cheeks, shrieked, Ay, Ay, Ay!...

The song "Ay, Ay, Ay" was being sung at that time, and one heard everywhere the sighs of Argentine tangos which had come from Barcelona by way of traveling salesmen who told tales of the Thousand and One Nights of roulette and baccarat, that had just been legalized in the Catalonian capital. A German painter, Siegfried Burman, who painted exclusively with knives, using enormous daubs of colour, spent the whole period of the war in Cadaqués teaching ladies the steps of the Argentine tango and singing German songs to the accompaniment of the guitar. A rich gentleman giving a flower party had the idea of harnessing to his flower-decked chariot two horses completely covered with confetti. For this he first had the horses coated with hot glue, several men simultaneously pouring pails of it on the animals. Then the horses were made to roll on an immense pile of confetti in which they were completely submerged. In less than an hour the two horses were dead. Ay, ay, ay – Ay, ay, ay!...

Peace burst like a bomb. The armistice had just been signed, and preparations were made for a great celebration. The repercussions of the armistice were almost as joyous in this countryside of Catalonia as in France,

for the country was unanimously Francophile. It had a pleasant, splendid and golden memory of the war, and here was victory, besides, right next door, with all its seductiveness: it was going to make the most of it, right down to the bone. A public demonstration was planned in the streets of Figueras, in which there would be popular and political representatives of all the small towns and villages of the region – flags, posters, meetings, *sardanas*[5] and balls. The students formed an organization of a "progressive" type, which it was decided to name "Grupo Estudiantil,, and which was to adopt a platform and elect a committee charged with organizing the students' participation in the "victory parades" that were being prepared.

The president of the "Grupo Estudiantil" came to me to ask me to make the opening speech. I had one day in which to prepare it.

"You are the only student who can do this," he said, "but be sure to make it powerful, stirring – something in your own line." He shook my hand vigorously.

I agreed, and immediately set myself to preparing my speech, which began something like this: "The great sacrifice of blood which has just been made on the field of battle has awakened the political conscience of all oppressed peoples! etc. etc." I was extremely flattered at having been chosen to make the speech, which I rehearsed melodramatically before the mirror. But as time passed an encroaching and destructive timidity took hold of me, becoming so extreme that I was beginning to think it might get out of control. This was my first public speech, however, and with the legend that had already grown up around me it would be a shame to disappoint my audience at the last moment by a stupid childish timidity! If my "funk" continued I might be able to plead illness, but I could not resign myself to giving up my speech, which swelled in rhetorical splendor and profundity of ideas as my timidity grew more paralyzing. Already it prevented me from delivering my memorized speech, even without witnesses, confusing my memory, mixing up all the words, and blurring the letters of my own handwriting as with a beating heart and flushed cheeks I tried to decipher what I had written, my eyes gaping as though the letters had suddenly become an inexplicable hieroglyph! No! I could not! I could not! There was nothing to be done! And I stamped my foot with rage, burying my face devoured by shame and rancour at myself in the rumpled papers on which I had traced the brilliant path of my first speech with so much eloquence and assurance! No, no, no! I would not be capable of delivering my speech! And I went out to roam through the outskirts of town, to try to recover courage in the contemplation of the communicative serenity of the landscape.

The speech was scheduled for the following day. Before returning home in the late afternoon I mingled with a group of students who were all making fun of the speech I was going to give, and the slight amount of courage which I had recovered in the course of my solitary walk fell back to below zero.

5. A Catalonian popular dance.

The following day I awoke with my heart constricted by a mortal anguish. I could not swallow my coffee-and-milk. I took my speech, which I rolled up and secured with an elastic, combed my hair as best I could, and left for the Republican Centre, where the meeting was to take place.

I walked down the street as though I were going to my execution I arrived on purpose an hour ahead of time, for I thought that by familiarizing myself with the place and the audience as it gradually foregathered, I would perhaps succeed in lessening the brutal shock of finding myself suddenly facing a crowded hall, in which as you appear silence suddenly falls with the sole aim of sucking in, as through a syphon, the speech which you bear within you. But as I reached the Republican Centre my discouragement reached its peak. The grown-up people were terribly intimidating, and there were even girls! As I entered I blushed so violently that everything became blurred before my eyes, and I had to sit down. Someone immediately brought me a glass of water. The people were pouring in in great numbers, and the sound of voices was deafening. A platform had been erected and dressed with the republican flags, and I had to take my place on it. On this platform there were three chairs. The one in the middle was reserved for me; to my right was the chairman, to my left the secretary. We sat down and were received with scattered applause and a few mocking laughs (which remained seared in my flesh like brands). I put my head between my hands as though I were studying my speech, which I had just unfolded with a firmness which I would not have thought myself capable of a moment before. The secretary got up and began a long explanation of the reasons for the meeting. He was being constantly interrupted by the more and more numerous members of the audience who took our meeting as a joke.

My eyes, unable to see a thing, were glued to my speech, and my ears could register only a confused hum amid which the only distinct notes were the clear, cruel and brutal stridences of the sarcasms directed at us. The secretary hurriedly concluded his introduction because of the audience's lack of interest, and gave me the floor, not without alluding to my heroism on the occasion of the burning of the flag. An impressive silence fell over the hall, and I had for the first time the consciousness that the people in the audience were there only to hear me. Then I experienced that pleasure which I have since prized so highly: feeling myself the object of an "integral expectation." Slowly I rose to my feet without having the slightest idea what I was going to do. I tried to remember the beginning of my speech. But unable to do so, I did not open my mouth. The silence around me became even thicker, until it became an asphyxiating embrace: something was going to happen – I knew it! But what? I felt my blood rise to my head and, lifting my am in a gesture of defiance, I shouted at the top of my lungs, "Long live Germany! Long live Russia!" After which, with a violent kick, I flung the table at the audience. Within a few seconds the hail became a scene of wild confusion, but to my surprise nobody paid any further attention to me. The members of the audience were all arguing and fighting among themselves. With sudden self-possession I sipped out and ran home.

"What about your speech?" my father asked.

"It was fine!" I answered.

And it was true. Without my realizing it, my act had led to a result of great political originality and immediacy. Martin Villanova,[6] one of the agitators of the region, undertook to explain my attitude in his own way.

"There are no longer allies or vanquished," he said. "Germany is in revolution, and must be considered on the same basis as the victor. This is especially true of Russia, whose social revolution is the only fruit of this war that offers a real hope."

The kick that had overturned the table was just what was to awaken a public too slow to become alive to historic facts.

The next day I took part in the parade, carrying a German flag which was greeted with applause, and Martin Villanova carried another, bearing the name of the Soviets, the U.S.S.R. These were certainly the first of their kind to be borne in a Spanish Street.

Some time later, Martin Villanova and his group decided to baptize one of the streets of Figueras "President Wilson". Villanova came to my house bringing a long canvas like a ship's sail, and asked me to paint on it in large "artistic" letters the words, "The City of Figueras Honors Woodrow Wilson, Protector of the Liberties of Small Nations". We climbed up on the roof of the house and hung the canvas by its four corners to rings which usually served to hang the laundry. I promised him I would go and buy pots of paint and begin the work that very afternoon so that all would be ready the next day for the unveiling of the marble plaque which would give the new illustrious name to the street.

The following morning I awoke very early, gnawed by a feeling of guilt, for I had not yet begun my work. It was probably already too late for my letters to dry in time, even if I should begin work right away. Then I had an idea. Instead of painting the letters with paint, I would cut them out, so that the motto would be made by the blue of the sky that would show through. With the lack of practical sense which characterized me at this time, I did not realize how difficult this would be and I went down to fetch some scissors. The canvas was so tough that I was not even able to puncture it. I then went and fetched a large kitchen knife. But after many efforts I succeeded only in cutting out a formless hole, which completely discouraged me from pursuing this method further. After all sorts of reflections, I decided on a new technique, even madder and more impracticable – I would burn holes in the canvas following roughly the forms of the letters, after which I would even them out with the scissors, and I would have several pails of water handy in case the canvas should start to burn beyond the edges of the letters. But this was an even more categorical failure than the last effort: the canvas caught fire, and though I managed to put it out there remained

6. Martin Villanova is one of the few revolutionaries of 'good faith" whom I have known in the course of my life. He was immeasurably naïve, but also immeasurably generous and prepared to make any sacrifice.

of all my labors of two hours only a blackish hole and another smaller hole which I had previously pierced with the knife.

I now felt that it was definitely too late to make any further attempt. Discouraged, dead tired, I lay down on the canvas that hung like a hammock. Its swinging seemed very pleasant, and I immediately felt like going to sleep. I was about to doze off, but I suddenly remembered my father's telling me that one could get a sunstroke from going to sleep in the sun. I felt my head benumbed both by the sun and sleepiness, and in order to arouse myself from this state I decided to undress completely, after which I placed one of the buckets just below the burned hole. I had just invented a new fantasy by which, in the most unexpected and innocent manner in the world, I was going to risk an almost certain death! Lying flat on my belly on the great suspended cloth which served as a hammock, I passed my head through the burned hole[7] in such a way as to be able to plunge it into the cool water. But to get my head in and out of the water it was not enough merely to contract my shoulders, for the hole had widened and one of my shoulders was already halfway through. Then my foot found the solution, making my plan extremely easy to execute. For the second hole, the one I had made with the kitchen knife, happened to be just at the level of my foot; I introduced my foot into this hole, and all I had to do to bring my head up was slightly to contract my leg.

I immersed my head several times satisfactorily, deriving an immense voluptuous pleasure from the performance. But during one of these operations there occurred an accident which might well have been fatal. After having held my breath for a long time and wishing to pull my head out of the pail of water I exerted the necessary pressure with my leg. Just then the hole in which my foot was caught tore, and instead of coming out of the water my head sank all the way to the bottom. I found myself suddenly in a critical situation, unable to make an movement, or even to upset the pail in which my head was now thoroughly caught and which immobilized me by its weight. The twisting and squirming of my body only made me swing on the hammock in a futile way, and it is thus that I found myself with no alternative but to wait for death.

It was Martin Villanova who came to my rescue; seeing that I did not appear with my poster, he came to my house, all out of breath, to find out what had happened to me. And what was happening was simply this, that Salvador

7. In my intra-uterine memories I have already told about the games which consisted in making my blood go to my head by hanging and swinging it, which eventually provoked certain retinal illusions similar to phosphenes. This new fantasy which occurred just at the end of the war must be related to the same kind of intra-uterine fantasy. Not only the fact that I had my head down, but also that I passed it through a hole, as well as everything that follows, are exemplary in this regard. The 'frustrated acts", the "unsuccessful holes", made with great expenditure of effort and means, clearly revealed the principle of displeasure provoked by real mechanical obstacles. Also the fear of the external world incarnated in the people participating in the celebration were looking forward to seeing my poster, which I knew could not be finished in time, provoked in me the need to seek refuge in the prenatal world of sleep. But the fear of death assailed me, unconsciously evoking for me the traumatism of birth by the agreeable symbolism of the hanging parachute simulacrum of my counter-submarine!

Dalí was in the act of dying of asphyxiation on the heights, on those same dangerous heights on the roof of the house where as a child-king he had experienced for the first time the sensation of vertigo. It took me some time to recover after I had been delivered from the pail. Martin Villanova looked at me, stupefied.

"What in the world were you doing here, stark naked, with your head inside the bucket – you might have drowned! And the mayor has already arrived, and the whole crowd is there, we've been waiting for more than half an hour for you to arrive! Tell me what you were doing here."

I have always had an answer for everything, and this time I also had one. "I was inventing the counter-submarine[8]," I said.

Martin Villanova was never able to forget this scene, and he told it that very evening on the *rambla*. "What do you think of Dalí, isn't he great! While we were waiting with all the notabilities and the band was there, and everything, there he was stark naked on the roof inventing the 'counter-submarine', with his head plunged into a bucket of water. If by some misfortune I had not arrived in time, he would be good and dead right now! Isn't he great! Isn't Dalí great!"

The following evening they were playing *sardanas* on President Wilson Street, and the poster, which I had finally succeeded in painting his honor, floated across the street, fastened to two balconies. Two sinister, torn holes could be seen in the canvas, and it was only Martin Villanova and I who knew that one of them corresponded to Salvador Dalí's neck and the other to his foot. But Salvador Dalí was there, alive, quite alive! And we shall still hear many strange things of him. But patience! We must proceed methodically.

Thus, let us summarize Dalí's situation at the outset of this decisive post-war period: Dalí, thrown out of school, is to continue his baccalaureate studies at the institute; martyrized by the anguishing grasshoppers, running away from girls, always imbued with the chimerical love of Galuchka, he has not yet experienced "it"; he has grown pubic hair; he is an anarchist, a monarchist, and an anti-Catalonian; he has been under criminal indictment for a supposed anti-patriotic sacrilege; at a pro-Ally meeting he has shouted, "Long live Germany! Long live Russia!", kicking over the table at the audience; finally he has been within a hair's breadth of meeting death in the invention of the counter-submarine! How great he is! Look how great Salvador Dalí is!

8. Narciso Monturiol is the inventor of the first submarine that ever navigated under water. An illustrious son of Figueras, he has his monument in the town and for as long as I can remember I have felt a strong jealousy toward him, for my ambition was to make a great invention of this kind, too.

CHAPTER SEVEN
1918-1921

I was growing. On Señor Pitchot's property, at Cadaqués, there was a cypress planted in the middle of the courtyard; it too was growing. I now wore sideburns that reached below the middle of my cheek. I liked dark suits, preferably of very soft black velvet, and on my walks I would smoke a meerschaum pipe of my father's on which was carved the head of a grinning Arab showing all his teeth. On my father's excursion to the Greek ruins of Ampurias the curator of the museum made him a present of a silver coin with the profile of a Greek woman. I liked to imagine that she was Helen of Troy. I had it mounted into a tie-pin which I always wore, just as I always carried a cane. I have had several famous canes, but the most beautiful one had a gold handle in the shape of two-headed eagle – an imperial symbol whose morphology adapted itself in a happy way to the possessive grip of my ever-dissatisfied hand.

I was growing, and so was my hand. "It" finally happened to me evening in the outhouse of the institute; I was disappointed, and a violent guilt-feeling immediately followed. I had thought "it" was something else! But in spite of my disappointment, overshadowed by the delights of remorse, I always went back to doing "it", saying to myself, this is the last, last, last time! After three days the temptation to do "it" once more took hold of me again, and I could never struggle more than one day and one night against my desire to do it and I did "it", "it", "it" again all the time.

"It" was not everything... I was learning to draw, and I put into this other activity the maximum of my effort, of my attention and of my fervor. Guilt at having done "it" augmented the unflagging rigour of my work on my drawings. Every evening I went to the official drawing school. Señor Nuñez was a very good draftsman and a particularly good engraver. He had received the Prix de Rome for engraving; he was truly devoured by an authentic passion for the Fine Arts. From the beginning he singled me out among the hundred students in the class, and invited me to his house, where he would explain to me the mysteries of chiaroscuro and of the "savage strokes" (this was his expression) of an original engraving by Rembrandt which he owned; he had a very special manner of holding this engraving, almost without touching it, which showed the profound veneration with which it inspired him. I would always come away from Señor Nuñez' home stimulated to the highest degree, my cheeks flushed with the greatest artistic ambitions. Imbued with a growing and almost religious respect for Art, I would come home with my head full of Rembrandt, go and shut myself up in the toilet and do "it". "It" became better and better, and I was beginning to find a psychic technique of retardation which enabled me to do "it" at less

frequent intervals. For now I no longer said, "This is the last time". I knew by experience that it was no longer possible for me to stop. What I would do was to promise myself to do "it" on Sunday, and then "occasionally on Sunday". The idea that this pleasure was in store for me calmed my erotic yearnings and anxieties, and I reached the point of finding a real voluptuous pleasure in the fact of waiting before doing it. Now that I no longer denied it to myself in the same categorical way, and knew that the longer I waited the better "it" would be when it came, I could look forward to this moment with more and more agreeable and welcome vertigos and agonies.

My studies at the institute continued to progress in a mediocre way, and everyone advised my father to let me become a painter, especially Señor Nuñez, who had complete faith in my artistic talent; my father refused to make a decision – my artistic future frightened him, and he would have preferred anything to that. Nevertheless he did everything to complete my artistic education, buying me books, all kinds of reviews, all the documents, all the tools I needed, and even things that constituted only a pure and fugitive caprice. My father kept repeating, "When he has passed his baccalaureate we shall see!"

As for myself, I had already made up my mind. I turned to silence, and began to read with real frenzy and without order of any kind. At the end of two years there was not a single book left for me to read in my father's voluminous library. The work which had the greatest effect on me was Voltaire's *Philosophical Dictionary*. Nietzsche's *Thus Spake Zarathustra*, on the other hand, gave me at all times the feeling that I could do better in this vein myself. But my favourite reading was Kant. I understood almost nothing of what I read, and this in itself filled me with pride and satisfaction. I adored to lose myself in the labyrinth of reasonings which resounded in the forming crystals of my young intelligence like authentic celestial music. I felt that a man like Kant, who wrote such important and useless books, must be a real angel! My eagerness to read what I did not understand, stronger than my will, must have obeyed a violent necessity for the spiritual nourishment of my soul, and just as a calcium deficiency in certain weakened organisms of children causes them blindly and irresistibly to break off and eat the lime and plaster on walls, so my spirit must have needed that categorical imperative, which I chewed and rechewed for two consecutive years without succeeding in swallowing it. But one day I did swallow it. In a short time I actually made unbelievable progress in understanding the great philosophical problems. From Kant I passed on to Spinoza, for whose way of thinking I nourished a real passion at this time. Descartes came considerably later, and him I used to build the methodical and logical foundations of my own later original researches. I had begun to read the philosophers almost as a joke, and I ended by weeping over them. I who have never wept over a novel or over a play, no matter how dramatic or heart-rending, wept on reading a definition of "identity" by one of these philosophers, I don't remember which. And even today, when I am interested in philosophy only incidentally, each time I find

myself in the presence of an example of man's speculative intelligence, I feel tears irresistibly spring to my eyes.

One of the younger professors at the institute had organized a supplementary course in philosophy, which was completely outside the curriculum, and which met in the evening, from seven to eight. I immediately enrolled in this course, which was to be devoted specially to Plato. It was spring, late spring, when these sessions began, and the night air was balmy. We brought our chairs out-of-doors and sat around a well overgrown with ivy, with a bright moon shining overhead. There were several girls among us whom I did not know and whom I found very beautiful. Immediately I chose one of them with a single glance – she had just done the same with me. This was so apparent to both of us that we both stood up almost at the same moment, our attitudes exactly expressing,

"Let's leave! Let's leave!" And we left. When we got outside the institute our emotion was so great that neither one of us could utter a word. So we began to run, holding each other by the hand. The institute was situated near the outskirts of town, and we had only to climb a few blocks of poor unlighted streets to be right out in the country; with one mind we turned our steps toward the most solitary spot, a little road between two fields of wheat that already grew very high. It was completely deserted and auspicious at this hour...

The girl looked into my eyes with a fiery and provocative sweetness; she would laugh from time to time and start off again at a run. But if I had been at a loss for words to begin with, I was even more so now. I thought I should never be able to utter a word again. I tried, and nothing came. I attributed this phenomenon now more to my paroxysmal fatigue than to my emotional state. She was trembling with every breath, which made her doubly, triply desirable to me. Pointing with my finger to a slight hollow in the field of wheat, I said with a supreme effort, "There!" She ran to the spot and when she reached it lay down, disappearing completely in the wheat. I arrived there in turn; there the girl lay, stretched out full length, appearing much taller than she had before. I saw then that she was very blonde, and had extremely beautiful breasts which I felt wriggling under her blouse like fish caught in my hands. We kissed each other on the mouth for a long time. At times she would half open her mouth, and I would press my lips against her teeth, kissing them till it hurt me.

She had a severe cold and she held a little handkerchief in her hand, with which she vainly tried to blow her nose, as the handkerchief was already completely soaked. I had no handkerchief of my own to offer her, and I did not know what to do... She was constantly sniffing up her mucus, but it was so copious that it would immediately reappear. Finally she turned her head away in shame and blew her nose with the edge of her skirt. I hastened to kiss her again, to prove to her that I was not disgusted by her mucus, which was indeed the case, for it was so fluid, colourless and runny that it rather resembled tears. Moreover, her bosom was continually quivering with her breathing which gave me the illusion that she was weeping. Then I looked at her hard. "I don't love

you!" I said. "And I shall never love any woman. I shall always live alone!" And as I spoke I could feel the skin on my cheek contract with the beautiful girl's drying mucus. A complete calm possessed my mind, and again I was working out my plans in the minutest detail. with such calculating coldness that I felt my own soul grow chill.

How had I been able in such a short time to become master of myself again? The girl, on the other hand, felt more and more embarrassed. Obviously her cold had a good deal to do with this. I held her enveloped in my two arms, which had suddenly become sure of their movements, keeping her enfolded in a strictly friendly pose. I suddenly felt the contractions of the dry mucus on my cheek pricking me in an irresistible way. But instead of scratching myself with one of my hands, I lowered my head and pretended to caress my mistress's shoulder with concentrated tenderness, my nose happening to strike just the level of the fold of her armpit. She had perspired profusely during our running about, and I was thus calmly able to breathe in a sublime fragrance compounded of heliotrope, and lamb, to which a few burnt coffee-beans might have been added. I raised my head. She looked at me, bitterly disenchanted, and with a vexed, contemptuous smile, said,

"Then you won't want to come back again tomorrow evening?"

"Tomorrow evening, yes," I answered, ceremoniously helping her up, "and for another five years, but not a day longer!" I had my plan – it was my five-year plan!

And so she was my mistress for five years, not counting the summers, which I spent in Cadaqués. During this time she remained faithful to me to the point of mysticism. I never saw her except at different times during the twilight hours; on the days when I wished to remain alone I communicated this fact to her by a little note which I sent her by a street urchin. Otherwise we would meet in the open countryside as if by chance. In order to do this she had to resort to a thousand ruses, even to bringing some of her girl friends along, who in turn were sometimes accompanied by boys. But I disliked this, and on most of our walks we were alone.

It was in the course of this five-year romance that I put into play all the resources of my sentimental perversity. I had succeeded in creating in her such a need of me, I had so cynically graduated the frequency of our meetings, the kinds of subjects I would talk about, the sensational lies about supposed inventions, which I had not made at all, and which for the most part were improvised on the spur of the moment, that I could see the sway of my influence growing day by day. It was a methodical, encircling, annihilating, mortal fascination. A time came when I considered my girl "ripe", and I began to demand that she perform acts, sacrifices for me – had she not often told me she was ready to give her life, to die for me? Well, then! I would see about that! We still had – how much time? Four years? I have to mention – in order that the ever-growing passion which I unleashed in this woman's soul may be better understood and not solely attributed to my gifts as a Don Juan – that nothing more occurred between us

two, in an erotic way, than has been described on the first day: we kissed each other on the mouth, we looked into each other's eyes, I caressed her breasts, and that was all. I think also that the sense of inferiority which she felt the day we met, because of her cold and her lack of a dry handkerchief, created in her mind such a dissatisfaction, such a violent continued desire to rehabilitate herself in my eyes, that in the sequel of our relationship, never being able to obtain more from me in the way of passion than what I had shown her on that occasion – rather less on the contrary (for the simulation of coldness was one of the most hallucinatory themes of sentimental mythology. Tristan undoubtedly contributed to maintaining that state of growing amorous tension which, far from suffering the decline that goes with satiated sentiments, each day grew with alarming, dangerous and unhealthy wishes, more and more sublimated, more and more unreal, and at the same time more and more vulnerable to the terribly material crises of crime, suicide, or nervous collapse.

Unconsummated love has appeared to me since this experience to be one of my most formidable weapons) – her own constantly prodding love and Isolde are the prototypes of one of those tragedies of unconsummated love which in the realm of the sentiments are as ferociously cannibalistic as that of the praying mantis actually devouring its male on their wedding day, during the very act of love. But the keystone of this cupola of moral torture which I was building to protect the unconsummated love of my mistress was without doubt the fully shared realization that I did not love her. Indeed I knew and she knew that I did not love her; I knew that she knew I did not love her; she knew that I knew that she knew that I did not love her. Not loving her, I kept my solitude intact, being free to exercise my "principles of sentimental action" on a very beautiful creature, hence on an eminently aesthetic and experimental form. I knew that to love, as I should have adored my Galuchka, my Dullita Rediviva, was something altogether different, calling for the annihilation of the ego in an omnipotent confusion of all sentiments, in which all conscious discrimination, all methodical choice of action perpetually threatened to break down, in the most paradoxically unforeseeable fashion. Here, on the contrary, my mistress became the constant target of my trials of skill, which I knew were going to "serve" me later. I was quite aware that love is receiving the arrow, not shooting it; and I tried out upon her flesh that Saint Sebastian whom I bore in a latent state in my own skin, which I should have liked to shuffle off as a serpent does. Knowing that I did not love her, I could continue at the same time to adore my Dullitas, my Galuchkas, and my Redivivas with a love more idealized, absolute and pre-Raphaelitic, since now I had a mistress of flesh and blood, with breasts and saliva, whom I cretinized with love for me, whom I pressed violently against my flesh, not loving her. Knowing that I did not love her I would not have with her, either, that always unsatisfied yearning to mount to the summit of a tower! She was earthy, real, and the more her thirsty desire devoured her flesh. and the more sickly she looked – the less she appeared to me to be fit to mount my tower; I wold have liked her to croak!

I would sometimes say to her, as we lay somewhere out in the fields, "Make believe you are dead." And she would cross her two hands on her chest and stop breathing. Her two little nostrils became so motionless, she would stop breathing so long that sometimes, becoming frantic, I would pat her cheeks, believing her to be really inanimate. She derived an unmistakable pleasure from her growing pallor, which I guided with bridles of delicate anguish like an exhausted moon-white horse with a dishevelled mane.

"Now we'll run together without stopping, as far as to the cypress tree." She was afraid of my anger and would obey me, dropping at the foot of the cypress at the end of the race, almost fainting with fatigue. "You want me to die," she would often say, knowing that I liked her to say this, and that I would reward her by kissing her on the mouth.

Summer came, and I left for Cadaqués. Señor Pitchot announced that the cypress planted in the centre of the patio had grown another two feet. I made a very detailed drawing of this cypress from life. I had observed its seed balls and been struck by their resemblance to skulls, especially because of the jagged sutures between the two parietal bones.

The letters that I received from my mistress were more exalted in tone than ever, and I answered her only rarely, always with a barb of venom which I knew could not fail to poison her and make her yellow as wax.

At the end of the summer it rained for a whole day. We were one of the last families to leave, and on the last day I went for a walk around the property of the Pitchots, which was already deserted. I picked up my jacket which had been left out in the rain and was soaked; exploring the pockets, I pulled out a sheaf of letters from my mistress, which I used to keep and take with me on my walks. They were all drenched, and the bright blue handwriting on them was almost effaced. I sat down before my cypress, thinking of her. Mechanically I began to squeeze and compress the letters between my hands, so that they became like paste, and soon I made a kind of ball by rolling together several wads of these wet papers. I suddenly realized that in doing so I was involuntarily imitating the cypress balls, for mine was exactly the same size, and similarly made up of several sections joined by lines like the sutures between the parietal bones. I went over to the cypress and replaced one of its balls by the white conglomerate ball of my letters, and with the rest of these I made a second ball which I placed symmetrically in relation to the first. After which I continued on my walk, becoming absorbed in meditation upon the most varied subjects. I remained seated for more than an hour on the extreme point of a rock so close to the breaking waves that when I left my face and hair were all wet; the taste of sea salt which was on my lips evoked in my mind the myth of incorruptibility, of immortality, so obsessing to me at the time. Night had come, and I no longer saw where I was walking. Suddenly I shuddered and put my hand on my heart, where I felt a twinge as though something had just bitten it – in passing I had been startled by the two motionless white balls which I had left in the cypress tree and which loomed out of the dark as I came almost close enough to touch

them. A lightning presentiment flashed through my mind: is she dead? I broke into a cold sweat, which did not leave me till I got to the house where a letter from my mistress awaited me, which she concluded by saying, "I am getting fatter, and everyone thinks I look very well. But I am only interested in what you will think of me when you see me again. A thousand kisses, and again, I could never forget you, etc. etc.".... The idiot!

I was preparing myself. My father was beginning to yield, and I knew that after my six years of the baccalaureate I was going to be a painter! This would not be before three more years, but there was already talk of the School of Fine Arts of Madrid, and perhaps, if I won prizes, I would go and complete my studies in Rome. The thought of attending "official courses" again, even if these were courses in painting, deeply revolted me at first, for I should have liked to be given full freedom of action, without anyone's being able to interfere with what went on inside my head. I was already planning a desperate struggle, a struggle to the death, with my professors. What I intended to do had to happen "without witnesses". Besides, the sole present witness of my artistic inventions, Señor Nuñez, no longer had any peace with me. Each day I flabbergasted him, and each day he had to acknowledge that I was right.

I was making my first technical discoveries, and they all had the same origin: I would start out by doing exactly the contrary of what my professor told me. Once we were drawing an old man, a beggar, who had a beard of very curly, fine hair – almost like down, and absolutely white. After looking at my drawing Señor Nuñez told me that it was too much worked over with pencil strokes to make it possible to get the effect of that very delicate white down; I must do two things – begin again with an absolutely clean sheet of paper, and respect its "whiteness", which I could then utilize; and also, in order to get the effect of the extremely fine down of his hair I would have to use a very soft pencil, and make strokes that would barely brush the paper. When my professor had left, I naturally began to do the opposite of what he had just advised, and continued to work away with my pencil with extreme violence, using the blackest and heaviest pencils. I put such passion into my work that all the pupils gathered around to watch me work. I was eventually able, by the cleverness of my contrasts, to create an illusion suggestive of the model. But still dissatisfied, I continued to blacken my drawing still more, and soon it was but an incoherent mass of blackish smudges which became more and more homogeneous, and finally covered the whole paper with a uniform dark tone.

The next day when the professor came and stood in front of my work he uttered a cry of despair.

"You've done just the opposite of what I told you to do, arid this is the result!"

To which I answered that I was on the verge of solving the problem. And, taking out a bottle of India-ink and a brush, I began to daub my drawing with pitch black precisely where the model was whitest. My professor, thinking

he understood, exclaimed,

"Your idea is to make the negative!"

"My idea," I answered, "is to paint exactly what I see!"

The professor went off again, shaking his head, saying, "If you think you can finish it with chalk you're mistaken, because your India-ink won't take chalk!"

Left to myself I took out a little pen knife and began to scratch my paper with a special stroke, and immediately I saw appear the most dazzling whites that one can obtain in a drawing. In other parts of the drawing where I wanted my whites to emerge more subdued, I would spit directly on the given spot and my rubbing then produced peelings that were more greyish and dirty. The beard of the old beggar who sat as the model emerged from the shadows of my drawing with a paralyzing realism. Soon I mastered the operation of bringing out the pulp of the paper in such a way as really to look like a kind of down, which was made by scratching the paper itself,[1] and I almost went to the length of pulling out the fibres of the paper with my fingernails, and curling them to boot. It was, so to speak, the direct imitation of the old man's beard. My work completed, I lighted my drawing with a slanting light, placed close to the edge of the paper. When Señor Nuñez came to see it he could say nothing, so greatly did his perplexity overflow the habitual frame of his admiration. He came over to me, pressed me hard against his chest with his two robust arms in an embrace which I thought would choke me, and repeated approximately what Martin Villanova had said (on the occasion of my invention of the counter-submarine), "Look at our Dalí – isn't he great!" Deeply moved, he patted me on the shoulder. This experiment of scratching the paper with my pen knife made me ponder a great deal upon the peculiarities of light and its possibilities of imitation. My researches in this field lasted a whole year, and I came to the conclusion that only the relief of the colour itself, deliberately piled on the canvas, could produce luminous effects satisfying to the eye.

This was the period which my parents and myself baptized "The Stone Period". I used stones, in fact, to paint with. When I wanted to obtain a very luminous cloud or an intense brilliance, I would put a small stone on the canvas, which I would thereupon cover with paint. One of the most successful paintings of this kind was a large sunset with scarlet clouds. The sky was filled with stones of every dimension, some of them as large as an apple! This painting was hung for a time in my parents dining room, and I remember that during the peaceful family gatherings after the evening meal we would sometimes be startled by the sound of something dropping on the mosaic. My mother would stop sewing for a

1. Later, in studying the water-colours of Mariano Fortuni, the inventor of "Spanish colourism" and one of the most skillful beings in the world, I realized that he utilizes similar scratchings to obtain his most luminous whites, taking advantage like myself of the relief and irregularity of the whites in question to catch the light in the tiny particles of the surface and thus heighten the effect of stupefying luminousness.

moment and listen, but my father would always reassure her with the words, "It's nothing – it's just another stone that's dropped from our child's sky!" Being too heavy and the coat of paint too thin to keep them attached to the canvas, which eventually would crack, these stones which served as kernels to large pieces of clouds illuminated by the setting sun would come tumbling down on the tiled floor with a loud noise. With a worried look, my father would add, "The ideas are good, but who would ever buy a painting which would eventually disappear while their house got cluttered up with stones?"

In the town of Figueras my pictorial researches were a source of constant amusement. The word would go round that "now Dalí's son is putting stones in his pictures!". Nevertheless, at the height of the stone period, I was asked to lend some of my paintings for an exhibition that was to take place in the hall of a musical society. There were represented about thirty local and regional artists, some of them from as far away as Gerona and even Barcelona. My works were among the most noticed, and the two intellectuals of the town who carried the most weight, Carlos Costa and Puig Pujades, declared that without the slightest doubt a brilliant artist's career lay before me.

This first consecration of my glory produced a powerful impression on my mistress's amorous imagination, and I took desperate advantage of this to enslave her to me more and more. Above all I did not want her to have any friends, whether girls or boys, children or grown-ups. She had to remain always alone, like myself, and when I wanted to she could see me – me, the only one who had intelligence, who understood everything differently from others, and whom the very newspapers were surrounding with clouds of glory. As soon as I learned that she had made a new acquaintance, or if she spoke to me of someone in a sympathetic way, I immediately tried to deprecate, ruin and annihilate this person in her mind, and I always succeeded. I invariably found just the right observation, the prosaic simile that defined the person with such realism that she could no longer see him in any other manner than the one which I dictated to her. I exacted the subservience of her sentiments in a literal way, and every infraction of my pitiless sentimental inquisition had to be punished by her bitter tears. A contemptuous tone directed at her, slipped as if unintentionally into a casual conversation, was enough to make her feel as though she were dying. She no longer expected me to be able to love her, but she clutched at my esteem like a drowning woman. Her whole life was concentrated into the half-hour of our walk which I granted her more and more rarely, for this was all going to end! The temple of the Academy of Fine Arts of Madrid already loomed before me, with all its stairways, all its columns and all its pediments of glory. I would say to my mistress, "Profit while you may; you still have another year." She spent her life making herself beautiful for our half hour. She had overcome her sickliness, and she now possessed a violent health which only her tears could make acceptable to me.

I would carry with me on my walks numbers of *"L'Esprit Nouveau"*

(The New Spirit) which I received; she would humbly bow her forehead in an attentive attitude over the cubist paintings. At this period I had a passion for what I called Juan Gris' "Categorical imperative of mysticism". I remember often speaking to my mistress in enigmatic pronouncements, such as, "Glory is a shiny, pointed, cutting thing, like an open pair of scissors". She would drink in all my words without under standing them, trying to remember them... "What were you saying yesterday about open scissors?"

On our walks we would often see the mass of the Muli de la Torre rising from the dark greenery in the distance. I liked then to sit down to look at it. "You see that white smudge over there? That's just where Dullita sat." She would look without seeing what I was pointing at. I would hold one of her breasts in my hand. Since the first time I had met her her breasts had gradually hardened, and now they were like stone. "Show them to me," I said. She undid her blouse and showed them to me. They were incomparably beautiful and white; their tips looked exactly like raspberries; like them they had a few infinitely fine and minute hairs. She was about to button up her blouse again, but I commanded, with a trace of emotion in my voice, "No. Stay the way you are!" She let her hands fall along her body, inclined her head slightly to one side, and lowered her eyes. A violent breathing shook her bosom. Finally I said, "Come on." She buttoned up her blouse again and got up, smiling feebly. I took her tenderly by the hand and began the walk home. "You know," I said, "when I go to Madrid I won't ever write to you again."

And I walked on another ten steps. I knew that this was exactly the length of time it would take for her to start crying. I was not mistaken. I then kissed her passionately, feeling my cheek burn with her boiling tears, big as hazel-nuts. In the center of my brain glory shone like a pair of open scissors! Work, work, Salvador; for if you were endowed for cruelty, you were also endowed for work.

This capacity for work always inspired everyone with respect, whether I fastened stones to my canvases or worked minutely at my painting for hours on end, or spent my day taking notes to try to untangle a complicated philosophic text. The fact is that from the time I arose, at seven in the morning, my brain did not rest for a single moment in the course of the entire day. Even my idyllic walks I considered a laborious and exacting labor of seduction. My parents would always remark, "He never stops for a second! He never has a good time!" And they would admonish me, "You're young, you must make the most of your age!" I, however, was always thinking, "Hurry up and grow old you are horribly 'green', horribly 'bitter'." How, before I reached maturity, could I rid myself of that dreamy and puerile infirmity of adolescence? I was supremely conscious of one thing – I had to go through cubism in order to get it out of my system once and for all, and during this time perhaps I could at least learn to draw!

But this could not appease my avid desire to do everything. I still had to invent and write a great philosophic work, which I had begun a year before, and which was called, "The Tower of Babel". I had already written five hundred

pages of it, and I was still only on the Prologue! At this period my sexual anxiety disappeared almost completely, and the philosophic theories of my book took up all the room in my psychic activity. The bases of my "Tower of Babel" began with the exposition of the phenomenon of death which was to be found, according to my view, at the inception of every imaginative construction. My theory was anthropomorphic, for I always considered that I was not so much alive as in the process of resuscitating from the "amorphous unintelligence" of my origins and, moreover, I considered a premature old age as the price I would pay for a promise of immortality. That which at the base of the tower was "comprehensible life" for everyone was for me only death and chaos; on the other hand everything on the summit of the tower that was confusion and chaos for everyone else was for me, the Anti-Faust, the supreme thaumaturge, only "logos" and resurrection. My life was a constant and furious affirmation of my growing and imperialistic personality, each hour was a new victory of the "ego" over death. On the other hand, I observed around me only continual compromises with this death. Not for me! With death I would never compromise.

My mother's death supervened, and this was the greatest blow I had experienced in my life. I worshipped her; her image appeared to me unique. I knew that the moral values of her saintly soul were high above all that is human, and I could not resign myself to the loss of a being on whom I counted to make invisible the unavowable blemishes of my soul – she was so good that I thought that "it would do for me too". She adored me with a love so whole and so proud that she could not be wrong – my wickedness, too, must be something marvelous! My mother's death struck me as an affront of destiny – a thing like that could not happen to me – either to her or to me! In the middle of my chest I felt the thousand-year-old cedar of Lebanon of vengeance reach out its gigantic branches. With my teeth clenched with weeping, I swore to myself that I would snatch my mother from death and destiny with the swords of light that some day would savagely gleam around my glorious name!

CHAPTER EIGHT
1921-1924

The profusion of articles that were beginning to flood the house made my father decide to start a large notebook in which he would collect and paste everything that he had and everything that appeared about me. He wrote a preface to this collection for the benefit of posterity, of which the following is a complete and faithful translation:

Salvador Dalí y Domenech, Apprentice Painter

After twenty-one years of cares, anxieties and great efforts I am at last able to see my son almost in a position to face life's necessities and to provide for himself. A father's duties are not so easy as is sometimes believed. He is constantly called upon to make certain concessions, and there are moments when these concessions and compromises sweep away almost entirely the plans he has formed and the illusions he has nourished. We, his parents, did not wish our son to dedicate himself to art, a calling for which he seems to have shown great aptitude since his childhood.

I continue to believe that art should not be a means of earning a livelihood, that it should be solely a relaxation for the spirit to which one may devote oneself when the leisure moments of one's manner of life allow one to do so. Moreover we, his parents, were convinced of the difficulty of his reaching the preeminent place in art which is achieved only by true heroes conquering all obstacles and reverses. We knew the bitterness, the sorrows and the despair of those who fail. And it was for these reasons that we did all we could to urge our son to exercise a liberal, scientific or even literary profession. At the moment when our son finished his baccalaureate studies, we were already convinced of the futility of turning him to any other profession than that of a painter, the only one which he has genuinely and steadfastly felt to be his vocation. I do not believe that I have the right to oppose such a decided vocation, especially as it was necessary to take into consideration that my boy would have wasted his time in any other discipline or study, because of the "intellectual laziness" from which he suffered as soon as he was drawn out of the circle of his predilections.

When this point was reached, I proposed to my son a compromise: that he should attend the school of painting, sculpture and engraving in Madrid, that he should take all the courses that would be necessary for him to obtain the official title of professor of art, and that once he had completed his studies he should take the competitive examination in order to be able to use his title of professor in an official pedagogical center, thus securing an income that would provide him with all the indispensable necessities of life and at the same time

permit him to devote himself to art as much as he liked during the free hours which his teaching duties left him. In this way I would have the assurance that he would never lack the means of subsistence, while at the same time the door that would enable him to exercise his artist's gifts would not be closed to him. On the contrary, he would be able to do this without risking the economic disaster which makes the life of the unsuccessful man even more bitter.

This is the point we have now reached! *I* have kept my word, making assurance for my son that he shall not lack anything that might be needed for his artistic and professional education. The effort which this has implied for me is very great, if it is considered that I do not possess a personal fortune, either great or small, and that I have to meet all obligations with the sole honorable and honest gain of my profession, which is that of a notary, and that this gain, like that of all notaryships in Figueras, is a modest one. For the moment my son continues to perform his duties in school, meeting a few obstacles for which I hold the pupil less responsible than the detestable disorganization of our centers of culture. But the official progress of his work is good. My son has already finished two complete courses and won two prizes, one in the history of art and the other in "general apprenticeship in colour painting". I say his "official work", for the boy might do better than he does as a "student of the school", but the passion which he feels for painting distracts him from his official studies more than it should. He spends most of his hours in painting pictures on his own which he sends to expositions after careful selection. The success he has won by his paintings is much greater than I myself could ever have believed possible. But, as I have already mentioned, I should prefer such success to come later, after he had finished his studies and found a position as a professor. For then there would no longer be any danger that my son's promise would not be fulfilled.

In spite of all that I have said, I should not be telling the truth if I were to deny that my son's present successes please me, for if it should happen that my son would not be able to win an appointment to a professorship, I am told that the artistic orientation he is following is not completely erroneous, and that however badly all this should turn out, whatever else he might take up would definitely be an even greater disaster, since my son has a gift for painting, and only for painting.

This notebook contains the collection of all I have seen published in the press about my son's works during the time of his apprenticeship as a painter. It also contains other documents relating to incidents that have occurred in the school, and to his imprisonment, which might have an interest as enabling one to judge my son as a citizen, that is to say, as a man. I am collecting, and shall continue to collect, everything that mentions him, whether it be good or bad, as long as I have knowledge of it. From the reading of all the contents something may be learned of my son's value as an artist and a citizen. Let him who has the patience to read everything judge him with impartiality.

Figueras, December 31, 1925. Salvador Dalí, Notary.

I left for Madrid with my father and my sister. To be admitted to the School of Fine Arts it was necessary to pass an examination which consisted of making a drawing from the antique. My model was a cast of the Bacchus by Jacopo Sansovino, which had to be completed in six days. My work was following its normal and satisfactory course when, on the third day, the janitor (who would often chat with my father while the latter waited impatiently in the court for me to get out of school) revealed his fear that I would not pass the examination.

"I am not discussing the merits of your son's drawing," he said, "but he has not observed the examination rules. In these rules it is clearly stated that the drawing must have the exact measurements of an Ingres sheet of paper, and your son is the only one who has made the figure so small that the surrounding space cannot be considered as margins!"

My father was beside himself from that moment. He did not know what to advise me – whether to start the drawing over again or to finish it as best I could in its present dimensions. The problem troubled him all during our afternoon walk. At the theatre that evening, in the middle of the picture, he made everyone turn round by suddenly exclaiming, "Do you feel you have the courage to start it all over again?" and, after a long silence, "You have three days left!" I derived a certain pleasure from tormenting him on this subject; but I myself was beginning to feel the contagion of his anguish, and I saw that the question was actually becoming serious.

"Sleep well," he advised me before I went to bed, "and don't think about this; tomorrow you must be at your best, and you will decide at the last moment." The next day, filled with great courage and decision, I completely rubbed out my drawing without a moment's hesitation. But no sooner had I completed this operation than I remained paralyzed by fear at what I had just done. I looked, flabbergasted, at my paper which was all white again, while my fellow-competitors all around me, on their fourth day of work, were already beginning to touch up their shadows. The following day all of them would be almost through; and then they would have plenty of time left to check on final corrections, which always require calm and reflection. I looked at the clock with anguish. It had already taken me half an hour just to erase. I thus anxiously began my new figure, trying this time to take measurements so that it would have the dimensions which the regulations required. But so clumsily did I go about these preliminary operations, which any other student would have executed mechanically at a single stroke, that at the end of the session I had once more to rub out the whole thing. When the class was over my father instantly read in the pallor of my face that things were not going well.

"What did you do?"

"I erased it."

"But how is the new one going?"

"I haven't begun it. All I did was to erase and take measurements. I want to be sure this time!"

My father said, "You're right – but two hours to take measurement!

Now you have only two days left. I should have advised you not to erase your first drawing."

Neither my father nor I could eat that evening. He kept saying me, "Eat! Eat! If you don't eat, you won't be able to do anything tomorrow." We fretted the whole time, and my sister, too, looked shaken. My father confessed to me later that he spent the whole night without being able to sleep for one second, assailed by insoluble doubts – I should have erased it, I should not have erased it!

The next day arrived. Sansovino's *Bacchus* was marked and impregnated so deeply in my memory that I threw myself into the work like a starving wolf. But this time I made it too large. There was nothing to be done – it was impossible to cheat! His feet extended entirely beyond the paper. This was worse than anything, a much worse fault than to have left immense margins. Again I erased it completely.

When I got out of class my father was livid with impatience. With an unconvincing smile and trying to encourage me he said, 'Well?"

"Too big," I answered.

"And what do you intend to do?"

"I've already erased it." I saw a tear gleam in my father's eyes.

"Come, come, you still have tomorrow's session. How many times before this you've made a drawing in a single session!"

But I knew that in two hours this was humanly impossible, for it would take at least one day to sketch it out, and another to make the shadows. Besides, my father was saying this only to encourage me. He knew as well as I that I had failed in the examination and that the day after the next we would have to return to Figueras covered with shame – I who was the best of them all back there – and this after the absolute assurances that Señor Nuñez had given him that I could not possibly fail to pass my examinations, even if by chance my drawing should be the poorest that I was capable of making.

"If you don't pass the examinations," he said, trying to continue to console me, "it will be my fault and the fault of that imbecilic janitor. If your drawing was good, which it seemed to be, what would it have mattered whether it was a little smaller or larger?"

Then I whetted my maliciousness and answered, "It's as I've been telling you. If a thing is well drawn, it forces itself upon the professors' esteem!"

My father meditatively rolled one of the strands of white hair that grew on each side of his venerable skull, bitten to the quick by remorse.

"But you yourself told me," he said "that it was very, very small."

"Never," I answered. "I said it was small, but not very *very* small!"

"I thought you had told me it was very very small," he insisted. "Then perhaps it would have passed, if it wasn't small-small! Tell me exactly how it was, so that I can at least form an opinion."

Then I began one of the most refined tortures. "Now that we have spoken so much about it, I can't exactly remember its dimensions; it was average,

rather small, but not exaggeratedly small."

"But try to remember. Look, was it about like this?" showing me a dimension with his thumb and his fork.

"With the twisted form of the fork," I said, "I can't tell."

Then patiently he resumed his questioning. "Imagine that it was this knife; it has no curve. Tell me if it was as small as that?"

"I don't think so," I answered, pretending to search my memory, "but perhaps it was."

Then my father began to get impatient and exclaimed furiously, "It's either yes or no!"

"It's neither yes nor no," I answered, "for I can't remember!"

Then my father paced back and forth in the room in absolute consternation. Suddenly he took a crumb of bread, and put one knee on the floor. "Was it as small as this," he asked, in a theatrical pleading tone, showing me the crumb with one hand, "or as big as that?" pointing to the cupboard with the other hand. My sister wept, and we went to the cinema. It was a popular type of motion picture, and in the intermission everyone turned round to look at me as though I were a very rare object. With my velvet jacket, my hair which I wore like a girl's, my gilded cane and my sideburns reaching more than halfway down my cheeks, my appearance was in truth so outlandish and unusual that I was taken for an actor. There were two little girls, in particular, who looked at me ecstatically, with their mouths open. My father grew impatient. "Soon we won't be able to go out with you. We're made a show of every time. All that hair, and those long side-burns – and anyway we'll damn well have to go back to Figueras like beaten dogs with our tails between our legs."

An expression of infinite bitterness had come over my father's bluish gaze in the last two days, and the white strand of hair which he was the habit of fingering in his moments of cruelest doubt and anxiety now stood out stiff, like a horn of white hair into which was condensed all the torment and all the yellowish and menacing bile of my problematic future.

The following day dawn broke dismally, with lurid flashes of capital punishment. I was ready for anything. I was no longer afraid, for my sense of impending catastrophe had reached its peak in the infernal atmosphere of the previous day. I set to work, and in exactly one hour had completely finished the drawing, with all the shading. I spent the remaining hour doing nothing but admiring my drawing, which was remarkable – never had I done anything so precise. But suddenly I became terrified as I noticed one thing: the figure was still small, even smaller than the first one.

When I got out my father was reading the newspaper. He did have the courage to ask any questions; he waited for me to speak.

"I did wonderfully well," I said calmly. And the drawing is even smaller than the first one I made!"

This remark came like a bomb-shell. So did the result of my examination. I was admitted as a student to the School of Fine Arts of Madrid,

with this mention, "In spite of the fact that it does not have the dimensions prescribed by the regulations, the drawing is so perfect that it is considered approved by the examining committee".

My father and sister went back to Figueras, and I remained alone, settled in a very comfortable room in the Students' Residence, an exclusive place to which it required a certain influence to be admitted, and where the sons of the best Spanish families lived. I launched upon my studies at the Academy with the greatest determination. My life reduced itself strictly to my studies. No longer did I loiter in the streets, or go to the cinema. I stirred only to go from the Students' Residence to the Academy and back again. Avoiding the groups who foregathered in the Residence I would go straight to my room where I locked myself in and continued my studies. Sunday mornings I went to the Prado and made cubist sketch-plans of the composition of various paintings. The trip from the Academy to the Students' Residence I always made by streetcar. Thus I spent about one *peseta* per day, and I stuck to this schedule for several months on end. My relatives, informed of my way of living by the Director and by the poet Marquina, under whose guardianship I had been left, became worried over my ascetic conduct, which everyone considered monstrous. My father wrote me on several occasions that at my age it was necessary to have some recreation, to take trips, go the theatre, take walks about town with friends. Nothing availed. From the Academy to my room, from my room to the Academy, and I never exceeded the budget of one *peseta* per day. My inner life needed nothing else; rather, anything more would have embarrassed me by the intrusion of an unendurable element of displeasure.

In my room I was beginning to paint my first cubist paintings, which were directly and intentionally influenced by Juan Gris. They were almost monochromes. As a reaction against my previous colourist and impressionist periods, the only colours in my palette were white, black, sienna and olive green.

I bought a large black felt hat, and a pipe which I did not smoke and never lighted, but which I kept constantly hanging from the corner of my mouth. I loathed long trousers, and decided to wear short pants with stockings, and sometimes puttees. On rainy days I wore a waterproof cape which I had brought from Figueras, but which was so long that it almost reached the ground. With this waterproof cape I wore the large black hat, from which my hair stuck out like a mane on each side. I realize today that those who knew me at that time do not at all exaggerate when they say that my appearance "was fantastic". It truly was. Each time I went out or returned to my room, curious groups would form to watch me pass. And I would go my way with head held high, full of pride.

In spite of my generous initial enthusiasm, I was quickly disappointed in the professorial staff of the School of Fine Arts. I immediately understood that those old professors covered with honors and decorations could teach me nothing. This was not due to their academicism or to their philistine spirit but on the contrary to their progressive spirit, hospitable to every novelty. I was

expecting to find limits, rigour, science. I was offered liberty, laziness, approximations! These old professors had recently glimpsed French impressionism through national examples that were chock-full of *tipicismo* (local colour) – Sorolla was their god. Thus all was lost.

I was already in full reaction against cubism. They, in order to reach cubism, would have had to live several lives! I would ask anxious, desperate questions of my professor of painting: how to mix my oil and with what, how to obtain a continuous and compact matter, what method to follow to obtain a given effect. My professor would look at me, stupefied by my questions, and answer me with evasive phrases, empty of all meaning.

"My friend," he would say, "everyone must find his own manner; there are no laws in painting. Interpret – interpret everything, and paint exactly what you see, and above all put your soul into it; it's temperament, temperament that counts!"

"Temperament," I thought to myself, sadly, "I could spare you some, my dear professor; but how, in what proportion, should I mix my oil with varnish?"

"Courage, courage," the professor would repeat. "No details – go to the core of the thing – simplify, simplify – no rules, no constraints. In my class each pupil must work according to his own temperament!"

Professor of painting – professor! Fool that you were. How much time, how many revolutions, how many wars would be needed to bring people back to the supreme reactionary truth that "rigour" is the prime condition of every hierarchy, and that constraint is the very mold of form. Professor of painting – professor! Fool that you were! Always in life my position has been objectively paradoxical – I, who at this time was the only painter in Madrid to understand and execute cubist paintings, was asking the professors for rigour, knowledge, and the most exact science of draughtsmanship, of perspective, of colour.

The students considered me a reactionary, an enemy of progress and of liberty. They called themselves revolutionaries and innovators, because all of a sudden they were allowed to paint as they pleased, and because they had just eliminated black from their palettes, calling it dirt, and replacing it with purple! Their most recent discovery was this: everything is made iridescent by light – no black; shadows are purple. But this revolution of impressionism was one which I had thoroughly gone through at the age of twelve, and even at that time I had not committed the elementary error of suppressing black from my palette. A single glance at a small Renoir which I had seen in Barcelona would have been ample for me to understand all this in a second. They would mark time in their dirty, ill-digested rainbows for years and years. My God, how stupid people can be!

Everyone made fun of an old professor who was the only one to understand his calling thoroughly, and the only one, besides, possessing a true professional science and conscience. I myself have often regretted not having been sufficiently attentive to his counsels. He was very famous in Spain, and his name

was José Moreno Carbonero. Certain paintings of his, with scenes drawn from *Don Quixote*, I still enjoy today, even more than before. Don José Moreno Carbonero would come to class wearing a frock coat, a black pearl in his necktie, and would correct our works with white gloves on so as not to dirty his hands. He had only to make two or three rapid strokes with a piece of charcoal to bring a drawing miraculously back on its feet, into composition; he had a pair of sensationally penetrating, photographic little eyes, like Meissonier's, that are so rare. All the students would wait for him to leave in order to erase his corrections and do the thing over again in their own manner, which was naturally that of "temperament", of laziness and of pretentiousness without object or glory – mediocre pretentiousness, incapable of stooping to the level of common sense, and equally incapable of rising to the summits of delirious pride. Students of the School of Fine Arts! Fools that you were!

One day I brought to school a little monograph on Georges Braque. No one had ever seen any cubist paintings, and not a single one of my classmates envisaged the possibility of taking that kind of painting seriously. The professor of anatomy, who was much more given to the discipline of scientific methods, heard mention of the book in question, and asked me for it. He confessed that he had never seen paintings of this kind, but he said that one must respect everything one does not understand. Since this has been published in a book, it means that there is something to it. The following morning he had read the preface, and had understood it pretty well; he quoted to me several types of non-figurative and eminently geometrical representations in the past. I told him that this was not exactly the idea, for in cubism there was a very manifest element of representation. The professor spoke to the other professors and all of them began to look upon me as a supernatural being. This kind of attention threatened to reawaken my old childhood exhibitionism, and since they could teach me nothing I was tempted to demonstrate to them in flesh and blood what "personality" is. But in spite of such temptations my conduct continued to be exemplary: never absent from class, always respectful, always working ten times faster and ten times harder at every subject than the best in the class.

But the professors could not bring themselves to look upon me as a "born artist". "He is very serious," they said, "he is clever, successful in whatever he sets out to do. But he is cold as ice, his work lacks emotion, he has no personality, he is too cerebral. An intellectual perhaps, but art must come from the heart!" *Wait, wait,* I always thought deep down within myself, *you will soon see what personality is!*

The first spark of my personality manifested itself on the day when King Alfonso XIII came to pay an official visit to the Royal Academy of Fine Art. Already then the popularity of our monarch was in decline, and the news of his coming visit divided my fellow-students into two camps. Many spoke of not appearing on that day, but the faculty, to forestall any sabotage of the splendor of the occasion, had bluntly announced severe penalties for any failure to he present on that day. One week beforehand there began a thorough-going

house-cleaning of Academy, which was transformed from a frightfully run-down state one that was almost normal. A carefully planned organization was se up to change the aspect of the Royal Academy, and several clever ruses were tried out. In the course of the King's visit to the different classes the students were to run from one room to the next by some inner stairways and take their places before the King arrived, keeping their back to the door, so that he would have the impression that there were many more students than there really were. At that time the school had a very small attendance, and the large rooms always had a deserted look. The authorities also changed the nude models in the life classes – young but very poor creatures, and not much to look at, who were paid starvation wages – for very lovely girls who, I am sure, habitually exercised much more voluptuous professions. They varnished the old paintings, they hung curtains, and decorated the place with many trimmings and green plants.

When everything had been made ready for the comedy that was to be played, the official escort arrived with the King. Instinctively – and were it only to contradict public opinion – I found the figure of our King extremely appealing. His face, which was commonly called degenerate, appeared to me on the contrary to have an authentic aristocratic balance which, with his truculently bred nobility, eclipsed the mediocrity of all his following. He had such a perfect and measured ease in all his movements that one might have taken him for one of Velasquez's noble figures just come to life.

I felt that he had instantly noticed me among my fellow-students. Because of my hair, my sideburns, and my unique appearance this was not hard to imagine; but something more decisive had just flashed through our two souls. I was considered a representative student and, with some ten of my school-mates who had also been chosen, I was accompanying the King from one class to another. Each time I entered a new class and recognized the backs of the students whom we had just left and who were now busily working I was devoured by a mortal shame at the thought that the King might discover the comedy that was being played for his benefit. I saw these students laugh while they were still buttoning up their jackets, into which they had hurriedly changed while the Director of the School detained the King for a moment to have him admire an old picture and thereby gain a little time. Several times I was tempted to cry out and denounce the deception that was being practiced on him, but I managed to control my impulse. Nevertheless my agitation kept growing as we visited one room after another, and knowing myself as I did, I kept constantly repeating to myself, "Look out, Dalí, look out! Something phenomenal is about to happen!"

When the inspection was over preparations were made for taking group pictures with the King. An armchair was ordered for the King to sit in, but instead he seated himself on the floor with the most irresistibly natural movement. Thereupon he took the butt of the cigarette he had been smoking, wedged it between his thumb and forefinger and gave it a flick, making it describe a perfect curve and fall exactly into the hole of a spittoon standing more than two metres away. An outburst of friendly laughter greeted this gesture, a peculiar

and characteristic stunt of the *"Chulos"* – that is, the common people of Madrid. It was a graceful way of flattering the feelings of the students, and especially of the domestics who were present. They had seen executed to perfection a "feat" which was familiar to them and which they would not have dared to perform in the presence of the professors or of the well-bred young gentlemen.

It was at this precise moment that I had proof that the King had singled me out among all the others. No sooner had the cigarette dropped into the hole of the spittoon than the King cast a quick glance at me, with the obvious idea of observing my reaction. But there was something more in this incisive glance; there was something like the fear lest someone discover the flattery he had just proffered to the people – and this someone could be none other than I. I blushed, and when the King looked at me again he must necessarily have noticed it.

After the picture-taking, the King bade each one of us goodbye. I was the last to shake his hand, but I was also the only one who bowed with respect in doing so, even going to the extent of placing one knee on the ground. When I raised my head I perceived a faint quiver of emotion pass across his famous Bourbon lower lip. There can be no doubt that we recognized each other! Nevertheless when, two years later the same King Alfonso XIII signed the order for my permanent expulsion from the School of Fine Arts of Madrid, he would never have believed that I was the expelled student. Or perhaps, yes – he would have believed it!

The consequences of this royal visit did not end for me that day. My emotion and my repressed tension remained unable to find an outlet; and with my feeling of discomfort further augmented, after the King had left, by the regret at not having denounced the whole farce to him, I continued to hear that inner voice repeat to me, "Dalí, Dalí! You must do something phenomenal." I did. And I chose the sculpture class in which to do it. This, then, is what did. I shall tell you about it, for I am sure it cannot fail to please you.

I happened to choose the sculpture class because in this class there was an abundance of plaster, and I needed a great deal of plaster for what I wanted to do. There were in fact several sacks of it, of the finest sculptor's plaster. The time I had chosen for this was exactly half past twelve, when everyone would be gone. Thus I would not be bothered by anyone's presence, and I could do as I pleased. I went into the sculpture class and locked the door behind me. There was a large basin where old pieces of dried clay were usually being softened. I removed the largest pieces, and opened the faucet above it full force. In a few minutes the basin was almost full. Then I emptied one of the sacks of plaster into it, and waited for the resulting milk-white liquid to begin to overflow. My idea was very simple: to cause a great inundation of plaster. I accomplished this without difficulty. I used all the four sacks of plaster that were in the room with this intent, about one sack for every basinful spilled over the floor-tiles. The whole class was inundated with the plaster. As it was greatly diluted with water, the plaster took a long time to dry, and thus was able to flow under the doors. Soon I could hear the sound of the cascade which my inundation was producing,

flowing from the top of the stairway all the way down to the entrance hall. The great well of the stairway began to reverberate with such cataclysmic sounds that I suddenly realized the magnitude of the catastrophe I was producing. Seized with panic I dropped everything and left, ploughing my way through the plaster and getting frightfully bespattered. Everything was unexpectedly deserted, and no one had yet discovered what had happened. The effect of that whole great stairway inundated by a river of plaster majestically pouring down was most startling, and in spite of my fear I was forced to stop to admire this sight, which I mentally compared with something as epic as the burning of Rome, though on a smaller scale. Just as I was about to leave the inner court of the school I ran into a model, called El Segoviano (because he was from Segovia), coming in the opposite direction. As he saw the approaching avalanche of plaster he raised his arms to heaven.

"What in God's name is that?" he exclaimed in his burly peasant voice.

At this a little spark of humour flashed through my brain. Going over to him I whispered into his ear,

"At least it can't possibly all be milk!"

I reached the Students' Residence more daubed with plaster than any mason. I took a shower, changed all my clothes and stretched out on the bed, seized with a mad laughter which gave way little by little to a growing uneasiness. Because of El Segoviano who had seen me leave, it would inevitably be found out that I was the guilty one. However, from the moment I had decided to create the inundation I had not cared whether I was caught or not. This in fact was what I had wanted. I was already pondering the explanation I would give for my action, which was an oblique kind of protest against the disloyal attitude that had been shown toward our King by deceiving him. I had even had the idea of threatening to make a written declaration to this effect, thinking that this would strengthen my position to the point of making me invulnerable. But all these explanations remained vague, imprecise, and dissatisfying to my mind, which was becoming more and more rigorously attached to intelligence. All that could not be resolved in my mind in a lucid and rapid fashion created in me a feeling of deep oppression which often became a real waking nightmare. The motives and the meaning of an action as considerable as the plaster inundation which I had just produced escaped me and continued to resist my attempts at interpretation. This made me more and more uneasy, subjecting my spirit to a frightful moral torture. Was I really mad? I knew that I certainly was not. But then, why had I done this?

Suddenly I solved the enigma. And the solution to the enigma was there before me on an easel, entirely contained within the limits of an absolutely immaculate canvas which I had prepared for painting, and on which my eyes had been riveted since the beginning of this whole imaginative disturbance. As soon as I understood, I got up. I went over and took my large black felt hat, put it resolutely on my head, and placed myself before the wardrobe mirror. Then, with ceremonious gestures imbued with an extreme dignity, I saluted myself; I

saluted my intelligence with the maximum of respect. But, finding that my bow was not sufficient, I humbly stooped before my own reflection, modestly lowering my head. Finally I put one knee to the floor, imitating as close as possible the genuflection I had made that very morning before my own King.

I realized that I had been the plaything of a dream, and whole episode of the plaster inundation was but an illusion. The remarkable stroke of genius, however, was not this discovery itself, but its interpretation,[1] which sprang to my mind in an almost instantaneous way! Now I remembered everything.

This is what had happened.

After His Majesty the King had left the Academy of Fine Arts I took my street-car and went back to the Students' Residence. When I got to my room I lay down on the bed, exhausted by the nervous tension in which the royal ceremony had kept me during the whole morning. I remembered very well having looked with pleasure at the two white canvases all prepared and ready to be painted, placed on an easel just at the foot of the bed. After this I had fallen asleep and my sleep, according to my calculations, could have lasted at the most one hour (from half past twelve to half past one), during which I dreamed, with an intensity of realism one rarely experiences, all the vicissitudes of my plaster inundation.

I have noted down several dreams I have experienced in the course of my life which present the same typical development. They always begin by being linked to an actual event. Their argumental vicissitudes culminate exactly at the spot and in the situation in which the sleeper finds himself at the moment of awakening. This fact, greatly augmenting the dream's verisimilitude, creates a factor that is highly propitious to its confusion with reality, especially when the "manifest content" of the dream does not present (as is the case for the one I shall attempt to analyze) flagrant absurdities, always maintaining itself within the strict limits of the possible. In my own case such dreams have always come during sleep accidentally occurring at unaccustomed hours in the daytime. I believe it is also true as a general rule, as far as my own experience is concerned, that an intense light in the place where sleep occurs is favourable to dreams of a heightened visual intensity. On several occasions I have also been able to observe that sunlight beating directly on my shut eyelids has produced coloured dreams.

To return to the analysis of the dream of the plaster inundation, here are some preliminary data for determining the intentional role of certain elements of the preceding waking period – a symbolic role of the first order. *First of all, the two prepared canvases which I have at the foot of my bed and which I look at with self-satisfaction before going to sleep:* these two canvases had previously been two studies executed in the class in what was called "drapery", which was under the auspices of the painter Cordova Julio Romero de Torres. These studies

1. At this period I had just begun to read Sigmund Freud's *Interpretation of Dreams.* This book presented itself to me as one of the capital discoveries in my life, and I was seized with a real vice of self-interpretation, not only of my dreams but of everything that happened to me, however accidental it might seem at first glance.

had been made in very painful circumstances in which my work, encountering the constant obstacles of incomprehension, finally sank into complete failure. The two canvases represented exactly the same subject – a little naked girl covered with a very new and shiny white silk fabric which fell from her shoulders in the form of a cape. The principal subject was this fabric. But it was impossible for me to paint it, for the model not only posed very badly, moving constantly – which made the shadows and the highlights change – but also the little girl would rest every half hour, afterwards attempting to replace the folds in something like the original arrangement, which made it practically impossible for me to go on with my work. For the other pupils who merely derived from the model a very vague general impression, corresponding (as the habitual phrase went) rather to the folds of their temperament than to those of the white silk fabric, which they pretended nonchalantly to look at, these changes were not of the slightest importance. For me, on the contrary, who with my dilated pupils was trying to clutch everything I could of what I saw before me, each of the model's little movements, even the most imperceptible, glued itself to my attentive impatience like real arrows of torture. My two attempts failed. Discouraged, I left them unfinished and took them home with me, intending to paint something else over them.

But a new and even more anguishing factor appeared, weighting those two ill-fated canvases with an admixture of horror and displeasure such that I could no longer look at them. I had been forced from the beginning, not only to turn them against the wall but to shut them up in the wardrobe so as not to see them. And even so their invisible presence continued to annoy me! The second factor of anguish was the following. The little girl who served as a model had a very perfect face and a delightful pink body, like a lovely porcelain. While I was painting her she suddenly evoked for me the image of myself when as a child I would stand naked before a mirror, with my king's ermine cape over my shoulders. As I have already related at the beginning of my childhood memories, I would sometimes conceal my sexual parts by holding them between my thighs so as to look as much as possible like a little girl. During the whole painful process of working on those two uncompleted canvases, executed from the model of that disquieting double of myself as a child-king, I would spend my whole time mentally evaluating the relative beauty of these two kings, the one in the memories of the past, the other in actuality, posed before me on a platform, the two bitterly struggling in jealous competition. In this competition I felt that the real absence of the male sex organs in the idealized Dalí (whom I saw come to life again before me) constituted one of his most advantageous attributes, for I have desired ever since to be "like a beautiful woman", and this in spite of the fact that since my first disappointed love for Buchaques I have continued to feel a complete sexual indifference toward men. (No! Let there be no misunderstanding on this point – I am not a homosexual.) But where the rivalry between the two kings reached its peak, as an aesthetic revenge to which I was entitled, was in the white satin fabric, taken from the stock-room, which I

compared to the ermine the little model ought to have worn. That naked and hairless little body, had it been draped in ermine, would have appeared to me as one of the most desirable and most truly exquisite things that one could have "seen". I suggested this to the professor, who shrugged his shoulders and declared that fur was not pictorial!

I thereupon began to build the fantasy of hiring the little model for myself and going to look for an ermine cape in the shops supplying theatrical costumes. No, two ermine capes! And I began an exhausting and persevering reverie which it seemed to me that nothing could stop or deflect from its course. Two ermine capes, one for her and the other for me! At the beginning I would have her hold a normal pose. But for this I needed a studio, for I could not bring her to the Students' Residence – I would not have dared – and besides, the atmosphere of my room did not lend itself to the mood of my incipient reverie. Hence I had to imagine exactly how the studio in which all this was to take place "would be". I was already beginning to see it. It was very large, it looked a little like...

But suddenly I felt that I could not go any further, could not continue to imagine. There was in fact something that did not work, for naturally it would be necessary to find money for this. How could I explain to my father the sudden expense of renting a large studio, a model, ermine capes? I was marking time in my reverie, and I felt that I could not advance a single step without having first solved this grave financial question which had interrupted everything. And above all I was feverishly looking forward to the erotic scenes that my reveries had made me glimpse, flashing before me in lightning succession samples of vivid images, each more desirable than the last, like the previews of films calculated by a series of brief, incoherent shots selected from the whole to give you an irresistible desire to plunge yourself into the complete contemplation of something that makes your mouth water in mere anticipation.

But as method is everything in life, so it is in reverie, and I said to myself, "Salvador, do begin at the beginning. If you go step by step without haste, everything will come in due time. If you do otherwise, if you rush in and start snatching and gluttonously peeling the images which seem the most captivating at first sight, you will find that these images, not having a solid basis, not possessing a tradition, will be mere copies; they will be forced, like slaves, to resort to other similar situations in your memory that you have already exhausted. It will be a pathetic plagiarism,[2] and not 'invention', 'novelty' – which is after all what you are after. But what will happen to you will be worse than this: your little bits of images, though flashing, will not be able to resist that constant need of 'fetishistic verification'; when you ask for it they will not be able to show you that passport which you yourself, the supreme chief of the police of your spirit, have constantly given and checked for each of those short little voyages – not possessing the complete dossier of their public and secret life they will be unable to produce it. You will no longer be able to give them your confidence, and either you will banish them as intruders and agents of disorder,

paid by the propaganda of the external world, who come and disturb the peace and prosperity of the imaginative climate in which you live, or else you will simply throw them into the prison of your subconscious. Therefore, if you want to follow the course of your reverie through to the end, go back a little, and before minutely imaging the neurotic setting of your studio, where you will see your little model with her hairless body come in every evening, undress and afterward drape herself with malicious modesty in her ermine cape – before all this find the money you need to make the adventure of your studio plausible, to make you believe it!"

In order to bring all this about I had to find a friendly painter who was already in possession of that studio. He had to have unqualified admiration for me, and be about to leave for Catalonia... No, Paris would be better – he would leave for Paris. Then he would say to me, "Come to the studio whenever you want, here is the key; and no one needs to know anything about what goes on here." I knew no one in Madrid, and the course of my reverie was becoming unsatisfactory, when all at once I remembered the photograph of a well-known painter in Barcelona. At this moment my reverie was brusquely interrupted by the professor's arrival. I got up. He simply said to me, "Don't disturb yourself, I'll come back later." But he had already disturbed me, and how! I felt that I was in the midst of thinking about something highly desirable, the only thing I would like to be able to think about again. But I tried in vain!

There is no greater anguish and bitterness than to run madly from one idea to another without being able to find again that most magic of all spots "where you were so comfortable" before you were interrupted. Everything is insipid, everything around you is worthless. But suddenly you find it again! Then you feel that the rediscovered train of thought, though agreeable enough, is not so marvelous as you had thought before you found that "thing", so greatly desired.

2. Eugenio d'Ors once made the profound observation that "everything that is not tradition is plagiarism". Everything that is not tradition is plagiarism, Salvador Dalí repeats. The most exemplary case that one can give of this to a young student of the history of art is that of Perugino and Raphael. Raphael, while still a very young student, found himself almost without realizing it incorporating and possessing the whole tradition of his master, Perugino: drawing, chiaroscuro, matter, myth, subject, composition, architecture – all this was "given" to him. Hence he was lord and master. He was free. He could work within such narrow limits that he could give his whole mind to doing it. If he decided to suppress a few columns or to add a few steps to the stairway; if he thought the head of the Madonna should lean forward a little more, that the shadow of the orbits of her eyes should have a more melancholy accent, with what luxury, what intensity, what liberty of invention he could do this. The complete opposite is Picasso, as great as Raphael, but damned. Damned and condemned to eternal plagiarism; for, having fought, broken and smashed tradition, his work has the dazzle of lightning and the anger of the slave. Like a slave he is chained hand and foot by the chains of his own inventions. Having reinvented everything, he is tyrannized by everything. In each of his works Picasso struggles like a convict; he is tyrannized, reduced to slavery by the drawing, the colour, the perspective, the composition, by each of these things. Instead of leaning upon the immediate past which is their source, upon the 'blood of reality" which is tradition, he must lean upon the "memory" of all that he has seen – plagiarism of the Etruscan vases, plagiarism of Toulouse-Lautrec, plagiarism of Africa, plagiarism of Ingres. THE POVERTY OF REVOLUTION. Nothing is truer: "The more one tries to revolutionize, the more one does the same thing."

Nevertheless I have found it again, and I can continue my reverie. Let's go ahead; it will last four or five hours. And perhaps I can continue it the next day, and at the same time perfect it. Good heavens, what a prodigious worker you are, Salvador Dalí! But I overcome my temptations, and right here I shall stop describing my reverie, for even though it is one of the strangest my brain has produced, it would make its lose the thread of the interpretation of the dream of the "plaster inundation", which we were discussing before we were distracted by these general considerations on the course of the river of "Reverie", always so instructive.

So let the reader try to remember (by going back a little) that I had more than sufficient reasons to detest the two abortive paintings of the young girl. These canvases which I had temporarily hidden I intended, as I have already said, to paint over. As soon as this was possible I decided one morning to prepare the two canvases together, and I put them next to each other on the floor so that I could paint them both together, covering them with a coat of white colour diluted with glue. This coat dried fast, but I was very much dissatisfied with the result, for the two frightful botched pictures of the little girl-model could be seen standing out very sharply through the transparent colour. Then, deciding to resort to desperate measures, I prepared a large pot of white paint and poured it over the two canvases. The paint flowed over the edges and spread on the floor, but, as usual in such circumstances, far from being discouraged or stopping because of this incident, I decided that the damage was already done, and that a little more or less no longer made the slightest difference. I would clean it all up later. But for the moment I wanted to take advantage of the "inundation" to pour still another pot of paint over the canvas, this time making the paint even thicker. It would cover the two coats that were already there and would form a new one that not only would make the two detested pictures completely disappear but also and especially would cause my two canvases to acquire very thick and smooth surfaces, as though they were "covered with plaster". I poured out the second pot of paint with such lack of concern over spilling it that it was now spreading across the floor of the room like a flood. The sun poured in through the windows, and the dazzling white consciously reminded me of the town of Figueras covered with snow, at the period of my false memories.

Having finished the story of my canvases, let us now undertake the analysis of the dream of the plaster-flood which, as we shall see, is a dream which by its blinding symbols betrays my ambitious autocratic desires of "absolute monarchy" to which I have already alluded, and which constituted the continuous desire of my whole early childhood. What did these two paintings represent for me? First of all, the double and jealous image of myself as king and as young girl. This is even illustrated materially by the fact that the two paintings representing the same subject are considered by me as two kings. This conflict of the two kings broke out on the occasion of His Majesty's visit to the Academy of Fine Arts. In fact I immediately noticed that he had singled me out among all the others. This distinction, in the unconscious, meant: he had recognized that I

was a king. It is quite natural that the effect produced on my imagination by the real encounter with His Majesty Alfonso XIII should have awakened in my mind the violent royal feelings with which I had lived during my whole childhood. The King's presence revived in my mind the King I bore within my skin! During the entire visit to the school I had this impression, which did not leave me a single moment that the two of us were uniquely and continually isolated from all the rest.

But this dualism finally disappeared, for at the moment when I made my genuflection before him I felt myself agreeably but totally depersonalized: I was completely identified with him! I was he, and since he was the real thing, all my autocracy was directed against the false one. The false king was the one I had painted on the two canvases. There the rivalry was flagrant because of the desire to have the sex organs that were the contrary of my own. When I spilled the plaster and inundated the sculpture class I realized the same symbol as I had realized in pouring the paint over my two canvases. "I effaced the rival false king." This plaster, and this paint, of an immaculate white, was the ermine mantle of the absolute monarchy which unifies all, covers, makes occult, and dominates all "majestically". It was exactly the same ermine mantle which in my memories covered the hostile reality of the town of Figueras with a shroud of snow. It was the same purifying mantle which, as it covered and hid the Academy of Fine Arts, also covered the two paintings made in this Academy, representing for me the sum of the most painful experiences suffered in this place of spiritual degradation. The plaster flood was thus nothing other than the ermine mantle of my absolute monarchy solemnly spreading from above, from the summit of the tower of the sculpture class, over everything that was "below".

Misunderstood king! Dalí, for your twenty-one years you were assimilating your readings wonderfully well! I congratulate you! And now, continue, go right on telling us things and things about yourself; it fascinates us more and more! Go to it! Here we are, listening to you. Wait, wait, let me drink a glass of water!...

Four months had passed since my arrival in Madrid, and my life continued to be as methodical, sober and studious as on the first day. I am not altogether telling the truth when I say this – for in reality as my sobriety, my capacity for study, and the minute rigour to which I subjected my spirit, grew from week to week, I felt myself reaching that limit of daily discipline composed of the ritualized perfecting of each moment which leads by a direct short-cut to the very border of asceticism. I should have liked to live in a prison! I was sure that if I had lived in one I should not have regretted a single iota of my liberty. Everything in my paintings took on a more and more severe and monastic flavor, and it was on the plaster-like surface of the canvases which I had unhappily prepared with such a thick coat of paint mixed with glue that I painted these things.

I say "unhappily", because the two cubist paintings which I executed during those first four months of my stay in Madrid were two capital works, as

impressive as an *auto-da-fé* – which is what they were. The excessively thick preparation caused them to crack, they began to fall to pieces, and the two paintings were thus totally destroyed.

But before this, one day, they were discovered, and I with them. The Students' Residence where I lived was divided into quantities of groups and sub-groups. One of these groups was that of the artistic-literary advance guard, the non-conformist group, strident and revolutionary, from which the catastrophic miasmas of the post-war period were already emanating. This group had recently inherited a narrow negativistic and paradoxical tradition deriving from a group of "ultra" *littérateurs* and painters – one of those indigenous "isms" born of the confused impulses created by European advance guard movements, and more or less related to the Dadaists. This group was composed of Pepin Bello, Luis Buñuel, García Lorca, Pedro Garfias, Eugenio Montes, R. Barrades and many others. But of all the youths I was to meet at this period only two were destined to attain the dizzy heights of the upper hierarchies of the spirit – García Lorca, in the biological, seething and dazzling substance of the post-Gongorist poetic rhetoric, and Eugenio Montes, in the stairways of the soul and the stone-canticles of intelligence. The former was from Granada, and the latter from Santiago de Compostela.

One day when I was out, the chamber maid had left my door open. and Pepin Bello happening to pass by saw my two cubist paintings. He could not wait to divulge this discovery to the members of the group. These knew me by sight, and I was even the butt of their caustic humour. They called me "the musician", or "the artist", or "the Pole". My anti-European way of dressing had made them judge me unfavourably, as a rather commonplace, more or less hairy romantic residue. My serious, studious air, totally lacking in humour, made me appear to their sarcastic eyes a lamentable being, stigmatized with mental deficiency, and at best picturesque. Nothing indeed could contrast more violently with their British-style tailored suits and golf jackets than my velvet jackets and my flowing bow ties; nothing could be more diametrically opposed than my long tangled hair falling down to my shoulders and their smartly trimmed hair, regularly worked over by the barbers of the Ritz or the Palace. At the time I became acquainted with the group, particularly, they were all possessed by a complex of dandyism combined with cynicism, which they displayed with accomplished worldliness. This inspired me at first with such great awe that each time they came to fetch me in my room I thought I would faint.

They came all in a group to look at my paintings, and with the snobbishness which they already wore clutched to their hearts, greatly amplifying their admiration, their surprise knew no limits. That I should be a cubist painter was the last thing they would have thought of! They frankly admitted their former opinion of me, and unconditionally offered me their friendship. Much less generous, I still kept a speculative distance. I wondered what benefit I could derive from them, and whether they really had anything to offer me.

They literally drank my ideas, and in a week the hegemony of my

thought began to make itself felt. Wherever members of the group were present the conversation was sprinkled with, "Dalí said..." "Dalí answered..." "Dalí thinks..." "How did Dalí like this?" "It looks like Dalí." "It's Dalínian..." "Dalí must see that..." "Dalí ought to do that..." And Dalí this, and Dalí that, and Dalí everything!

Although I realized at once that my new friends were going to take everything from me without being able to give me anything in return – for in reality of truth they possessed nothing of which I did not possess twice, three times, a hundred times as much – on the other hand, the personality of Federico García Lorca produced an immense impression upon me. The poetic phenomenon in its entirety and "in the raw" presented itself before me suddenly in flesh and bone, confused, blood-red, viscous and sublime, quivering with a thousand fires of darkness and of subterranean biology, like all matter endowed with the originality of its own form.[3] I reacted, and immediately I adopted a rigorous attitude against the "poetic cosmos". I would say nothing that was indefinable, nothing of which a "contour" or a "law" could not be established, nothing that one could not "eat" (this was even then my favourite expression). And when I felt the incendiary and communicative fire of the poetry of the great Federico rise in wild, dishevelled flames I tried to beat them down with the olive branch of my premature Anti-Faustian old age, while already preparing the grill of my transcendental prosaism on which, when the day came, when only glowing embers remained of Lorca's initial fire, I would come and fry the mushrooms, the chops and the sardines of my thought (which I knew were destined to be served some day – fried to a turn, and good and hot – on the clean cloth of the table of the book which you are in the midst of reading) in order to appease for some hundred years the spiritual, imaginative, moral and ideological hunger of our epoch.

Our group was taking on a more and more anti-intellectual colour; hence we began to frequent intellectuals of every sort, and to haunt the cafés of Madrid in which the whole artistic, literary and political future of Spain was beginning to cook with a strong odour of burning oil. The double vermouths with olives contributed generously to crystallize this budding "post-war" confusion, by bringing a dose of poorly dissimulated sentimentalism which was the element most propitious to the elusive transmutations of heroism, bad faith, coarse elegance and hyperchloridic digestions, all mixed up with anti-patriotism; and from this whole amalgam a hatred rooted in bourgeois mentality which was destined to make headway grew, waxed rich, opening up new branches daily, backed by unlimited credit, until the day of the famous crash of the then distant Civil War.

I said a moment ago that the group which had just taken me so generously to its bosom was incapable of teaching me anything, and even as I

3. Form presents itself as the result of elementary physical modifications. Among these are the reactions of matter (general morphology).

said this I knew that it was not altogether true, since the group nevertheless taught me one thing, and it was precisely because of this thing that I remained in the group, and that I was going to continue to remain. They taught me how to go on a bender. I spent about three days at it: two days for the barber, one morning for the tailor, one afternoon for money, fifteen minutes to get drunk, and until six o'clock the next morning to go on the "bender". I must relate all this in detail.

One afternoon the whole group of us were having tea in one of the fashionable spots in Madrid, which naturally was called the Crystal Palace. No sooner did I enter it than everything became clear to me. I had radically to change my appearance. My friends, who took a much more decided pride in my person than I (since my immeasurable arrogance always immunized me against being affected by anything), were eager to defend my truculent appearance, and even to force its acceptance, with an energetic and resolute courage. They were ready to sacrifice everything for this, and their vehement non-conformism tended to make a veritable battle-flag of my preposterous get-up. By their offended air they seemed to want to answer the furtive, discreet, though insistent glances from the elegant throng that surrounded us by saying, "Well! Our friend looks like a gutter rat, to be sure, but he is the most important personage you have ever met, and at the slightest incivility on your part we'll knock you down." Buñuel especially, who was the huskiest and most daring among us, would survey the room to discover the slightest occasion to pick a fight. For that matter, he would seize on any pretext that promised to end in a free-for-all. But nothing happened. When we got outside I said to the bodyguards of my outlandishness, "You've been very decent with me. But I'm not at all anxious to keep this up. Tomorrow I'm going to dress like everyone else!"

This decision, made on the spur of the moment, impressed everyone deeply, for they had all become terribly "conservative" about my appearance. My decision was discussed endlessly and with the same kind of emotion that must have possessed Socrates' disciples when he stoically announced that he was going to drink the hemlock. They tried to make me go back on my decision – as though my personality were attached to my clothes, my hair and my sideburns, and ran the risk of being destroyed and of disappearing along with the paralyzing aspect of my amazing capillary and sartorial emblems. But my decision was irrevocable. The principal and secret reason was that I was bent on something which suddenly appeared to me as of capital importance. I wanted to be attractive to elegant women. And what is an elegant woman? I had found out just now, in the tea-room, by observing one sitting at the opposite table. An elegant woman is a woman who despises you and who has no hair under her arms. On her for the first time I had discovered a depilated armpit, and its colour, so finely and delicately blue-tinged, appeared to me as something extremely luxurious and perverse. I made up my mind to study "all these questions", and to do so – as I did everything – thoroughly!

The next morning I began at the beginning – with my head. However, I

did not dare go directly to the Ritz barbershop, as my friends had recommended. I therefore went in search of an ordinary barber. I thought I would have him do it just "roughly", and have the rest of my hair properly cut at the Ritz in the afternoon. But each time I reached the door of a barbershop I would suddenly be seized with timidity and decide to go elsewhere. The time it would take to say "Cut my hair" was really a difficult moment to get across.

Toward the end of that afternoon, after a thousand hesitations, I finally made up my mind to it. But as soon as I saw the white towel in which the barber had enveloped me become covered with my ebony-black strands I was seized for a moment with a Samson complex. What if the story about Samson were true? I looked at myself in the mirror in front of me, and I thought I saw a king on his throne. But this produced in me a great uneasiness. Nothing, in fact, more resembles the grotesque parody of a royal ermine cape than the large and solemn white towel sprinkled with the black tails of our own hair that are being snipped off our heads. It is curious, but that is how it is. It was the first and the last time in my life that for several minutes I lost faith in myself. My image of a king-child appeared to me suddenly as a painful case of biological deficiency, the product of a catastrophic disequilibrium between my sickly, feeble, backward constitution and a precocious but sterile intelligence incapable of functioning in the realm of action, with nothing to look forward to but the degeneration of the terribly incomplete and spiritually aged freak that I was.

I was thinking all these things while the hair fell in shreds on my knees and on the tiled floor – which I remember very well having been of yellow, white and blue porcelain representing a kind of dragon-fish biting its tail. Was I perhaps an imbecile like all the others? I paid, gave the tip and headed toward the Ritz where the barber would put the finishing touches on the work.

As soon as I was in the street, with the barber's door shut behind me, I felt myself a different man, and all my recent scruples and fears melted in an instant like a soap bubble. I knew that the slamming of that door had separated me forever from the swampy blackness of my hair which they must now be sweeping up. I no longer regretted anything, anything, and with the allegorical, age-avid mouth of the Medusa of my anti-sentimentalism, of my Anti-Faust, I spat the last unprepossessing hair of my adolescence upon the pavement of time. Instead of going to the barber's when I reached the Ritz, I headed for the bar and asked for "a cocktail".

"What kind will you have?" asked the bartender.

"Make it a good one!" I said, not knowing there were several kinds.

It tasted horrible to me, but at the end of five minutes it began to feel good inside my spirit. I definitely dropped the idea of the barber for the afternoon and asked for another cocktail. I then became aware of this astonishing fact: in four months this was the first day I had missed school, and the most stupefying part of it was that this did not give me the slightest feeling of guilt. On the contrary, I had a vague impression that this period was ended, and that I would never return. Something very different was going to come into my life.

In my second cocktail I found a white hair. This moved me to tears, in the euphemistic intoxication produced by the first two cocktails I had drunk in my life. This apparition of a white hair at the bottom of my glass appeared to me to be a good omen. I felt ideas and ideas being born and vanishing, succeeding one another within my head with an unusual speed – as if, by virtue of the drink, my life had suddenly begun to run faster. I said to myself, "This is my first white hair!" And again I sipped that fiery liquid which I had to swallow with my eyes shut, because of its violence. This perhaps was the "elixir of long life", the elixir of old age, the elixir of the Anti-Faust.

I was sitting in a dark corner from which I could easily observe everything, without being observed – which I was able to verify, as I had just said 'elixir of the Anti-Faust" aloud and no one had noticed it. Besides, there were only two persons in the bar in addition to myself – the bartender, who had white hair but seemed very young, and an extremely emaciated gentleman, who also had white hair, and who seemed very old, for when he lifted his glass to his lips he trembled so much that he had to take great precautions not to spill everything on the floor. I found this gesture, betraying a long habit, altogether admirable and of supreme elegance; I would so much have liked to be able to tremble like that! And my eyes fastened themselves once more on the bottom of my glass, hypnotized by the gleam of that silver hair. "Naturally I'm going to look at you close," I seemed to say to it with my glance, "for never yet in my life have I had the occasion, the leisure, to take a white hair between my fingers, to be able to examine it with my avid and inquisitorial eyes, capable of squeezing out the secret and tearing out the soul of all things."

I was about to plunge my fingers into the cocktail with the intention of pulling out the hair when the bartender came over to my table to place two small dishes on it, the one containing olives stuffed with anchovies, the other *pommes soufflées*.

"Another?" he asked with a glance, seeing that my glass was less than half full.

"No thanks!"

With a ceremonious gesture he then wiped up a few drops that I had spilled on the table and went back to his post behind the bar. Then I plunged my forefinger and my thumb into my glass. But as my nails were cut very, very short it was impossible for me to catch it. In spite of this I could feel its relief; it seemed hard and as if glued to the bottom of the glass. While I was immersed in this operation an elegant woman had come in, dressed in an extremely light costume with a heavy fur hanging around her neck. She spoke familiarly, lazily to the bartender. Full of respectful solicitude, the latter was preparing for her something that required a great din of cracking ice. I immediately understood the subject of their conversation, for an imperceptible glance cast by the bartender toward the spot where I was sitting was followed after a short interval by a long scrutinizing gaze from the lady. Before fixing her eyes on me with an insistent curiosity she let her eyes wander lazily around the entire room, resting them on me for a mere

moment, meaning in this clumsy way to make me believe it was by pure chance that her gaze settled on me. With his eyes glued to the metal counter, the bartender waited for his companion to have time to examine me at her leisure, and then, with rapid words and an ironic though kindly smile, he told her something about me which had exactly the effect of making the woman's face turn in my direction a second time. This time she did it with the same slowness, but without taking any precautions. At this moment, exasperated as much by this scrutinizing gaze as by my clumsiness in not being able to get out the white hair, I pressed my finger hard against the glass and slowly pulled it up, slipping it along the crystal with all my might. This I could do without being seen, for a column concealed half of my table from the lady and the bartender just at the spot where my hand and my glass happened to be.

I did not succeed in detaching the white hair, but suddenly a burning pain awakened in my finger. I looked, and saw a long cut that was beginning to bleed copiously. Out of my wits, I put my finger back into the glass so as not to spatter blood all over my table. I instantly recognized my error. There was no hair at the bottom of my glass. It was simply a very fine crack that shone through the liquid of my accursed cocktail. I had cut myself by mistake in sliding the flesh of my finger hard along this crack, with the impulsive pressure which the lady's second glance had increased in intensity. My cut was at least three centimetres long and it bled uniformly and without interruption. My cocktail became almost instantly coloured a bright red and began to rise in the glass.

I was sure I knew what the bartender had said to the lady. He had told her that I was most likely a provincial who had dropped in here by chance, and that not knowing what kind of cocktail to order I had naïvely asked him to "make it a good one". In spite of the distance I could have sworn that I had seen exactly these syllables emerge from between the bartender's lips. At the moment when he finished telling his anecdote my blood had begun to colour my drink, making it rise, and my haemorrhage continued. Then I decided to tie a handkerchief round my finger. The blood immediately went through it. I put my second and last handkerchief over it, making it tighter. This time the spot of blood which appeared grew much more slowly, and seemed to stop spreading.

I put my hand in my pocket and was about to leave, when a Dalínian idea assailed me. I went up to the bar and paid with a twenty-five *peseta* bill. The bartender hastened to give me my change – my drink was not more than three *pesetas*. "That's all right," I said with a gesture of great naturalness, leaving him the whole balance as a tip. I have never seen a face so authentically stupefied. Yet I was already familiar with this expression; it was the same that I had so often observed with delight on the faces of my schoolmates when as a boy I had exchanged the famous ten-*centimo* pieces for fives. This time I understood that it worked "exactly" the same way for grown-ups and I at once realized the supremacy of the power of money. It was as if by leaving on the bar the modest sum of my disproportionate tip I had "broken the bank" of the Hotel Ritz.

But the effect I had produced did not yet satisfy me, and all this was but

the preamble to that Dalínian idea which I announced to you a while ago. The two cocktails I had just drunk had dissipated every vestige of my timidity, all the more so as I felt after my tip that the roles were reversed and that I had become the author of intimidation. An assurance and perfect poise now presided over the slightest of my gestures, and I must say that everything I did from this moment until I reached the doorstep was marked by a stupefying ease. I could read this constantly on the face of the bartender as in an open book.

"And now I should like to buy one of those cherries you have there," I said pointing to a silver dish full of the candied fruit.

He respectfully put the dish before me. "Help yourself, Señor, take all you want."

I took one and placed it on the bar.

"How much is it?"

'Why, nothing, Señor. It's worth nothing."

I pulled out another twenty-five *peseta* bill and gave it to him.

Scandalízed, he refused to take it.

"Then I give you back your cherry!"

I put it back into the silver dish. He reached the dish over to me, beseeching me to put an end to this joking. But my face became so severe and contracted, so offended, so stony, that the bartender, completely bewildered, said in a voice touched with emotion,

"If the Señor absolutely insists on making me this further present..."

"I insist," I answered in a tone which admitted of no argument.

He took my twenty-five *pesetas*, but then I saw a rapid gleam of fear flash across his face. Perhaps I was a madman? He cast a quick glance at the lady seated beside me at the bar whom I could feel staring at me hypnotically. I had not looked at her for a single second, as though I ad been completely unaware of her presence. But now it was to be her turn. I turned toward her and said,

"Señora, I beg you to make me a present of one of the cherries on your hat!"

"Why, gladly," she said with agile coquettishness, and bent her head a little in my direction. I took hold of one of the cherries and began to pull it. But I saw immediately that this was not the way to do it, and I remembered my long experience with such things. My aunt was a hat-maker, and artificial cherries had no secrets for me. So instead of pulling, I bent the stem back and forth until the very slender wire that served as its stem broke with a snap, and I had my cherry. I performed this operation with a prodigious dexterity and with a single hand, having kept my other, wounded, hand buried in the pocket of my coat.

When I had obtained my new artificial cherry I bit it, and a small tear revealed the white cotton of its stuffing. Having done this, I placed it beside the real cherry, and fastened the two together by their stems, winding the wire stalk of the false one around the tail of the real one. Then, to complete my operation, I picked off with a cocktail straw a little of the whipped cream that covered the lady's drink and applied it to the real cherry, so that now the real and the false

both had a white spot, the one of cream and the other of cotton.

My two spectators followed the precise course of all these operations breathlessly, as if their lives had hung on each of my minute manipulations.

"And now," I said, solemnly raising my finger, "you will see the most important thing of all."

Turning round, I went over to the table I had just occupied and, taking the cocktail glass filled with my blood, and holding my hand around it, carried it cautiously and daintily put it clown on the metal top of the bar; after which, quickly removing my hand from it and picking up the two cherries by their joined stems I plunged them into the glass. "Observe this cocktail carefully," I said to the bartender. "This is one you don't know!" Then I turned on my heels and calmly left the Ritz Hotel. I thought over what I had just done, and I felt as greatly moved as Jesus must have felt when he invented Holy Communion. How would the bartender's brain solve the phenomenon of the apparition, in a glass which he had observed with his own eyes to be half empty a moment before, of the red liquid which now filled it to the brim? Would be understand that it was blood? Would he taste it? What would they to each other, the lady and the bartender, after my departure?

From these absorbing meditations I passed abruptly and with transition to a mood of joyous exaltation. The sky over Madrid was a shattering blue and the brick houses were pale rose, like a sigh filled with glorious promises. I was phenomenal. I was phenomenal. The distance which separated the Ritz Hotel from my street-car stop was rather long and I was hungry as a wolf. I began to run through the streets as fast as my legs would carry me. It astonished me that the people I passed were not more surprised at my running. They barely turned their heads in my direction and continued about their business in the most natural way in the world. Peeved by this indifference, I embellished my run with more and more exalted leaps. I had always been very adept at high-jumping, and I tried to make each of my leaps more sensational than the last. If my running, unusual and violent though it was, had not succeeded in attracting much attention, the height of my leaps surprised all passers-by, imparting an expression of fearful astonishment to their faces which delighted me. I further complicated my run with a marvelous cry. "Blood is sweeter than honey," I repeated to myself over and over again. But the word "honey" I shouted at the top of my lungs, and I pushed my leap as high and hard as I could. "Blood is sweeter than HONEY." And I leaped. In one of these mad leaps I landed right beside a fellow-student of the School of Fine Arts, who had never known me otherwise than in my studious, taciturn and ascetic aspect. Seeing him so surprised I decided to astonish him even further. Making as if to whisper an explanation of my incomprehensible leaps, I brought my lips close to his ear. "Honey!" I shouted with all my might. Then I ran toward my streetcar which was approaching and jumped aboard, leaving my co-religionist in study glued to the sidewalk and looking after me till I lost sight of him. The next day this student told everyone, "Dalí is crazy as a goat!"

That next morning I arrived at the Academy immediately before the end of classes. I had just bought the most expensive sport suit in the most expensive shop I could find in Madrid, and I wore a sky-blue silk shirt with sapphire cuff-links. I had spent three hours slicking down my hair, which I had soaked in a very sticky brilliantine and set by means of a special hairnet I had just bought, after which I had further varnished my hair with real picture varnish.[4] My hair no longer looked like hair. It had become a smooth, homogeneous, hard paste shaped to my head. If I struck my hair with my comb it made a "tock" as though it were wood.

My complete transformation, effected in a single day, created a sensation among all the students of the School of Fine Arts, and I immediately realized that, far from getting to look like everybody else as I had tried to, and in spite of having bought everything in the most exclusive and fashionable shops, I had succeeded in bringing these things together in such an unusual way that people still turned round to look at me as I went by exactly as they had before.

Nevertheless my potentialities as a dandy were now definitely established. My grubby and anachronistic appearance was replaced by a contradictory and fanciful amalgam which at least produced the effect of being expensive. Instead of inspiring sarcasm, I now released an admiring and intimidated curiosity. On coming out from the School of Fine Arts I ecstatically savoured the homage of that street, so intelligent and full of wit, in which spring was already seething. I stopped to buy a very flexible bamboo cane from whose leather-sheathed handle dangled a shiny strap of folded leather. After which, sitting down at the terrace of the Café-Bar Regina, and drinking three Cinzano vermouths with olives, I contemplated in the compact crowd of my spectators passing before me the whole future that the anonymous public already held in reserve for me in the bustle of their daily activities – activities that left no trace, activities devoid of anguish and of glory.

At one o'clock I met my group in the bar of an Italian restaurant called "Los Italianos", where I had two vermouths and some clams, after which we went over to occupy a table which was reserved for us. The story of the tip I had given the bartender had spread like wildfire into the dining-room, and when we got there all the waiters saw us coming and stood at attention. I remember perfectly the menu that I selected on that first day at the restaurant – assorted *hors d'oeuvres*, jellied madrilene, macaroni au gratin, and a squab, all this sprinkled with authentic red Chianti. The coffee and the cognac served as a further stimulant to the continuance of the principal theme of our conversations, which was none other than the initial theme of the vermouth developed in the course of the meal and which, naturally, was "anarchy".

4. Removing this varnish from my head was a whole drama. The only way to dissolve it was by dipping it in turpentine, which was dangerous for the eyes. After this (except on one occasion that I shall describe in its proper place) I never used picture varnish again, but I achieved almost the same effect by adding white-of-egg to the brilliantine.

There were about half a dozen of us at that dinner, all members of the group, but already it was apparent that a large majority tended vaguely toward the kind of liberal socialism which would some day become a fertile pasture for the extreme left. My position was that happiness or unhappiness is an ultra-individual matter having nothing to do with the structure of society, the standard of living or the political rights of the people. The thing to do was to increase the collective danger and insecurity by total systematic disorganization in order to enhance the possibilities of anguish which, according to psychoanalysis, condition the very principle of pleasure. If happiness was anyone's concern it was that of religion! Rulers should limit themselves to exercising their power with the maximum of authority; and the people should either overthrow these rulers or submit to them. From this action and reaction can arise a spiritual form or structure – and not a rational, mechanical and bureaucratic organization. The latter will lead directly to depersonalization and to mediocrity. But also, I added, there is a utopian but tempting possibility – an anarchistic absolute king. Ludwig II of Bavaria was after all not so bad!

Polemics gave an increasingly sharp form to my ideas. (Never has it served to modify my ideas, but on the contrary to strengthen them.)

Let us examine, if you will, the case of Wagner. Consider the Parsifal myth impartially from the social-political point of view... I reflected for a moment and, as if overcoming my doubts, turned to the waiter who had quickly become corrupted by our intellectualism and never missed a word of our discussions.

"Waiter, please..." I said, and he stepped forward respectfully, "on thinking it over I think I'd like a little more toast and sausage."

He went immediately. I called after him,

"And another drop of wine!"

The case of the Parsifal myth, considered from the political and social point of view, did in fact require still further reinforcements.

Leaving the Italian restaurant I went back to the Students' Residence to get some more money. What I had taken in the morning had been incomprehensibly spent. Getting money was simple. I went to the Residence office, I asked for the sum I wished, and I signed a receipt.

When I had finished my business at the Residence our group reconstituted itself at the table of a German beer-house where authentic brown beer could be had. With it, by way of accompaniment, we ate some hundred cooked crabs, the shelling and sucking of whose legs was most propitious to the continued development of the Parsifal theme.

Evening fell very fast, as if by miracle, and we were obliged to move to the Palace in order to drink our aperitif, which this time consisted of just two Martinis. These were my first dry Martinis, and I was to remain pretty faithful to them from then on. The *soufflées* potatoes disappeared dizzily from our table, but immediately a swift and willing hand brought new ones in their place.

The question soon arose as to where we should eat! For the idea of returning to the clean and sober refectory of the Students' Residence did not

occur to me for a moment. I have always adored habits, and when something has succeeded I am capable of adopting it for the whole rest of my life.

"Suppose we return to The Italians?"

Everyone acclaimed this suggestion; we telephoned to Los Italianos to reserve a small dining-room, and we patiently directed our footsteps toward this spot, with a growing famine devouring our entrails.

The dining-room was small but charming. There was a black piano with lighted pink candles on it, and a wine-stain on the wall, as visible as a decoration. What shall we eat? I should be lying if I were to tell you that I can remember. I know only that there was white wine and red wine in abundance, and that the conversation became so stormy, everyone shouted so loudly, that I ceased to take part in it. Sitting down to the piano I tried to play Beethoven's *Moonlight Sonata* with one finger. I even succeeded in inventing an accompaniment for my left hand, and they had to tear me from the piano by main force in order to take me along to the Rector's Club at the Palace (which was one of the smartest places) to drink a little champagne. This "little" I knew was a good deal, for after all the hour was approaching at which I had already planned to get drunk. Once we were seated Buñuel, who was more or less our master of ceremonies, suggested,

"Let's begin by drinking some whiskey, and later on we'll eat a few tidbits before going to bed – and then we'll take some champagne."

Everyone thought this idea excellent, and we set to work. All of us agreed that a revolution was necessary. This point was not arguable. But how was it to be made, who was to make it, and why did it have to be made? This was not so clear as it had seemed at first. Meanwhile, as the revolution was not going to break out this very night, and as it would serve no good purpose to become too much absorbed in this question, we ordered a round of iced mint to fill in between whiskeys, for after all we had to rest from time to time. At the end of the fourth whiskey everyone began to get impatient, and ask Buñuel anxiously, 'What about that champagne?"

With all this it was getting to be two o'clock in the morning and our wolfish hunger made it a foregone conclusion that the champagne would have to be accompanied by something. I took a plate of hot spaghetti and the others a cold chicken. Toward the end of my spaghetti I began to regret my choice and to look more and more longingly at the cold chicken. I had been offered some several times, and as I had refused I did not want to go back on my decision. The talk now revolved about the theme imposed by the lyricism of the champagne which had been flowing for several minutes. This theme, as you have already guessed, was "love and friendship". Love, I said, strangely resembled certain gastric sensations at the first signs of seasickness, producing an uneasiness and shudders so delicate that one is not sure whether one is in love or feels like vomiting.

"But I'm sure that if we went back to the subject of Parsifal it might still throw some light."

Everyone uttered cries of protest. They wanted to hear no more of that!

"Well, then we will come back to it another day. But anyway, save me a chicken wing for later on, for just before we leave."

It was five o'clock, and the last minute was approaching. It was a cruel thing to have to go to bed just when everything was beginning to go better. With a sense of bitterness we uncorked a fresh bottle of champagne. My friends' eyes were moist with tears. The Negro orchestra was excellent and stirred the depths of our bowels with the spoon and fork of its syncopated rhythm which gave us no respite. The pianist play with a divine incontinence, and in the high lyrical moments, during his accompaniments composed of expectations, one could hear the sound of his panting rise above the noises; and the saxophone player, having blown out all the blood of his passion, collapsed with exhaustion never to rise again. It was our discovery of jazz, and I must say in all honesty that it made a certain impression upon me at the time. In the course of the night we sent up several sizable tips, discreetly folding the bills in an envelope, and this was so unusual that all the Negroes, at the order of the pianist who conducted them, got up in unison and bowed, machine-gunning us with the dazzling fire of all their teeth laughing at once. Buñuel proposed that we serve them a bottle of champagne, and because of this we ordered still another one so as to be able to clink glasses at a discreet distance with the musicians, for the Negroes would never have been allowed to approach our table. For us money did not count. We were really of a limitless magnificence and generosity with the money earned by our parents' labors.

The fresh bottle of champagne inspired my friends to a vow which was to join all of us together in a solemn pact. We pledged ourselves on our "word of honour" that whatever happened to us in life, whatever might be our political convictions, and whatever might be the difficulties – even if we should find ourselves in the most distant countries and a long voyage should be required – we pledged ourselves, as I said, to meet in the same spot in exactly fifteen years; and if the hotel had been destroyed, then in the spot which it had occupied. The possibility of being able to find again the exact spot where we were in case the hotel and its surroundings had by chance suffered an intense bombardment shortly before, or in case this should happen at the very time when, fifteen years later, we were about to appear at our pledged meeting, started a discussion that got endlessly complicated, and I lost all interest in it.

I began to let my glance stray over that elegant jewel-besprinkled flesh that surrounded us and that seemed to clutch at my heart. Was it really this, or a slight urge to vomit, as I had said a while ago to be cynical? With a dubious appetite I ate the chicken leg that someone had saved for me.

Another bottle of champagne proved indispensable to enable us to reach an agreement. There were six of us, and we divided into six parts the card on which the Rector's Club and the table number were printed (I think I remember that the number was 8, because of a discussion on the symbolic significance of that number), and on each part we wrote the date and other data on one side,

and on the other, the six signatures. I called attention to the symbolic significance – since we were talking precisely about symbols – of our signing a pact on a piece of paper that we had immediately before torn up several times. But no one would take this into consideration, and we signed on the six pieces as we had agreed. After which each one of us kept his piece.[5]

The pact having been religiously signed, a last bottle was absolutely required to enable us to celebrate the happy conclusion of our agreement with due ceremony.

At about the time when the meeting stipulated in our pact was to have taken place, civil war raged in Spain. Imagine the Palace Hotel of Madrid, where we had lived our golden youth, transformed into a blood transfusion hospital and bombed. What a fine subject for Hollywood could be made of the heroic Odyssey of those six friends – separated for so long, separated, too, or united, by irreducible hatreds or the unanimous fervor of their fanatical opinions – repressing for a moment their tumultuous passions, temporarily putting aside their disagreements, in a dramatic, lugubrious and ceremonious meal, as a noble tribute to the honor of a word! I do not know whether this chimerical meal took place or not. All I can tell you, and I whisper this into your ear, is that I was not present.

As all things in the world must have an end, so did our night at the Rector's Club. But we found yet another *bistrot* which was open till dawn, frequented by carters and night-watchmen and the kind of people who take trains at impossible hours. There we gathered for a last round of *anis del Mono*. Dawn was already pecking, with the crowing of the first cocks, at the windows of the *bistrot*. Come on! Come on, let's get some sleep! Enough for today. Tomorrow is another day.

Tomorrow I was going to begin my new Parsifal! My Parsifal of the morrow was as follows. Up at noon. From noon to two o'clock, five vermouths with olives. At two o'clock, a dry Martini with very fine slices of "Serrano" ham and anchovies, for I had to pass the time before the arrival of the group. I have no recollection of the lunch, except that at the end of it I had the whim of drinking several glasses of chartreuse, in memory of the end of certain Sunday dinners at my parents' in Cadaqués – which made me weep.

At five or six o'clock in the afternoon we found ourselves once more seated around a table, this time in a farm on the outskirts of Madrid. It was a small patio with a magnificent view overlooking the Sierra del Guadarrama, spotted with very black oak trees. We decided it was time to have a bite to eat. I had a large plate of cod with tomato sauce. Some carters at an adjoining table were eating it with their knives, and the idea of combining the taste of the metal directly with that of the cod struck me as extremely delicate and aristocratic.

5. When, nine years later, I met one of these friends again in Paris who admitted to me that he still preciously preserved his piece of this pact, I was once more stupefied by the endemic childishness of humanity. Of all animals, of all plants. of all architectures, of all rocks, it is man who finds it hardest to age.

After the cod I asked for a partridge, but there were none at this season. I wanted by all means to eat something succulent. The proprietress suggested either warmed-over rabbit with onions, or a squab. I said I did not want anything warmed-over, and decided on the squab. The proprietress, a little annoyed, called my attention to the fact that sometimes warmed-over things are the best. I hesitated for a moment but persisted in ordering the squab. The trouble was that it was already so late that in not more than two hours we would have to eat dinner in earnest. We therefore decided that it was better to eat now, and later on, around midnight, we would just have something cold. So I said to the proprietress,

"All right, bring me the rabbit you speak so well about, too."

How right she was! With the sensual intelligence that I possess in the sacred tabernacle of the palate I understood in a moment the mysteries and the secrets of the warmed-over dish. The sauce had attained a suggestion of elasticity peculiar to the warmed-over dish which made it adhere delicately to the inside of the mouth, seeming to distribute the taste uniformly and making one click one's tongue. And believe me, that prosaic sound, which so much resembles the horror of hearing a cork pop, is the very sound of that thing so rarely understood – even more rarely understood when it is not accompanied by this sound – "satisfaction." In short, that modest rabbit gave me a great deal of satisfaction.

We left, and at this moment I realized that we had come in two luxurious cars. No sooner had we returned to Madrid than our plan for a small cold supper at midnight vanished, and once more the spectre of food placed itself before us with its terrible and inevitable reality.

"Let's begin by drinking something," I suggested "We are not in a hurry. After that we will see."

This was necessary and reasonable, for the wine at the farm was poor, and I had eaten my rabbit to the sole accompaniment of water. I had three Martinis, and toward the end of the third I distinctly felt that my Parsifal was about to begin.

I had my plan. I got up, on the pretext of having to go to the toilet, and quietly left by another door. Breathing deeply the air of freedom, which was for me that of the entire sky, I was stirred by the joyful thrill of feeling myself suddenly alone once more. I had a fantastic plan for this night, and this plan I called my "Parsifal". I took a taxi that brought me to the Students' Residence, and had it wait. It would take me just an hour. My "Parsifal" required that I make myself very handsome. I took a long shower, gave myself a very close shave, glued down my hair as much as possible, putting paint-varnish on it again! I knew the serious inconveniences of this, and even that it would spoil my hair a little, but my Parsifal was worth this sacrifice, and more! I applied powdered lead around my eyes; this made me look particularly devastating in the "Argentine tango" manner. Rudolph Valentino seemed to me at that time to be the prototype of masculine beauty. I put on very pale cream-coloured trousers, and an oxford-grey coat. As for the shirt, I had an idea that appeared to me to

put the definitive touch of elegance to my outfit. The shirt was of *écru* silk, a silk fine as onion-skin and so transparent that on looking attentively one could see through it the rather well-lined black imperial eagle of the hair in the middle of my chest. But outline was too clear. So I took off the shirt, which had been freshly ironed, and squeezed it between my two hands, folding and pressing it to a bunch between my closed fists. I put this bundle of wrinkled silk under my trunk and got on top of it so as to crush it even more. The crumpled effect that resulted was ravishing, especially when I put it on and fastened a stiff smooth collar of immaculate whiteness to it.

Having finished dressing I jumped into the taxi again, stopped to buy a gardenia which the florist pinned to my lapel, and then gave the driver the address of the Florida, a fashionable ball-room where I had never yet been, but which I knew was patronized by the most exclusive crowd in Madrid. I intended to have supper there all alone, and to choose with scrupulous care the necessary feminine material among the most beautiful, the most luxuriously dressed women, in order to carry out, come what may, that mad, irresistible thing, that thing almost without sensation and yet oppressive with pent-up eroticism, that maddening thing which since the day before I had named my Parsifal!

I had no idea where the Florida was, and each time the taxi slowed down, I thought I had arrived, and my anxiety grew so anguishing that it made me shut my eyes. I sang Parsifal at the top of my lungs. Good heavens, what a night it was going to be! I knew it. It was going to age me by ten years.

The effect of the three Martinis had totally vanished, and my brain was turning toward grave and severe thoughts. My wickedness was losing its edge with the alcohol, which I was already theoretically "against". Alcohol confuses everything, gives free rein to the most pitiful subjectivism and sentimentalism. And afterwards one remembers nothing – and if one does, it is worse! Everything that one thinks while in a state of intoxication appears to one to have the touch of genius: and afterwards one is ashamed of it. Drunkenness equalizes, makes uniform, and depersonalizes. Only beings composed of nothingness and mediocrity are capable of elevating themselves a little with alcohol. The man of evil and of genius bears the alcohol of his old age already absorbed in his own brain.

I hesitated. Was I going to execute my Parsifal with or without alcohol? The pre-nocturnal sky of Madrid knows clouds of a fantastic and poisoned mineral blue that can be found only in the paintings of Patinir, and to the warmed-over rabbit that I had eaten at the farm was now added the venom of that delicately blue-tinged colour of depilated armpits toward which I was going to direct my activity that evening, with very definite ideas on the subject in the back of my head. I took advantage of the little clearings which intoxication left for brief moments in my mind to organize the details that would enable me to execute this sublime and absolutely original erotic fantasy which made my heart beat like hammer blows every time I thought about it.

To realize satisfactorily what I wanted to do (and what nothing would

prevent me from doing), to realize my Parsifal, I needed five very elegant women and a sixth who would help us with everything. None of them needed to get undressed, and neither did I. It would even be desirable to have these women keep their hats on. The important thing was for all but two of them to have depilated armpits. I had brought a considerable amount of money even though I believed my powers of seduction already to be considerable.

I arrived at the Florida – arrived there much too early. I settled myself before a table, and looked around. I was well placed to see everything, and had my back to a wall, which was indispensable.[6] I came back immediately to the same question: did I have to get drunk or not to carry out my adventure? For all the practical preliminaries – establishing contact with the women, putting them at ease with one another, finding "where" the thing was to take place (perhaps inviting a couple of them into a private room and having them take charge of everything, as well-remunerated accomplices?) – for all these preliminary steps alcohol would obviously be a precious means of overcoming the timidity of the first moments. But afterwards – afterwards it would be exactly the contrary. What I would need afterwards was a sharp eye to see everything at once. Afterwards, from the moment my Parsifal began, no lucidity would be too great, no inquisitor's glance sufficiently severe and perfidious to judge condemn and decide between the hell and the glory of the scenes and situations, verging on disgust and yet so desired, so beautiful, so frightfully humiliating for the seven protagonists of the Parsifal that I was going to direct (and how!) before the cocks of dawn, with the agonized and rusty notes of their first crowing, were capable of raising the festooned, red and abominable cockscomb of remorse in our seven imaginations exhausted from the acutest pleasures.

The head waiter was standing in front of me, waiting for me to end my day-dreaming.

"What will the Señor have?"

Without a moment's hesitation I answered, "Bring me a rabbit with onions – warmed-over!"

But instead of warmed-over rabbit I simply ate a quarter of a chicken, infinitely sad and insipid, accompanied by a bottle of champagne, which was followed by a second one. While I was eating the chicken wing people began to arrive. Until then the large boîte de nuit had been empty except for myself, the waiters, the orchestra and a couple of professional dancers who as they danced were putting on an act of quarreling. With a quick glance I eliminated the possibility of using this dancing girl, recognizing that she did not offer the slightest interest for me. She was out of the question for the "Parsifal": she was too beautiful, terribly and disagreeably healthy, and totally devoid of "elegance".

6. An area of empty space behind my head has always created in me a sense of anxiety so painful that it makes it impossible for me to work. A screen is not enough for me, I need a real wall. If the wall is very thick I know beforehand that my work is already well on the way to success.

I have never in my life met a very beautiful woman who was at the same time very elegant, these two things excluding each other by definition. In the elegant woman there is always a studied compromise between her ugliness, which must be moderate, and her beauty which must be "evident", but simply evident and without going beyond this exact measure. The elegant woman can and must get along without that beauty of face whose continuous flashing is like a persistent trumpet-call. On the other hand, if the elegant woman's face must possess its exact quota of the stigmas of ugliness, fatigue and disequilibrium (which with the arrogance of her "elegance" will acquire the intriguing and imposing category of carnal cynicism), the elegant woman will necessarily and inevitably have to have hands, arms, feet and under-arms of an exaggerated beauty and as exhibitionistic as possible.

The breasts are of absolutely no importance in an elegant woman. They do not count. If they are good, so much the better; if they are bad, so much the worse! In the rest of her body I exact only one thing for her to be able to attain this category of elegance which we are considering – this single thing is a special conformation of the hip bones, which absolutely must be very prominent – pointed, so to speak – so that one knows they are there, under no matter what dress: present and aggressive. You think that the line of the shoulders is of prime importance? This is not true. I grant all freedom to this line, and no matter how much or in what way it might disconcert me, I should be grateful to it.

The expression of the eyes, yes – very, very important; it must be very, very intelligent, or look as if it were. An elegant woman with a stupid expression is inconceivable; on the other hand, nothing is more appropriate to a perfect beauty than a stupid expression. The *Venus de Milo* is the most obvious example of this.

The mouth of the elegant woman should by preference be "disagreeable" and antipathetic. But suddenly and as if by miracle, either at the approach of ecstasy or as it half-opens in response to a choice and infrequent impulse of her soul, it must be capable of acquiring an angelic expression which makes her momentarily unrecognizable to you.

The elegant woman's nose... Elegant women have no noses! It is beautiful women who have noses. The hair of the elegant woman must be healthy; it is the only thing about the elegant woman that must be healthy. The elegant woman, moreover, must be totally tyrannized by her elegance, and her dresses and her jewels, while they are her chief *raison d'être*, must also constitute the chief reason for her exhaustion and her wasting away.

This is why the elegant woman is hard in her sentimental passions and only faintly aroused in her loves, this is precisely why bold, avid, refined and unsentimental eroticism is the only kind of eroticism to cling with luxury to her luxury, just as the luxury of her dresses and her jewels clings exhaustingly to the luxurious body which is made only to mistreat them and to wear them with the supreme luxury of disdain.

And this is what I was getting at – blasé, rich and luxurious disdain; for

in order to carry through my "Parsifal" I had to find, this very evening, exactly six disdainful elegant women, who could obey me to the letter without losing their glacial manners and without letting the mists or erotic emotion come and befog the continual luxury of their faces, six faces capable of experiencing pleasure ferociously, but with disdain.

With my eyes open, my pupils dilated, I looked around me impatiently without being able to attach my attention to anything decisive, for there was not a single really elegant woman present, and far too many beautiful ones. I was becoming impatient. But understanding that I could not count too much on people's continuing to arrive in any considerable number, since the *boîte* was already crowded, I began to make concessions and to establish comparisons in order to make a choice among possibilities. For this first time I could always content myself with an "approximate" Parsifal. But I knew at the same time that there is nothing worse than the "approximately elegant". Does it even exist? It is as if someone tells you, to encourage you to take medicine, that it's "almost" a sweet! Suddenly two elegant women came in together, and by good fortune they sat down all by themselves at a table not far from mine that had just been left vacant. They were just what I wanted. I was still lacking four! But not finding them, I returned to the observation of my two protagonists. The only thing I could not judge was their feet, which could not but be divine, unless there were an absence of conformity about their anatomies which struck me as inconceivable. Their hands rivalled one another in beauty and all four of them were interlaced in a tangled knot which their owners had formed with a cynical coldness that made me shudder.

My second bottle of champagne had just made me moderately drunk, and my thoughts skipped beyond the grooves that I had laid out with my plan and into which I vainly tried to force them back and make them stay. Revolted by my own mental dispersion which was beginning to vex my sense of order and continuity, I said to myself,

"Look here! Either you are Dalí or you are not Dalí. Come! Be serious. You risk spoiling your 'Parsifal'. Look over there. Is that an elegant wrist? Yes, but it would be necessary to combine it with a different mouth. There it is! A mouth you would like to match it to. Wrist, mouth, mouth, wrist... if one could put beings together in this way – as a matter of fact, one *could* put them together... Why don't you try! Choose carefully before you begin. Pull yourself together. Let's see how you'll like it. You've ready found three elegant armpits. Look at them well, at all three successively, and after that, without looking at anything else, you run with your glance and you pounce on that cold expression; then on the mouth, on the more contemptuous of the two I have already chosen...

"Let's proceed in order: have an armpit, another armpit, now quickly the mouth – but you've forgotten the second armpit, so start over again and pay attention... You see it clearly, don't you, the armpit?... Oh yes, how elegant and fine it is! Here, then, is the armpit, the armpit, the fine armpit. Now look at the expression – expression... mouth... Now back again, more slowly – mouth,

expression, armpit, armpit... once more, and dwell longer on the expression – armpit, expression, expression, expression, expression, expression, go back to the armpit, go back to the expression... A little longer on the armpit this time, and now faster... Armpit, expression, expression, armpit, armpit, armpit, armpit, armpit, expression, mouth, expression, mouth, expression, expression, mouth, expression, mouth, expression, mouth, expression, mouth..."

My head was reeling and a desire to vomit which this time could no longer be confused with the delicate and uncertain sensation of "feeling oneself fall in love" made me get up with a disciplined sequence of movements. I politely asked a cigarette girl dressed as a Louis XIV page where the dressing room was. She made me a sign which I did not see, and I went into a room where there was a desk covered with letters and typewritten sheets of paper. I braced myself with the palms of both hands on this table and vomited copiously. After this I had a breathing spell, knowing that it was not over with, that my almost liturgical labor of "throwing up everything" had just begun. The cigarette girl dressed as a Louis XIV page who had followed me remained motionless in the doorway watching me. I turned to her and, putting fifty *pesetas* in her cigarette tray, said to her beseechingly, "Let me finish!" And locking the door behind me I turned toward the table with the solemn and resolute step of one who is about to commit *hara-kiri*, and again placing my two palms on its surface in an attitude identical to that of a while ago, I vomited again with an increased intensity. I was half conscious, and all the tastes of my soul, mingled with all those of my entrails, were coming out of my mouth.

During the time that this lasted, I relived the experience of these two days of orgy, only backwards and all scrambled together, as though I had begun these two days over again but in reverse, experiencing in a practical way the Christian maxim, that "the last shall be first". Everything was there: the warmed-over rabbit, the two delicate armpits, the wrists, the Patinir clouds, and again a piece of delicate armpit, and again a piece of chicken leg, and the cold expression, and again the warmed-over rabbit, expression, cold expression, warmed-over rabbit, delicate armpit, warmed-over rabbit, mushrooms, olives, monarchy, anarchy, anchovy, spaghetti, chartreuse, spaghetti, warmed-over clams, warmed-over rabbit, chartreuse, warmed-over clams, chartreuse, warmed-over rabbit, clams, armpits, spaghetti, vermouth, warmed-over, vermouth, warmed-over warmed-over vermouth, vermouth, bile, warmed-over, vermouth, bile, warmed-over, vermouth, bile, bile, clams, bile, clams, warmed-over, bile, warmed-over, bile, warmed-over, bile, bile, bile, bile, bile, warmed-over rabbit, warmed-over rabbit, bile, bile, bile, bile, bile, bile, bile, warmed-over rabbit, vermouth, bile, bile, bile, spaghetti, bile, clams, bile! Warmed-over rabbit, bile! Bile, bile, clams, bile!

I wiped the sweat from my brow and the tears that I shed without weeping, and that flowed down my cheeks – everything had come up. Everything from the absolute anarchic monarchy to the last propellers of my nostalgic, sublime and lamented "Parsifal".

I spent the next day in bed drinking lemon-juice, and the day after I went to the Academy of Fine Arts at the usual hour, only to be expelled from school the following afternoon. When I arrived I found a group of students gesticulating and shouting, and I was seized with a feeling of impending disaster. If I could have remembered the scene of the burning of the flag in Figueras I should have been suspicious of the turn matters took, for I was once more to be the victim of the myth that spread its halo around me. Indeed the attentive reader of this book, who seeks to draw analytical conclusions from it, will have noticed what I myself have often had forced upon my attention only in writing it – namely, that as the development of my mind and character can always be summarized in a few essential myths that are peculiar to me, so the events of my life repeat themselves and develop a few rather limited, but terribly characteristic and unmistakable themes. Whenever in my life something happens to me with a cherry, or with a crutch, you can be sure that it will not stop there. Incidents, ever new, more or less truculent, mediocre or sublime, will occur in connection with cherries and with crutches my whole life long until I die.

If I had known this I could have foreseen, the very first time I was expelled from school, that it would not be a simple and vulgar isolated incident as would have been the case for spirits who, lacking paranoiac inspiration, escape without grief or glory the systematic principles which must govern every destiny worthy of greatness. But to return to the insurgent group that I ran into in the yard of the Academy of Fine Arts – this very group, when it saw me coming, surrounded me and took me automatically as witness, partisan and flag of its rebellion.

What was the occasion of this rebellion? I had already been informed that there was to be an examination to fill the vacant post of teacher of painting at the Academy, and that several renowned painters were coming to compete in it, this being one of the most important classes. The paintings that constituted the practical part of the examination had just been exhibited, each participant having had to execute one painting on a subject of his own choice and one on a prescribed theme. It appeared that all the paintings were utterly mediocre, with the exception of those of Daniel Vásquez Díaz, which corresponded exactly to what was at that time called "post-impressionism". The seed which I had nonchalantly let drop among the students of the School was in germination and a minority of them – the most active and the most gifted – had suddenly become enthusiastic over Vásquez Díaz, who without having gone as far as cubism was influenced by it, so that through him people were able to swallow what they would not even consider when it came from me.

Thus, according to the insurgents, I must of necessity be a partisan of Vásquez Díaz, and my friends were aroused because they were sure that an injustice was about to be committed and influence and intrigue used to give the post to someone who in no way deserved it. I went with my fellow-students to look at the exhibition, and for once I agreed with them. Doubt was impossible, even though in my heart I should have wanted none of these as professor of

painting. I should have preferred a real old academician. But this was a category of people that had disappeared, that had been totally exterminated. Since I had to choose, I gave my vote to Vásquez Díaz without any reservations.

That afternoon, after each of the competitors had briefly expounded his pedagogical ideas (the only intelligent one being Vásquez Díaz), the academicians retired to deliberate. When they reconvened on the platform, and when they pronounced the verdict that we had been expecting, thus consummating one of the thousand injustices and unedifying episodes of which the tapestry of this period of Spanish history was woven, I rose in sign of protest and without saying a word I left the hall before the President of the tribunal, one of the most eminent of the academicians, had finished his closing speech. I was awaited by my group in a gathering of republican writers that was held every afternoon at the Café-Bar Regina, and that was more or less under the influence of Manuel Azaña, who a few years later was to become the President of the Spanish Republic.

The following day when I returned to the school an atmosphere of panic reigned among my co-disciples, and they told me that I was going to be expelled for the incident of the previous day. I did not take the matter seriously, for I knew that it was impossible to take such a measure in retaliation for the mere act of having walked out in the middle of the President's speech. My gesture, though clearly one of protest, had remained strictly within the limits of politeness, since I had not interrupted the President or slammed the door as I left. But in my innocence I was not at all aware that this was not what the stir was about. It appeared that after I left, the students who supported Vásquez Díaz began to interrupt the academician's speech with insults and imprecations, and passing from words to deeds, persecuted the academicians till they were forced to make their escape and lock themselves up in the drawing-class. The students were on the point of breaking in the door by using a bench as a battering ram when the mounted police rode into the yard and shortly succeeded in rescuing the trembling academicians.

The morally visible leader of this state of mind was myself. And in spite of the fact that I had not been present at the disturbance, I was put down on the list of the rebels as having actively cooperated with them from the moment of my exit, which was interpreted as a signal for the demonstration to begin. It was in vain that I attempted to plead my innocence. I was suspended for a year from the Academy of Fine Arts, and after the disciplinary council had confirmed my suspension I returned to Figueras.

I had been home but a short time when I was taken into custody by the Civil Guard and locked up in the prison of Figueras. At the end of a month I was transported to the prison of Gerona, and was finally set free when no adequate charges could be found on which to try me. I had arrived in Catalonia at a bad moment. A very determined revolutionary upsurge had just been energetically repressed by General Primo de Rivera, who was the father of José Antonio, the future founder of the Spanish Falange. Elections had just taken place, and an effervescent political agitation absorbed all activities. My best childhood friends

of Figueras had all become revolutionaries, and my father, accomplishing is strict notarial functions, had had to testify to abuses committed by certain elements of the right during the elections. I had just arrived, and this was remarked even more than formerly. I was always talking about anarchy and monarchy, deliberately linking them together. It was from this whole amalgam of circumstances, which only my father could adequately and accurately relate, that my arbitrary imprisonment resulted, without any other consequence than to add a lively colour to the already highly coloured sequence of the anecdotic episodes of my life.

This period of imprisonment pleased me immeasurably. I was naturally among the political prisoners, all of whose friends, co-religionists and relatives showered us with gifts. Every evening we drank very bad native champagne. I had resumed writing the "Tower of Babel" and was reliving the experience of Madrid, drawing philosophic consequences from each incident and each detail. I was happy, for I had just rediscovered the landscape of the Ampurdán plain, and it was while looking at this landscape through the bars of the prison of Gerona that I came to realize that at last I had succeeded in aging a little. This was all I wished, and it was all that for several days I had wanted to tear out and squeeze from my experience in Madrid. It was fine to feel a little older, and to be within a "real prison" for the first time. And finally, as long as it lasted, it would be possible for me to let my mind relax.

CHRONOLOGY 1904-1974

1904
Birth, May 11, at 8:45 a.m., at 20 Calle Monturiol, Figueras, Gerona (Catalonia, Spain), of Salvador Domenech Felipe Jacinto Dalí, son of Salvador Dalí i Cusí, *notario,* and Felipa Domenech.

1911
Attended local public elementary school.

1913
Attended School of Brothers of the Christian Doctrine.

1914
Dalí is struck down by illness; a long convalescence at the Pichots', friends of the Dalí family; Salvador is struck by Ramón Pichot's Impressionist painting. At ten, enrolled at Marist Brothers' School, Figueras.

1916
Enters drawing classes of Professor Don Juan Nuñez, whom he reveres.

1918-19
His painting seems influenced by Modesto Urgel, Ramón Pichot, Mariano Fortuny, and a few of the realistic painters of the nineteenth century. Dabbles in Impressionism and Pointillism. Makes "collages" of stones in his pictures, to render depth of light. Reads the magazine *L'Esprit Nouveau* ("The New Spirit"), discovering Cubism and Juan Gris. Has two pictures in a show, with thirty local artists, at Figueras theatre; well noted by critics. Designs poster for the Figueras festival, *Fires i Festes de la Santa Creu.*

1919
January-June, with schoolmates, publishes the magazine *Studium,* in which he writes and edits the old masters department. Begins to paint in distemper. Participates in student political agitation; is arrested for twenty-four hours.

1920
His painting seems to reflect the influence of the Italian Futurists.

1921-22
Death of Dalí's mother. Attends Madrid's San Fernando Institute of painting, sculpture, and drawing; meets Federico García Lorca and Luis Buñuel. Goes from studious, monastic life with Bohemian habits of attire to worldly existence of Beau Brummel dandyism. Executes a series of classical paintings.

1922

In October, shows eight canvases at Dalmau Gallery, Barcelona, in exhibition of young Fine Arts School students.

1923

Influenced by school of metaphysical Italian painters, Giorgio de Chirico and Carlo Carra. Suspended for one year from San Fernando Institute for inciting students to protest, following demonstration against appointment of a professor. One month's political preventive arrest in prison of Figueras.

1924

Illustrations for *Les Bruixes de llers* by Fages de Climent. Vacations at Cadaqués with García Lorca.

ALSO BY SALVADOR DALI FROM DEICIDE PRESS

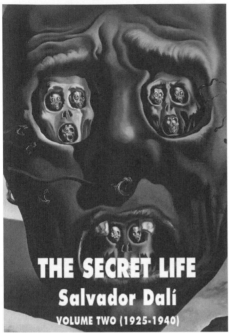

ISBN 978-1-84068-687-6

THE SECRET LIFE
VOLUME TWO (1925-1940)

THE SECRET LIFE, Salvador Dali's first volume of autobiography, was completed in 1941 and comprises one of modern art's most revelatory – and revolutionary – literary documents.

THE SECRET LIFE Volume Two documents the years 1925 to 1940, and presents an illuminating in-depth memoir of the artist's phenomenal ascendency to global renown as the living embodiment of Surrealism.

This new edition of THE SECRET LIFE is updated and corrected, and also contains a complementary chronology of Dali's life and works.

ISBN 978-1-84068-684-5

DIARY OF A GENIUS
(1952-1963)

DIARY OF A GENIUS stands as one of the seminal texts of Surrealism, revealing the most astonishing and intimate workings of the mind of Salvador Dalí, the eccentric polymath genius who became the living embodiment of the 20th century's most intensely subversive, disturbing and influential art movement.

Dali's second volume of autobiography, DIARY OF A GENIUS covers his life from 1952 to 1963, during which years we learn of his amour fou for his wife Gala and their relationship both at home in Cadaqués and during bizarre world travels.

This new edition includes a brilliant and revelatory essay on Salvador Dalí, and the importance of his art to the 20th century, by the author J G Ballard.

With 20 illustrations.